MATISSE, PICASSO, AND MODERN ART IN PARIS

Catalogue and exhibition organized by

MATTHEW AFFRON and JOHN B. RAVENAL with EMILY SMITH

Virginia Museum of Fine Arts, Richmond
University of Virginia Art Museum, Charlottesville
Distributed by the University of Virginia Press, Charlottesville and London

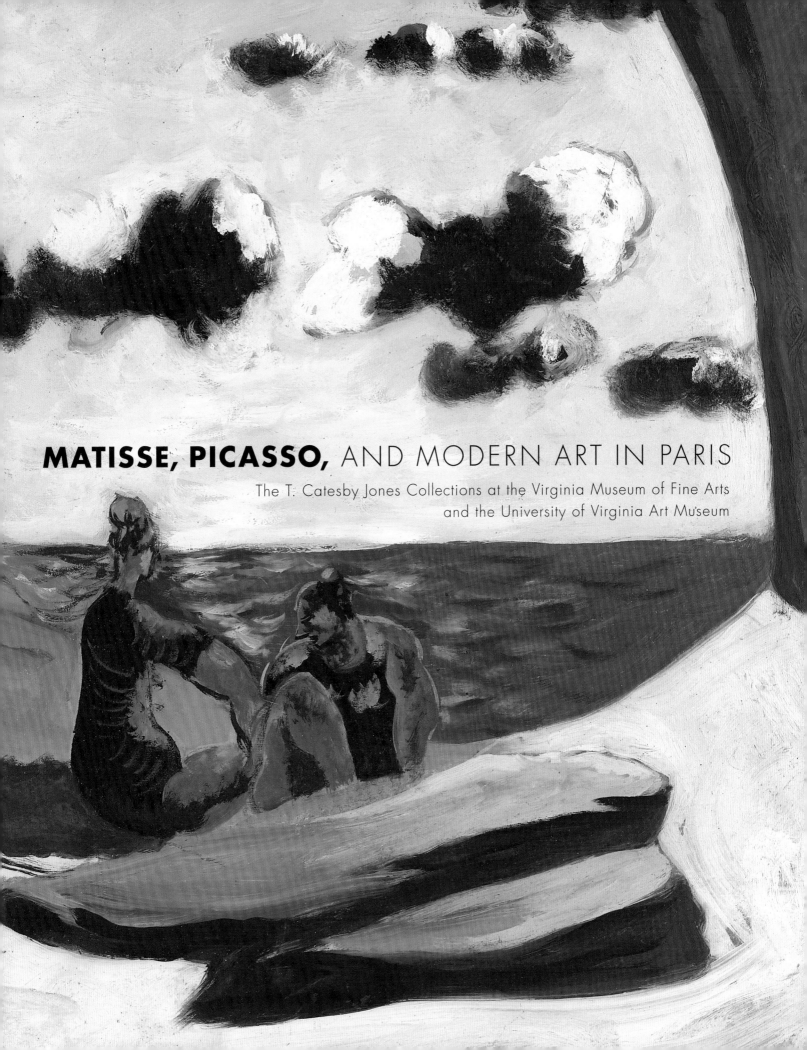

MATISSE, PICASSO, AND MODERN ART IN PARIS

The T. Catesby Jones Collections at the Virginia Museum of Fine Arts
and the University of Virginia Art Museum

This catalogue was published to accompany the exhibition *Matisse, Picasso, and Modern Art in Paris: The T. Catesby Jones Collections at the Virginia Museum of Fine Arts and the University of Virginia Art Museum.*

Matthew Affron served as the general editor for the catalogue.

UNIVERSITY OF VIRGINIA ART MUSEUM January 30–April 24, 2009

MUSEUM OF THE SHENANDOAH VALLEY August 15–November 29, 2009

WILLIAM KING REGIONAL ARTS CENTER December 11, 2009–February 21, 2010

VIRGINIA MUSEUM OF FINE ARTS April–June 2010

Library of Congress Cataloging-in-Publication Data

Matisse, Picasso, and modern art in Paris : the T. Catesby Jones collections at the Virginia Museum of Fine Arts
and the University of Virginia Art Museum / edited by Matthew Affron and John B. Ravenal with Emily Smith.
p. cm.
Published to accompany an exhibition held at the University of Virginia Art Museum and three other institutions between
Jan. 30, 2009 and May 30, 2010.
Includes index.
ISBN 978-0-917046-88-9 (alk. paper)
1. Art, French—20th century—Exhibitions. 2. Jones, T. Catesby (Thomas Catesby), 1880–1946—Art collections—Exhibitions.
I. Affron, Matthew II. Ravenal, John B. III. Smith, Emily H. IV. Virginia Museum of Fine Arts. V. University of Virginia. Art Museum.

N6848.M35 2008
709.44074'755451—dc22

2008046988

Produced by the Office of Publications, Virginia Museum of Fine Arts
200 N. Boulevard, Richmond, Virginia 23220-4007 USA
Edited by Stacy Moore
Book design by Lauren Kitts
Index by Anne Adkins
Digital photography by Katherine Wetzel and Travis Fullerton, VMFA, and Andrew Hersey, UVAM
Layout in Adobe InDesign with Futura and Adobe Garamond
Printed on Sappi McCoy Silk text by Worth Higgins & Associates, Inc., Richmond, Virginia

Printed in the United States of America

Front: Henri Matisse, *Lorette,* 1917 (cat. no. 174); Back: Pablo Picasso, *The Frugal Repast,* 1904 (cat. no. 187); title page: Jean Lurçat, *Bathers,* 1934 (cat. no. 136), detail; p. x: Jacques Lipchitz, *Theseus,* 1943 (cat. no. 103), detail; p. 18: Louis Marcoussis, *Interior (Pedestal Table with Breton Bread, Balcony),* ca. 1929–30 (cat. no. 152), detail; p. 30: Maurice de Vlaminck, *The Storm,* ca. 1912 (cat. no. 272), detail; p. 116: André Masson, *Dream of a Future Desert,* 1942 (cat. no. 158), detail.

CONTENTS

DIRECTORS' FOREWORD

To T. Catesby Jones we owe a tremendous debt of gratitude. This exhibition and catalogue, the outcome of an impressive collaboration between two great Virginia institutions, celebrate the life of an exceptional Virginia collector while exploring a period of innovation and experimentation in twentieth-century art.

The 1947 bequest of School of Paris and modernist works from the collection of T. Catesby Jones was a benchmark in the early establishment of the world-class collections at the Virginia Museum of Fine Arts. Jones's parallel gift, in the same year, of works on paper and books to the University of Virginia completed an outstanding act of philanthropy that demonstrated his lifelong attachment to the state in which he was born, nurtured, and educated.

Matisse, Picasso, and Modern Art in Paris showcases the breadth of T. Catesby Jones's aesthetic interests by reuniting these collections and offering opportunities for fresh analysis and research. By combining the resources of a public museum, a university museum, and an academic department, we have achieved a remarkable collaboration among not only art historians and curators from our respective institutions but also graduate students in the art history program at the University of Virginia. These young scholars have gained invaluable experience in primary research as well as in the processes of planning an exhibition and related publication.

The concept for the exhibition originated with Matthew Affron, associate professor of art at the University of Virginia and curator of modern art at the University of Virginia Art Museum. He proposed the collaboration with John Ravenal, the Sydney and Frances Lewis Family Curator of Modern and Contemporary Art at the Virginia Museum of Fine Arts. With the assistance of VMFA curatorial fellow Emily Smith, they have developed and implemented this fascinating and illuminating exhibition and publication.

Such an undertaking would not be possible without the generous contributions of several foundations and organizations. We thank the University of Virginia Art Museum Volunteer Board for its leading support of the exhibition in Charlottesville. We extend our appreciation to the Eugene V. and Clare E. Thaw Charitable Trust for generously supporting the exhibition and publication. We also gratefully acknowledge the Fabergé Ball Endowment at the Virginia Museum of Fine Arts and the support from Altria for VMFA traveling exhibitions; and, at the University of Virginia, the Carl H. and Martha S. Lindner Center for Art History, the Arts Enhancement Fund of the Office of the Vice Provost for the Arts, and Arts$.

This exhibition and publication offer a blueprint for future collaborations between our institutions, reinforcing our respective commitments to share knowledge, resources, and scholarship with partners and colleagues throughout Virginia. With this in mind, it gives us great pleasure to show this exhibition not only in Richmond and Charlottesville, but also in Winchester and Abingdon, thereby giving the collections, and their Virginia collector, the prominence they deserve. We are sure T. Catesby Jones would approve.

Alex Nyerges, *Director*
Virginia Museum of Fine Arts

Elizabeth Hutton Turner,
Interim Director
University of Virginia Art Museum

This book and the exhibition that it accompanies are the results of a proposal made some years ago by Matthew Affron to John Ravenal. With the sixtieth anniversary of the 1947 T. Catesby Jones bequests to the University of Virginia and the Virginia Museum of Fine Arts on the horizon, the time seemed right to celebrate those gifts. What ensued was an unusual and productive collaboration that honors an historical collection of artworks at two public Virginia institutions to which Jones had been particularly committed.

The effort to conceptualize, organize, and execute the project succeeded through the sharing of collections, the sharing of resources and, in a larger sense, the sharing of knowledge and experience. The Virginia Museum of Fine Arts and the University of Virginia Art Museum have each benefited from the exhibition and related programs. In addition, the project's academic component was enormously useful to both museums as well as to the McIntire Department of Art at the University of Virginia. This fresh inquiry into the T. Catesby Jones collections provided the occasion for much new scholarship. A great deal of that research is the work of current and former UVA graduate students in the history of art and architecture; the project has brought museum professionals and faculty members together with students and has helped bring new scholars into the field. We extend our warmest thanks to those catalogue authors: Katherine Eve Baker, Elizabeth T. Broadbent, Christopher C. Oliver, Leslie F. Cozzi, Melissa Sue Ragain, Rebecca Schoenthal, Jessica Stewart, and Jacqueline Taylor. Emily Smith, a former UVA graduate student who also contributed essays, deserves special recognition. In her capacity as the curatorial fellow in modern

and contemporary art at VMFA, she handled a broad range of exhibition- and publication-related responsibilities with professionalism and good cheer.

Circulating the exhibition to two further venues within Virginia fulfills an important aspect of the mission of the Virginia Museum of Fine Arts. It is worth noting that this tour of VMFA's portion of the Jones bequest is only the latest in a long history of travel throughout the Commonwealth. The VMFA bequest, which was the first important collection of modern art in a public Virginia museum, circulated regularly to other Virginia institutions from the time of its arrival in the 1940s through the decades of the 1960s and 1970s.

Any exhibition and publication project of this scope depends on the good will and assistance of a great number of institutions and individuals. We have repeatedly called upon Peggy Brooks, daughter of T. Catesby Jones, for help, and we are deeply in her debt. We also thank Richard Riley, one of T. Catesby Jones's grandchildren, for providing essential assistance at an early stage. Muriel Jaeger, the daughter of Jeanne Bucher, who is another central actor in our story, kindly provided access to her mother's personal archive. We also thank Véronique Jaeger of Galerie Jeanne Bucher for her help.

During the research phase we benefited enormously from the assistance, suggestions, and advice offered by many colleagues at other museums, libraries, and archives. The exhibition curators and catalogue authors would like to gratefully acknowledge the following: Tad Bennicoff, Seeley G. Mudd Manuscript Library, Princeton University; MacKenzie Bennett, Museum of Modern Art Archives; Marisa Bourgoin and Laura MacCarthy, Archives of American Art;

PREFACE AND ACKNOWLEDG- MENTS

Laura Barry, Donna Cooke, and George Yetter, Colonial Williamsburg; Stephanie D'Alessandro, Art Institute of Chicago; Marie Difilippantonio, Julien Levy Archive; Laura Drake Davis, Library of Virginia; Michael FitzGerald, Trinity College; Michèle Giffault, Musée départemental de la tapisserie, Aubusson; Stacey Goergen, Whitney Museum of American Art; Anna Heintzelman and Lynn Manner, Kenyon College Archives; Mattias Herold, Department of Painting and Sculpture, Museum of Modern Art; Eric Holzenberg and J. Fernando Peña, the Grolier Club; Shaunna Hunter, Hampden-Sydney College Library; Daniel Kramer and Francesca Volpe, Galerie Beyeler; Mary-Kay Lombino, Frances Lehman Loeb Art Center, Vassar College; Helen Long, Newberry Library; Karen Mansfield, Worcester Art Museum; Robert Parks and Maggie Portis, Morgan Library and Museum; Anne Rochfort, Marlborough Gallery; Jeffrey Ruggles, Virginia Historical Society; Ingrid Schaffner, Institute of Contemporary Art, University of Pennsylvania; Jennifer Schauer, Office of the Registrar, Museum of Modern Art; Sarah Suzuki and Emily Talbot, Department of Prints and Illustrated Books, Museum of Modern Art; and Laura Willoughby, Petersburg Museums. For his ceaseless good will, support, and expertise, we extend special thanks to Larry Goedde, chair of the McIntire Department of Art at the University of Virginia. The catalogue authors have, in addition, received valuable advice and expertise from Sarah Betzer and Douglas Fordham, faculty members in UVA's art department. We would like to extend our warm thanks to others who helped in many different ways: Christopher Colt, whose father was VMFA's founding director; Gérard Denizeau; Francesca Fiorani; Jodi Hauptman; Robert L. Herbert;

Joseph Inguanti; Marilyn MacCully; Maurie McInnis; Liz Magill; Mitchell Merling; Diane Miliotes; George Ong; George Rutherglen; and our peer readers, Marjorie Balge and Kevin Murphy. In addition, we offer our appreciation to two University of Virginia undergraduates who acted as research assistants during an early phase of the project: Joanna Gragnani and Aliya Reich.

At the Virginia Museum of Fine Arts, the enthusiasm of Director Alex Nyerges for the project has been instrumental to its success. Many colleagues at VMFA helped organize both the exhibition and the publication; the following deserve special mention for the energy and talent they contributed to making these possible: Robin Nicholson, deputy director for exhibitions; Aiesha Halstead, coordinator of exhibitions planning; Sarah Poitevent Porter, coordinator of traveling exhibitions; Susan Turbeville, assistant registrar; in the Department of Publications, Sarah Lavicka, chief graphic designer and acting manager; Rosalie West, editor in chief; Lauren Kitts, graphic designer; Stacy Moore, editor; and Anne Adkins, indexer; Carol Sawyer, Kathy Gillis, Bruce Suffield, and Daniel Brisbane in the Departments of Paintings and Objects Conservation; Howell Perkins, Katherine Wetzel, Travis Fullerton, and Susie Rock in the Departments of Photography and Photographic Resources; and Courtney Yevich in the VMFA Library.

At the University of Virginia Art Museum, the support and guidance of Interim Director Elizabeth Hutton Turner has been crucial to the success of this project. We have been aided in ways too numerous to list by Andrea Douglas, curator of collections and exhibitions; David Chennault, chief operating officer; Jean Lancaster Collier, collections manager; Nicole Anastasi, curatorial assistant; and

Ana Marie Liddell, exhibitions coordinator. Marilyn Wright, interim director of development, led the effort to fund our exhibition, catalogue, and associated programs. We also thank Ann-Marie Alford, senior researcher in the Office of University Development.

When the T. Catesby Jones collection came to the University of Virginia, in 1947, it was deposited in the Rare Books Department; substantial portions of that bequest, including the illustrated books and some print portfolios, remain there. For the loan of a number of prints to the exhibition and for much collegial help, we are indebted to Karin Wittenborg, university librarian, and Christian Dupont, former director of the Albert and Shirley Small Special Collections Library. We also thank, at the Albert and Shirley Small Special Collections Library: Edward Gaynor, associate director; Heather Riser, head of Public Services; Holly Robertson, head of Preservation Services; Mercy Quintos, exhibits coordinator; and Gayle Cooper, cataloguer. Allison White and Cecilia Brown assisted with research in the Arthur J. Morris Law Library at UVA.

Matthew Affron
Curator of Modern Art
University of Virginia Art Museum

John B. Ravenal
Sydney and Frances Lewis Family Curator
of Modern and Contemporary Art
Virginia Museum of Fine Arts

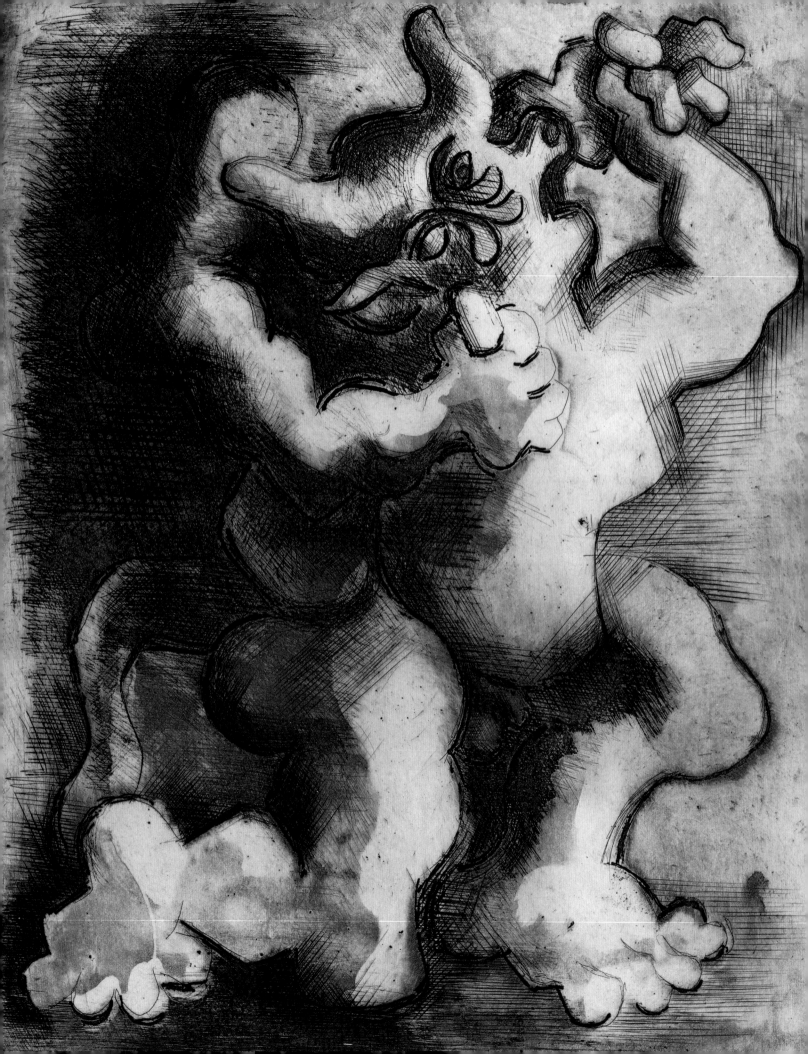

In the Museum of Modern Art archives is an inventory of an art collection that was kept in a Romanesque-revival townhouse on East Ninety-second Street in New York City. A prominent lawyer named T. Catesby Jones shared this house with his wife, Louisa Brooke Jones, and their two daughters. The home was decorated with old family furniture, chests purchased during trips to Europe, and oriental carpets. And, as the inventory shows, by the late 1930s it was also filled with modern French art.[1]

As a whole, these artworks formed an archetypal example of a private collection of the early twentieth century; that is, an assemblage of modernist painting, sculpture, drawings, and prints displayed in a single-family urban dwelling.[2] The works that were in the three main rooms alone indicate a collection of significant size and scope. The library contained, among other images, three paintings by Pablo Picasso, all dating from the decade before World War I. The earliest, *Woman with Kerchief* (cat. no. 200, p. 97), is a portrait made during Picasso's period of classical expression in 1906.[3] The two others are cubist still lifes: *Guitar and Glasses,* an oval composition of 1912 (fig. 1), and *Still Life (Wineglass and Newspaper),* dated 1914 (cat. no. 202, p. 98). Three portraits by Henri Matisse hung in the drawing room. Two of these, both 1917 paintings on panel, are part of an important series of pictures of a model named Lorette (also called Laurette; cat. nos. 174 and 175, pp. 88–89), and the third is a 1922–26 rendering of a figure in an interior, *Woman with a Bouquet* (fig. 2). There were also two still lifes by Georges Braque and, on the mantle, a pair of cast bronzes belonging to Jacques Lipchitz's *Transparents* series of 1925–30. This series explores the power of abstraction from

linearity and structural openness in sculpture. One of these bronzes, *The Harpist* (1928), fuses the form of a female musician with that of her instrument. The other, entitled *Pegasus* (1930, fig. 3), is one of several

T. Catesby Jones, 1921

Transparents with a horse-and-rider theme.[4] The drawing room also contained a 1929 pastel by André Masson (cat. no. 156, p. 82) and five oils by Jean Lurçat, an artist who is best known today as a master of modern tapestry but at the time had a considerable reputation as a painter.

In the dining room was an atmospheric landscape study by André Derain (ca. 1919–25, cat. no. 33, p. 41) and a 1927 series of four canvases on the theme of the seasons (cat. nos. 3–6) by André Bauchant, a self-taught artist who was much admired in the 1930s by forward-looking collectors in Paris and New York. This series mixes allusions to seventeenth-century landscape precedents—Flemish naïve realism as well as the pastorals of Claude Lorrain and other French masters—with modern motifs.

By the end of the 1930s, when the inventory was compiled, Jones had been a collector of modern French art for fifteen years and a supporter of the Museum of Modern Art since its very early days. Both roles would have warranted such an

FROM PARIS TO NEW YORK
BUILDING THE COLLECTION

Matthew Affron

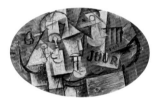

Fig. 1: Pablo Picasso, *Guitar and Glasses,* oil on canvas, 1912. Private collection

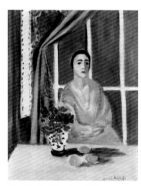

Fig. 2: Henri Matisse, *Woman with a Bouquet,* oil on canvas, 1928. Worcester Art Museum

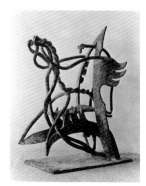

Fig. 3: Jacques Lipchitz, *Pegasus,* bronze, 1930. Private collection

accounting of his collection. And yet within a decade, the majority of his holdings would be transplanted to Virginia. In his will, dated May 2, 1946, Jones bequeathed 104 objects, mostly paintings, sculptures, and drawings by modern French artists, to the Virginia Museum of Fine Arts in Richmond. He had previously given works of art to VMFA, and additional gifts would subsequently come from the family and from the dealer Curt Valentin. Jones's will also directed that his illustrated books in the French language, his books on art and architecture, and the majority of his prints be given to the University of Virginia.[5] In August 1947 the University of Virginia Library completed an inventory of items received. This inventory lists some 175 items, but it does not distinguish consistently between individual prints, portfolios containing numbers of prints, and artists' books.[6] In 1975, the University of Virginia Art Museum received most of the prints, numbering 131, as a permanent loan from the Rare Books Department at the university's Alderman Library.[7]

Thomas Catesby Jones was born in 1880 in Petersburg, Virginia, into a family with a long and distinguished history in the state's Tidewater region. Captain Roger Jones (1625 or 1635–1701), who had emigrated from London to Virginia in 1680 and commanded a sloop-of-war on the Chesapeake Bay, was the first ancestor in North America. His son Colonel Thomas Jones (?–1757) patented large tracts of land in eastern Virginia and represented the College of William and Mary in the Virginia House of Burgesses in 1720–22. Thomas married Elizabeth Cocke Pratt (1701–1762), niece of Mark Catesby (1683–1749), famed naturalist and author of the first large-scale illustrated account of the flora and fauna of the southern American colonies, *Natural History of Carolina, Florida, and the Bahama Islands* (1731–47). Other notable family members of the nineteenth century were landowners, physicians, and lawyers, as well as military and naval officers. Commodore Thomas ap Catesby Jones (1789–1858), great-grandson of Colonel Thomas Jones, won distinction for bravery during the War of 1812 and served as commander of the United States Pacific Fleet in the 1840s. A young Herman Melville signed on as a seaman to Jones's frigate the *United States;* he later based his novel *White-Jacket* (1850) partly on his experiences aboard the vessel in 1843–44, and he mentioned Commodore Jones in a later poem, *Bridegroom Dick* (1876), recounting the same voyage. The commodore's great-nephew, Lieutenant Catesby ap Roger Jones (1821–1877), was the executive officer on the first Confederate ironclad, the *Virginia* (once *Merrimack*), and commanded the ship during its engagement with the Union *Monitor* in Hampton Roads in 1862.[8]

Petersburg, where T. Catesby Jones the collector was born and raised, is some twenty miles south of the capital city of Richmond. This proximity, together with its location on the Appomattox River, a natural trade route and power source for machinery, had helped make Petersburg a leading manufacturing center of the South by the 1830s. Walter Nelson Jones (1850–1920), T. Catesby Jones's father, made his fortune in the period of Petersburg's postbellum prosperity. Moving from his hometown of Richmond around 1875, he founded a firm that processed sumac and oak bark, agents used for tanning and dyeing leather. By 1902 his mill had a workforce of about a hundred and ranked among the city's most prominent enterprises. Walter Jones's two eldest sons entered the

family business, while another son went on to run a loan venture in South Carolina and the youngest became a prominent Navy doctor.[9]

Catesby, the third son, enrolled at Hampden-Sydney College in Virginia and graduated in 1899. He then attended Princeton University for one year of study that included jurisprudence classes taught by future president Woodrow Wilson as well as courses in political economy and sociology. After completing the MA in 1900, he returned to his home state to study law at the University of Virginia, taking his degree in 1902. Following a few months of travel in Europe, Jones moved to Norfolk, Virginia, where he worked for a year as a schoolteacher while setting up a law practice. In 1911 he joined the firm of Harrington, Bigham, and Englar in New York City; he became a partner in 1915 and remained a member of the successor firm, Bigham, Englar, Jones, and Houston, until the end of his life. Jones established a national and international reputation in maritime law. He appeared frequently before the Supreme Court in sovereign immunity and other cases involving admiralty law. In 1944 he was appointed a prize commissioner in the United States District Court for the Southern District of New York with jurisdiction over the Atlantic, and in 1945 he oversaw the seizure of the German liner *Europa* as a prize of war. Jones was married twice, first in 1911 to Olga Hasbrouck, who died in 1913 soon after the birth of their son, Catesby Thomas, and then to Louisa Brooke, a graduate of Vassar College and an aspiring writer, in 1916. They had two daughters, Mary (Polly) and Frances (Peggy).[10]

Outside his law practice, Jones's chief interests were Virginia and family history—and modern French art. Evidence of the former dates back to 1928 when Jones donated a set of the third edition of Catesby's two-volume *Natural History* (1771) to Colonial Williamsburg. The following year he presented the Bruton Parish Church in Williamsburg with a marble tablet commemorating two illustrious namesakes, Thomas Jones and Mark Catesby.[11] In 1940 Jones donated documents relating to Lieutenant Catesby ap Roger Jones and the *Virginia* to the Virginia Historical Society in Richmond, where he served as an officer beginning in 1935, and subsequently published articles on the same topic in the society's journal.[12] He was a benefactor of the University of Virginia School of Law and president of the law school association in 1940–41.[13]

The story of Jones the collector begins in 1924 when, at age forty-four and a long-established partner in his law firm, he began to acquire modern French art. (It bears noting that Jones collected in some other areas also, but with far less concentration and ambition; his involvement with French art was what defined him as a collector.[14]) The Joneses were in Paris in the summer of that year, the season of the Salon des Tuileries, a new large-scale exhibition of contemporary art. Jones acquired eight works there: paintings by Hermine David, André Lhote, and Félix Tobeen; prints by Achille Oeuvré and Kurt Mainz; sculpture by François Pompon; and an enamel by Léon Jouhaud. In November and December, after his return to New York, he purchased through Fearon Galleries the first of his two portraits of Lorette by Matisse, as well as canvases by Othon Friesz (cat. no. 53) and Maurice de Vlaminck (cat. no. 272, p. 115), former members of the fauve group who by then ranked as respected midcareer masters.[15]

Jones got his start as a collector at a time when, in the words of American painter and critic George L. K. Morris, "the modern movement [had] begun to lose some of its alarming modernity," meaning both that its place in history had begun to be clear and that it was garnering a broader appeal.[16] Even as hostility toward modernism in both the art world and the popular imagination remained intact, its market in major European centers as well as the United States was expanding. In New York this boom of the 1920s was fueled by merchants, curators, critics, and a new generation of collectors, many from the professional classes. The latter regarded contemporary European art, French art above all, as an intriguing and relatively affordable field of action.[17]

Over the course of his life as a collector, Jones developed significant relationships with a number of New York galleries that were associated with prestigious contemporary French artists. Early on, he bought works from the dealer Valentine Dudensing and his protégé Pierre Matisse, in addition to his purchases from Fearon. The son of the painter, Matisse came to New York in 1924 and the same year handled Jones's acquisition of Braque's *Still Life, Fruit* (ca. 1924–25, cat. no. 15), Derain's *Landscape in Provence* (ca. 1919–25, cat. no. 33, p. 41), and the second of the Lorette portraits (1914, cat. no. 175, p. 88) by Henri Matisse. This dealer-client relationship continued as late as 1939, when Jones purchased two important books from Pierre Matisse (who by then had his own successful gallery): Georges Rouault's *The Shooting Star Circus* (Cirque de l'étoile filante, 1938) and *Passion* (1939), the latter with text by André Suarès. In later years Jones was linked to Curt Valentin's Buchholz Gallery, which regularly exhibited Lipchitz

and Masson, and he was also cultivated as a collector by Germain Seligmann, of the venerable Jacques Seligmann and Company.[18]

Alliances between collectors and museums were crucial to the institutional and financial support system for modern art in New York. In October 1929 the newly appointed director of the Museum of Modern Art, Alfred H. Barr Jr., emphasized education as a primary reason for the recent foundation of that institution. Artists, students, critics, and the general public, he said, needed a museum that would define and sanction "some canon of comparison" for modern art, a body of works accepted as valid and important. But he attributed an even more fundamental impulse to the American market and the rise of a group of collectors with a taste for aesthetic innovation, those who turned "from the old masters to the adventure of buying the works of living men."[19]

Jones lent works to eight exhibitions organized by MoMA during its first decade. In 1930 the museum's third exhibition, *Painting in Paris from American Collections,* showcased the work of modernist masters and representatives of emerging trends. It featured Picasso's *Woman with Kerchief,* the gouache that Jones had acquired only months earlier through Dudensing. For its fifth anniversary in 1934 the institution held an exhibition with a dual purpose. According to A. Conger Goodyear, president of the board of trustees, one purpose was simply to celebrate the museum's accomplishments at the half-decade mark. The other, more important intention was to gather a selection of works (they came mostly from private collections and galleries) considered desirable for the museum in the future.[20] This model of an ideal permanent collection incorporated three works from Jones. The museum installed

his *Pegasus* by Lipchitz near two sculptures already in the permanent collection: *A Universe* (1934), a motorized mobile in painted pipe, wire, and wood by Alexander Calder, and Pablo Gargallo's wrought-iron *Picador* (1928). Also nearby was Matisse's bronze *The Serpentine* (1909) from a private collection (fig. 4). In another room (fig. 5) were a stacked pair of paintings by Max Ernst, *Savage Gestures for Enchantment* (1927) and *Forest* (1931), both in the collection of Julien Levy Gallery; a Masson pastel from Pierre Matisse Gallery entitled *The Lovers* (1931); and an oil by Picasso, *On the Beach* (1928), owned by George L. K. Morris. Surrounded by all of these was Jones's *Wind and Blue Sky* (1930, cat. no. 120, p. 69) by Lurçat. Barr focused on the poetic and melancholy quality of Lurçat's large composition and in the exhibition catalogue remarked that it was related, perhaps distantly, to surrealism.[21] The third Jones loan in the exhibition was Massimo Campigli's *Charity School* of 1929 (cat. no. 21).

Three more loans to exhibitions at MoMA are worth noting because of their great significance to the institution's history. In 1936 Barr organized *Cubism and Abstract Art,* an exhibition that both provided the classic account of the aesthetic of abstraction and confirmed its triumph. Masson's large pastel *Metamorphoses* (1929, cat. no. 156, p. 82) from the Jones collection exemplified the impetuous and abstracted drawing style that Barr identified as this artist's contribution to the intuitive and emotional strand of abstract art.[22] The composition was hung near a 1932 plaster by Alberto Giacometti, *Head-Landscape,* borrowed from the artist, and a 1929 canvas entitled *Illusion* by Ernst, from the collection of Katherine S. Dreier (fig. 6). In *Picasso: Forty Years of His Art* (1939)*,* the

museum again showed *Woman with Kerchief* along with another Picasso from the Jones collection, *Guitar and Fruit Bowl* (ca. 1924–25, cat. no. 210, p. 98), a cubist pastel. (Jones also lent this work to the Wadsworth Atheneum in Hartford for a 1934 retrospective, the first Picasso exhibition organized by a museum in the United States).[23] *Art in Our Time,* the exhibition that marked MoMA's tenth anniversary in 1939, celebrated the opening of the new building on Fifty-third Street (designed by Phillip L. Goodwin and Edward Durell Stone) and coincided with the New York World's Fair. For this occasion, Jones lent Lipchitz's *Pegasus,* which was the third loan of that sculpture for a show at MoMA. Barr inscribed a copy of the exhibition catalogue to the Joneses with a remark that underlined the museum's gratitude for their continuing support: "For Mr. and Mrs. Jones with renewed thanks for the now chronic loan of their fine Lipchitz."[24] In addition to loans, Jones supported MoMA through gifts, including Diego Rivera's *Jacques Lipchitz (Portrait of a Young Man)* of 1924 and a colorful cubist painting, *Landscape* (ca. 1912–14) by Jean Metzinger, both probably acquired through Dudensing in 1929.[25] Jones made these gifts in 1941, after more than a decade of engagement with the museum.[26]

Jones's collecting arena, however, was hardly restricted to New York City. In fact, it was transatlantic, and always had been. According to his wife, Louisa Brooke Jones, he acquired artworks in about equal measure from New York and Paris. Between 1924 and 1939 the Joneses made six visits to Paris for several weeks at a time.[27] Jones would later say that his taste had been substantially guided by friends, mainly the artists he met in France, and above all "a most unusual

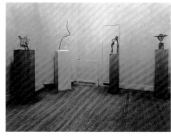

Fig. 4: Installation view of *Modern Works of Art: 5th Anniversary Exhibition,* 1934–35. Lipchitz's *Pegasus* is at far left.

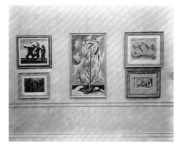

Fig. 5: Installation view of *Modern Works of Art: 5th Anniversary Exhibition,* 1934–35. *Wind and Blue Sky* by Lurçat is in the center.

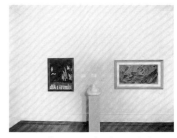

Fig. 6: Installation view of *Cubism and Abstract Art,* 1936. Masson's *Metamorphoses* is at right.

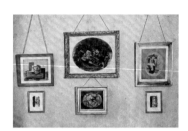

Fig. 7: Picasso still lifes in the *Exhibition of Contemporary Painters and Sculptors* at the *New Galerie Jeanne Bucher,* 1929. Jones's is at upper right.

woman, Mme. Jeanne Bucher of Paris, who has mothered and cared for practically every budding artist in France for the last twenty-odd years."[28] Bucher was the proprietor of an innovative Left Bank gallery and an important publisher of avant-garde artists' books. Jones first met her in 1927, only two years after she had opened her first gallery—a room attached to a store run by her friend, the architect and designer Pierre Chareau, on the rue du Cherche-Midi. This meeting was the beginning of a close and devoted friendship between Jones and Bucher that would last twenty years.

Louisa Brooke Jones remembered Jeanne Bucher as "a most unusual person, not just a *marchande de peinture* [dealer] but a genuine lover and patron of art and artists, with an influence far beyond the bounds of commerce."[29] Bucher's exhibitions were small and her capital relatively modest, but by working on commission and trading in the secondary market, she provided significant support for a wide spectrum of contemporary art. The well-known cubists were her blue-chip artists, but she also helped other, more recent arrivals on the scene by providing them exposure in her gallery.[30] By the time she moved to her own stand-alone gallery in 1929, she had a well-earned reputation as a tastemaker and a fighter for the avant-garde. On the occasion of the inaugural exhibition at Galerie Jeanne Bucher, the influential art magazine *Cahiers d'art* reported, "The ensemble of this small but elegant exhibition gives a very clear impression of the aspirations of the art of today."[31] The show featured a wall of beautiful cubist still lifes by Picasso (fig. 7), including one that Jones eventually purchased, the oval *Still Life (Wineglass and Newspaper)* of 1914 (cat. no. 202, p. 98).

It is quite clear that Bucher had a major role in training Jones as a connoisseur of modern art. A glance at the list of artists in his collection shows how substantially it mirrored Bucher's own roster. In many cases Jones followed these artists closely, acquiring examples from different stages in their careers and in various mediums. Bucher also made a significant contribution to the history of the illustrated book, publishing twenty-eight limited editions between 1925 and 1943, and this endeavor, too, was important for Jones. He also developed holdings in printmaking and artists' books, including some of Bucher's notable titles: Ernst's *Natural History* (Histoire naturelle, 1926), a masterpiece of his early surrealism, and *Plates of Salvation* (Planches de salut, 1931), a book of etchings that cubist printmaker and painter Louis Marcoussis paired with selections from his favorite poets.

Most significantly, Jones's Paris-based artist friends were all associated in one way or another with Bucher. He made the acquaintance of Jean-Émile Laboureur, best known for his work as a printmaker and book illustrator, in 1927.[32] The Joneses went on to accumulate a large group of his prints and illustrated books, including *Graphisms* (Graphismes, 1931), a collection of ten etchings paired with epigrams and aphorisms. Jones's copy contains the original pencil sketch for the portfolio's seventh plate, *She Who Sees,* which depicts Joan of Arc receiving her revelation. "I have been glad to be able to join to your copy an extra sketch [that] I used for one of the prints," Laboureur explained, writing in English to Jones. "It will make your copy a little more personal."[33] Jones met Lipchitz for the first time in 1929 and he also knew and corresponded with Massimo Campigli, who was a leader of

the Italiens de Paris, a loosely organized group of expatriate Italians painting in the French capital.[34]

The most extensive and remarkable of these friendships was the one Jones shared with Lurçat. The painter had been close to Jeanne Bucher since just before World War I, and she showed his work in her first exhibition, in 1925, and frequently thereafter. Jones first met him in 1927 during a visit to Lurçat's Paris studio.[35] In winter of 1928, the artist traveled to New York for his first one-man exhibition in the United States, at Dudensing's Valentine Gallery, and during that time he painted Jones's portrait.[36] Some months later, Lurçat sent Jones a copy of a new book about his work by novelist and essayist Charles-Albert Cingria. On the front endpaper he executed an elegant ink sketch of a monumental figure who holds a book and looks at the sun, a burst of red painted in watercolor or gouache. The inscription in Lurçat's hand reads: "For Monsieur Catesby Jones / an expression of fellow feeling" (fig. 8).[37] Jones eventually accumulated more works by Lurçat than by any other artist, and his collection maps the many twists and turns of the artist's career up to the World War II period. Jones's holdings included early works that combine a tendency toward expressionism with hints of Matisse and Picasso, orientalizing figures and landscapes of the mid-1920s, poetic still lifes and large nudes from the end of the decade, and the desolate landscapes of the 1930s and 1940s. Jones was also a collector of Lurçat's work in tapestry and other textiles.

Jones and Lurçat carried on a fifteen-year correspondence. A group of letters sent by the painter to the collector (now in the Musée départemental de la tapisserie in Aubusson) reveals the general tenor of the exchange.

The earliest letters document the beginning of their acquaintance in Paris, in 1927, and Lurçat's arrival in New York for the 1928 Valentine Gallery show. In the next set of much longer and much more reflective notes, Lurçat offered his observations on the state of things social, economic, and aesthetic. The worldwide economic slump of the early 1930s was much on his mind. "Europe is coming apart," he exclaimed in September 1932, "and this sense of anxiety that you and I discussed in our conversations of 1928–29 and 30, this anxiety has settled into our lives, no longer as a presentiment but as a fact."[38] Lurçat's meditations on this idea of Europe's dissolution took form in his ink drawings of derelict landscapes with alternately ironic and despairing titles (*The Last Monument to the Victims of Idealism; S.O.S.!*). In 1933 Jeanne Bucher published eight of these drawings as a portfolio of collotype reproductions entitled *P. P. C.* (*Pour prendre congé*, or Taking One's Leave; cat. nos. 124–131). Jones acquired one set.

In other letters of the 1930s, Lurçat insisted that prevailing conceptions of modern art needed to change. The days of *la peinture pure*, an art of limited subject matter focused mainly on issues of pictorial technique, had in his view come to an end. "How do you feel about this?" he asked Jones. "Should we protect the painter like a charming child, amuse ourselves apart from the world, almost ignore it?"[39] The question expresses a desire to get out from under the shadow of Picasso and others, but also makes a more interesting comment about the economic and social basis of modern art as well as its moral import. Still other letters disclose the painter's repeated yearning for a less isolated and individualist way of living and working. He also reported on specific political happenings, especially

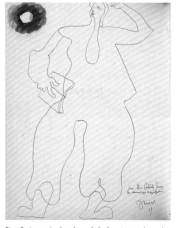

Fig. 8: Lurçat's sketch and dedication in Jones's copy of *Lurçat ou la peinture avec des phares*, 1929, by Charles-Albert Cingria. UVA Library, Special Collections

his experience as a delegate to the World Congress Against War and Fascism held in Amsterdam in August 1932.[40] Jones seems not to have been bothered that Lurçat was a Communist fellow traveler, and some years later he would praise his courage in fighting on the side of the Spanish Republican forces in the early days of the Spanish Civil War.[41] Likewise, the artist was no doubt sincere in initiating a discussion on politics with his American friend, a conservative Democrat.

The final and most poignant letters in the Lurçat-Jones correspondence are those written just before and during World War II. In 1939 Lurçat made a decisive change in his career, putting oil painting aside to concentrate on tapestry, a medium that had long interested him. Jones and Lurçat had traveled together two years earlier to the city of Angers to view the monumental fourteenth-century *Apocalypse* tapestries, which Lurçat subsequently came to see as a true touchstone and inspiration. Jones soon after acquired *The Cockfight* (1939, fig. 9), an example of Lurçat's new tapestry style; its coarse weave, reduced range of colors, and simplified design were partly modeled on medieval weaving principles but emphatically met modernist aesthetic premises. Finally, in September of that year, Lurçat left Paris for Aubusson, a town known since the sixteenth century for its textile manufacture, and worked there alongside artists Pierre Dubreuil and Marcel Gromaire in supervising the design of new hangings at the Aubusson works. Further tapestry collaborations, with artists André Derain, Raoul Dufy, and Boris Taslitzky, followed in 1940 and 1941.[42]

Lurçat wrote to Jones from Aubusson about his hopes for these tapestries and about his enthusiasm for working as part of a creative team. But these letters also laid bare the

Fig. 9: Jean Lurçat, *The Cockfight*, tapestry, 1939. Location unknown

deprivations of everyday life in Occupied France: shortages of material for tapestry work, and shortages of food. In one letter, Lurçat broke into English to reminisce about old times:

> I live, here, rather isolated of artistic activities, remembering with some melancholy the time of my one man show 57th Street [presumably a reference either to a December 1933 show at Pierre Matisse Gallery or a March–April 1939 exhibition at Étienne Bignou Gallery] or Queenstreet [here possibly misremembering the King Street address of Alex Reid & Lefevre Gallery, in London, where he showed in 1930 and 1936]. Trying to launch a movement in modern tapestry, we work, my comrades and I, without reviews, newspapers devoted to art.[43]

Just after the war, in June and July 1946, the Louvre Museum presented a survey exhibition (organized with the Musée d'art moderne in Paris) of French tapestry from the Middle Ages to the modern day; it opened with the Angers *Apocalypse* and concluded with more than eighty contemporary examples by Lurçat and others. While Jones did not see the exhibition, he referred to it at the beginning of a long essay about Lurçat the tapestry designer. His work, Jones said, signalled his belief in the continuity of French traditions in the face of the nation's struggle under German occupation. "He devoted his taste and his talents to France, through all her peril," Jones wrote, presumably thinking not only of Lurçat's wartime tapestries and their political import (notably a wool embroidery of 1943 on a theme suggested by Paul Éluard's resistance poem *Liberté*) but also of Lurçat's own political engagement. In 1941 Lurçat had

joined up with the French Resistance after leaving Aubusson for the Lot department in southwestern France, and in 1944 he was named to the Lot Committee of the Liberation and worked in clandestine publishing. Jones went on in his essay to describe all of Lurçat's wartime tapestry work as symbolic of the larger world situation, even if it was in no way reducible to crude propaganda. "With France in dire straits, no artist who was also a patriot could let his talents go for naught. Lurçat had to express an idea, and that idea necessarily had to be for France, for France's liberation—this was the idea next to his heart."[44] In short, if Jones made substantial commitments to the work of many modern French artists, with Lurçat he assumed a different and larger role, acting as a patron and, more broadly, promoting him in the New York art world.

And what was Catesby Jones's own place in that world among collectors of modern French art? The art dealer Julien Levy, who championed the cause of photography, avant-garde film, and twentieth-century art, provides an answer. In a history of his art gallery, Levy recalled one of his first exhibitions, the 1931 one-artist show he gave to Campigli, to which Jones lent at least one work. Levy placed Jones in the class of collectors who while not "spectacularly wealthy" were "interested in modestly participating in the cultural adventures of their time and owning some experimental pictures they liked to live with."[45]

This description, though laconic, is quite revealing. It confirms first that collecting styles are shaped fundamentally by matters of social class, profession, and economic resources. If collectors of modern art tended to belong to families of inherited wealth, the corporate elite, industry, and the professional classes, then that larger cohort was

subdivided into levels of investment and cultural prestige. Jones was not among the ranks of the most celebrated collectors—the stratum occupied by Albert C. Barnes, Lillie P. Bliss, Walter P. Chrysler Jr., Stephen C. Clark, Etta and Claribel Cone, Chester Dale, Adolph Lewisohn and his son Samuel Lewisohn, and Duncan Phillips—all of whom collected impressionism and postimpressionism, already the highest and most restrictive echelon of the market for modern art, as well as twentieth-century works.[46] In contrast, Jones's collection was roughly comparable—in scale, points of emphasis, and focus on relatively more plentiful and affordable twentieth-century objects—to the collections of artist and art critic Walter Pach or Frank Crowninshield, the editor of *Vanity Fair* magazine. Jones had a passing acquaintance with Pach, and he certainly knew of Crowninshield, one of the founders of the Museum of Modern Art and like Jones a collector of artists' books and School of Paris paintings.[47]

Julien Levy's comment also suggests that Jones had a taste for innovative work, that he selected art not as much for its commercial potential as for its personal appeal (and indeed the recorded instances of his reselling a work are very few), and that he defined himself to some degree through his activity as an art lover. It is important also to note that Jones was historically minded and methodical. While there were definite points of emphasis in his collection, he strove for a certain breadth and depth, a comprehensiveness within the period that interested him.

Catesby Jones's first public remarks about his avocation amount to a few sentences in the 1932 compendium celebrating the thirtieth anniversary of his law school class (of which he was secretary). In an autobiographical letter to his classmates, Jones summarized

the high points of his professional life and then gave brief mention of his involvement with art. "I have resorted to pictures as an antidote to too deep reflection on the origin of law," he explained, "and have managed to get together some modern French pictures which most of you would consider rubbish. This hobby has brought me into contact with many intelligent persons, some of whom call me their friend."[48] Despite the lightly self-mocking tone, Jones took care, in accounting to his old classmates for what had become of him, to stress his identity as a connoisseur of "difficult" art.

The same year, Jones had an exchange of letters with David Keppel, who had been a dinner guest at the family's Ninety-second Street home. This was probably the print expert David Keppel, who worked in a New York business named for his father, the print dealer and publisher Frederick Keppel, and who became a curator of prints at the National Gallery of Art in Washington, D.C., after World War II. David Keppel wrote to Jones encouraging him to record some of his basic ideas about modern art appreciation. Jones obliged in a long letter.[49] In contrast to the earlier message to former classmates, his response to Keppel used the epistolary form, a time-honored mode for writing on aesthetics, to convey sincere and thoughtful reflection. Jones began by warning his friend that to explain the meaning of modern art was no easy task. Aesthetic discrimination always has a dimension of risk and uncertainty, he explained, and it is always difficult to express. "If one could say in plain prose what is expressed in painting and the other arts, they would not and could not rise above adornments for the human race." He then described his interest in painting as, at its heart, an exercise in subjective judgment. "I found that

the painters of the modern French school were in the same mental situation as I was. They wished to discriminate between what they felt with clearness and that which was so vague as to be incapable of expression." The point was that art allowed a certain clarity of feeling and mental perception.

Jones went on to define the essence of painting: "First of all, painting involves the harmonious arrangement of line, form and mass of colors and their values. Indeed, without such arrangement I think that it is impossible to conceive of painting as an art."[50] He quickly added, however, that a pleasing visual arrangement is not art's sole purpose. Great painting, he declared, has a larger function, which is to express the spirit of the age. Jones used this notion to justify the necessity of modernism. "I see no escape from the conclusion that the reason for the preference for work of our own time is that these pictures express emotional thought which we feel is ours, whereas the pictures of a former era, although the artist may be a greater man than the best of our time, deals with emotions and conflicts with which we have had little to do."[51]

Jones then embarked upon a developmental account of art since the High Renaissance. The great masters of sixteenth-century Italy demonstrated marvelous pictorial ingenuity, he commented, but their worldview, based on the premise that an anthropomorphic God directs human destiny and that the "value of man is in conflict with that of God," did not ring true in a modern worldview. Similarly, the "empiricist" phase that took definite form in the eighteenth century and culminated in impressionism, which Jones interpreted as a kind of positivism, was concerned above all with a direct and faithful rendering of external reality. "Painters did not escape. Fidelity to their subject, values

which could be explained, compositions capable of exact analysis, and later (with the impressionists) the application of scientific analysis to faithful reproductions of color were the aims which drove them to their work."[52] Jones asserted, however, that the eighteenth- and nineteenth-century belief in a scientific and analytic method in art had in the face of modernity also faded away.

It was the art of Paul Cézanne that, as Jones saw it, opened the way for the aesthetic sentiment of the present. Jones's Cézanne was the postimpressionist Cézanne, in whose art the intrinsic and relational elements of design—significant forms and color patterns—acquire a charge of intense feeling and become part of a spiritual reality. Cézanne "discovered a fresh spiritual response," Jones noted.[53] The mantle was then passed to two others: Matisse, whose work was anchored in deep sensation and feeling ("recognizing what is the fact, that the senses, rather than the intellect, are close to reality"); and Picasso, who operated with a more intellectual and skeptical state of mind ("If we assume that harmony is conceived intellectually and that a canvas is mere recipient for what is in the mind of an artist, he is one of the greatest painters of all times"). Finally, Jones brought his historical schema to a close with a discussion of the lyrical and poetic painting of two artists of a younger generation. He found in the work of these painters, Lurçat and Masson, the signs of a new synthesis, a record of the mind working through abstract relationships. The resulting harmony of composition in their work, Jones believed, provided "a feeling of certainty that life has a quality which is above the commonplace," and approached "the universal" and "the wholeness of existence."[54]

All of these remarks bear traces of widely held ideas about modern art. Roger Fry, the only art critic to whom Jones specifically refers in the letter, was a source for Jones's ideas about the relationship between art and spirituality as well as his views on Cézanne and his importance in the history of art. Fry's formalist critical vocabulary can also be detected in Jones's writings.[55] In larger terms, the notion that a work of art shapes the viewer's soul, a point Jones would stress again in subsequent writings, was deeply rooted in American culture and art criticism.[56] The art lover, he insisted, must be something more than the self-indulgent pleasure seeker (a definition that Jones associated, perhaps unfairly, with Samuel Lewisohn, a fellow collector who occasionally published essays dealing with modern art).[57] For Jones, art's redemptive and morally uplifting capacity provided a sense of belonging that helped to overcome modern life's inherent isolation. Jones spoke of modernity's "specialization," meaning a general narrowness of things, but more particularly a flattening or fracturing of human experience under existing economic conditions. Thus, in a 1936 interview about his reasons for collecting modern art, he talked about feelings of wholeness and connection. "Collecting modern paintings," Jones said,

has taught me a sense of continuity. It seems to me that this sense becomes more and more difficult to retain the further the economic machine condemns each of us to a special job. Hence a correction is demanded. No means to give me that corrective is comparable to art. As I have no ear for music, but do see color, naturally my attention was to the work which gave me satisfaction, a satisfaction which involves an understanding and a feeling for relationships in colored forms. Those relationships have

fed my hunger for harmony and have restored to me a sense of belonging in the universe which too much specialization might have destroyed.[58]

The inventory taken by the Museum of Modern Art shows that by the end of the 1930s Jones's collection of modern French art had grown to its mature state. Jones, however, would never stop adding to it; he acquired, for example, a substantial group of objects at Jeanne Bucher's gallery during his final trip to Paris in summer of 1939.[59] One of these new works was a significant 1907 landscape in gouache by Picasso (cat. no. 201, p. 96).[60] *The Harpists,* a 1930 bronze by Lipchitz, also entered the collection at that time (fig. 10). This sculpture, as Lipchitz himself later explained, came directly out of the smaller *Harpist,* which Jones already owned. But it also changed the motif that its predecessor had established. Lipchitz used the plural title *Harpists* because he saw a double figure in his new composition. The 1930 work also added a new and striking visual image: the metamorphosis of the harp into a bird. And the wiry openness of the earlier sculpture had now shifted toward a heavier and more expressionistic handling.[61] The 1939 purchase also included two small works on paper by Paul Klee, Jones's first works by the artist, and an imposing painting entitled *Combat in Château-Renault Forest* (1939, cat. no. 7, p. 33) by André Bauchant, whom he had long supported.[62]

The advent of World War II profoundly reshaped the transatlantic dynamic in which Jones had formed his collection. During these years he did what he could to remain in contact with his friends in France. He served as an intermediary for Lurçat and Bucher, transmitting their news to friends in the United

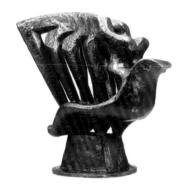

Fig. 10: Jacques Lipchitz, *The Harpists,* bronze, 1930

States, and he corresponded with Barr at MoMA about Lurçat's wish to donate a tapestry to the museum and about difficulties with U.S. customs regulations governing the importation of works of art.[63] He also maintained strong personal ties with many who sought refuge from the war in New York. "There was an impressive luncheon here today to welcome Breton, Lipchitz, Chargall [sic] and Masson, who are refugees just arrived from France," he wrote to Thomas C. Colt Jr., director of the Virginia Museum of Fine Arts, in June 1941. "Pathetic as well as impressive—these men begin life afresh in a strange land. All four of them have sensitive minds which should have a useful influence in this country."[64]

Another émigré artist who captured Jones's interest in New York was the English printmaker and painter Stanley William Hayter. In 1927 Hayter had founded a workshop for experimental printmaking in Paris, known as Atelier 17, and in 1940 he moved it to New York City, where it became a locus for European artists and young American modernists. When Jones organized an exhibition of modern French works on paper for the city's bibliophilic society, the Grolier Club, in fall of 1944, he featured a number of his recent acquisitions by Hayter and the artist was brought in to demonstrate modern printmaking methods.[65] Jones would publish an appreciation of Hayter's work in the *Kenyon Review* in 1945.[66]

During the war years Jones also intensified his longstanding commitment to the work of André Masson, with whom he had been acquainted since the late 1920s.[67] Jones lent his 1929 pastel *Metamorphoses* (cat. no. 156, p. 82) to the first major Masson exhibition of his American period, which Curt Valentin organized in October 1941 for the

Baltimore Museum of Art. The same year, Jones acquired the 1941 painting also called *Metamorphoses* (cat. no. 157) through Valentin, and several months later he lent it back to the dealer for a Masson exhibition at Buchholz Gallery. Jones also purchased a number of prints and illustrated books of Masson's American years and in spring of 1946 published a substantial essay on the artist in the *Kenyon Review.* This essay begins with a history of Masson's work and then develops a longer discussion of the artist's 1943 credo, *Anatomy of My Universe*. Masson emerges in Jones's telling as the all-embracing genius whose art achieves greatness by recording a mind plunging into the world's travails and conflicts.[68] This view reflected much current commentary on Masson, including the preface for the 1942 Buchholz Gallery exhibition brochure by Daniel-Henry Kahnweiler, who represented the artist in Paris.[69]

Finally, Jones remained strongly committed to Lipchitz. On July 4, 1941, soon after his arrival in New York, the artist wrote to Jones about *12 Drawings for Prometheus* (12 Dessins pour Prométhée), a folio of *pochoir* plates that Bucher had published only recently, "when the Germans were already in Paris."[70] Jones purchased that portfolio and two other limited-edition publications, *Twelve Bronzes by Jacques Lipchitz* (1943) and *The Drawings of Jacques Lipchitz* (1944), both released by Curt Valentin. These acquisitions together with a drawing and other prints in Jones's collection amounted to a survey of Lurçat's main themes in the years just prior to and during his exile. Also in 1941, in his Madison Square studio, Lipchitz executed a portrait bust of Jones (cat. no. 102, p. 65), and not long after the war's end, in August 1946, that work was illustrated in an interview Lipchitz gave to a French paper about his exile

experience. Lipchitz mailed it to Jones with the remark, "I think this clipping will amuse you and so I send it in fond remembrance."[71]

Jeanne Bucher had established a network of New York connections during her first trip to the United States, organized with the help of Jones and Lurçat in 1935. The Liberation of Paris in August 1944 made it possible to start planning a return visit. James Johnson Sweeney, director of painting and sculpture at MoMA, provided the official invitation: "The Museum of Modern Art would be very interested in a lecture, or series of lectures, given by Madame Jeanne Bucher who has been so closely in touch with artists in France during the years of occupation."[72] And thus Jones and Bucher met once again.[73] During her stay, from September 1945 to May 1946, she not only lectured on the theme of French art during the war, but also scouted the New York galleries for new opportunities to show her artists' work. One of these artists was Hans Reichel, who had exhibited with Bucher since 1928. The Willard Gallery in New York hosted a show of some thirty oils and watercolors by Reichel in March 1946.[74] Through Willard, Jones obtained a small gouache by Reichel entitled *Garden* (1940, fig. 11), an abstract and brightly colored fantasy on plant, leaf, and flower forms. It was Jones's final acquisition.[75] He died in New York on December 21 of that year.

T. Catesby Jones was buried in Petersburg, the city of his immediate forebears and the place where his life began. The grave is located in the cemetery adjacent to Old Blandford Church, the city's oldest structure and one of its chief sites of historical memory. Erected in the 1730s, the building was more or less abandoned after 1802, following the construction of a new church in another part of town, but a large graveyard subsequently

Fig. 11: Hans Reichel, *Garden*, gouache, 1940. VMFA

grew up around its ruins. By the late 1840s the taste for the picturesque and a renewal of appreciation for old colonial buildings helped to return it to prominence.[76] The church was used as a field hospital during the Civil War, and in 1901 it was restored as a Confederate shrine in honor of the thirty thousand soldiers buried in its graveyard.[77]

Jones's grave is situated close to the rear of the church and just beyond a brick wall that encloses its original burial ground. The grave is marked, according to Jones's own wishes, with an object from his art collection: Lipchitz's bronze sculpture *The Harpists*.[78] Louisa Brooke Jones brought the sculpture to Petersburg, most likely late in 1947, so that it could be placed atop the pedestal of Georgia granite that Lipchitz had designed for the purpose. The project, which involved mounting the pedestal to a brick base and slab, was beset with complications, however, and at some time in the next fourteen months, Jones's son, Catesby Thomas Jones, and Lipchitz went together to Petersburg to complete the installation (fig. 12).[79]

Lipchitz's simultaneously harplike and birdlike composition possesses associations that, although not intended for a funerary context, readily transferred to it: bird and harp, the soul ascendant, celestial music. However, in a 1949 letter to a family friend describing a photograph of the recently constructed grave marker, Louisa Brooke Jones stressed two additional aspects of its meaning. She perceived harmony with the historic setting and consonance with her husband's particular life story. "You can see the old ivy-clad wall of the churchyard and the gable of Blandford Church just beyond (1736). Modern as the figure is, the simplicity and dignity of it, with its base, do not seem out of place in the old surroundings. Because

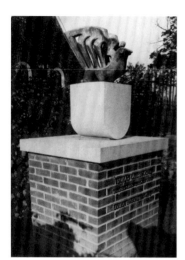

Fig. 12: *The Harpists* by Lipchitz at T. Catesby Jones's grave

they are also beautiful—and beauty has no date—and Catesby was a modern man—with his roots in the past."[80]

Notes

1. Inventory of the T. Catesby Jones collection, Early Museum History: Administrative Records, IV.23, Museum of Modern Art Archives, New York. Based on internal evidence, this document's earliest possible date is 1937. One of the three copies of this typescript in the Museum of Modern Art Archives is inscribed in pencil with the year 1939. For her gracious and tireless help in shedding light on many aspects of her father's life and his art collection, I am very grateful to Peggy Brooks.

2. On the significance of the character of the collector's dwelling, see Aline B. Saarinen, *The Proud Possessers* (New York: Random House, 1958), 376; and Richard R. Brettell, "Domestic Artifice: Art Collecting and Modern Bourgeois Life," in *Manet to Matisse: Impressionist Masters from the Marion and Henry Bloch Collection,* exh. cat., by Richard R. Brettell and Joachim Pissarro (Kansas City: Nelson-Atkins Museum of Art and Seattle: University of Washington Press, 2007), 19–27.

3. Unless noted otherwise, works of art mentioned in this essay are in the Jones bequests to the Virginia Museum of Fine Arts and the University of Virginia; some are illustrated in the Artist Entries and all appear in the Illustrated Catalogue.

4. *Pegasus* has recently been published with the title *Pierrot on Horseback,* which acknowledges a link to other works in which Lipchitz depicts that commedia dell'arte character. See Alan G. Wilkinson, *The Sculpture of Jacques Lipchitz, A Catalogue Raisonné,* vol. 2, *The American Years, 1941–1973* (London: Thames & Hudson, 1996), cat. 244a.

5. Last will and testament of T. Catesby Jones, May 2, 1946, curatorial files, Virginia Museum of Fine Arts.

6. Louise Savage and John Cook Wyllie, "T. Catesby Jones Print Collection Appraisers' Inventory," August 2, 1947, Correspondence Files, 1931–1990s, Accession # RG-12/11/4.021, Box A35-16E, Special Collections, University of Virginia Library.

7. Inventory of the Catesby Jones Print Collection, December 15, 1975, Correspondence Files, Box A35-16E, Special Collections, University of Virginia Library. Today the remainder of the bequest is housed in Special Collections, University of Virginia Library.

8. The publications on the Jones and Catesby families are Lewis Hampton Jones, *Captain Roger Jones, of London and Virginia: Some of his Antecedents and Descendants* (Albany: Joel Munsell's Sons, 1891) and Robert C. Catesby, *A History of the Catesbys from 1086 to 1986* (n.p., 1986). See also Lyon Gardiner Tyler, ed., *Encyclopedia of Virginia Biography,* vol. 1 (New York: Lewis Historical Publishing, 1915),

268–69. The Welsh preposition *ap* that frequently appears in Jones family names translates "the son of."

9. Marriage announcement of Ada V. Vaughan and Walter N. Jones, *Petersburg Index and Appeal,* November 26, 1875; Edward Pollock, *Historical and Industrial Guide to Petersburg, Virginia* ([Petersburg]: T. S. Beckwith, [1884]), 233; I. J. Isaacs, *Petersburg Virginia, its Interests and Facilities* (Petersburg: Franklin Press, 1904); Catesby, *History of the Catesbys,* 65–66.

10. Obituary of T. Catesby Jones, *New York Times,* December 22, 1946; D. Roger Englar, "Memorial of T. Catesby Jones," *Memorials* ([New York]: Maritime Law Association, 1947): 3016–17.

11. Williamsburg, Virginia, Colonial Williamsburg Foundation Archives, General Correspondence Records, Gifts and Loans–Gifts–Jones, T. Catesby, Arthur Woods to T. Catesby Jones, September 17, 1928. See also "Tablet Honors Ancestors," *New York Times,* March 22, 1929.

12. T. Catesby Jones, "The Iron-Clad Virginia," *Virginia Magazine of History and Biography* 49, no. 4 (October 1941): 297–303; "The Merrimack and Her Big Guns," *Virginia Magazine of History and Biography* 50, no. 1 (January 1942): 13–37.

13. In November 1946, a few weeks before his death, Jones lectured at the University of Virginia School of Law; see Jones, "Some Aspects of Allegiance," *Virginia Law Review* 32, no. 6 (November 1946): 1077–98. Jones left a number of law books to the law school library (Library Annual Report, Acquisitions Department, July 1, 1946–June 30, 1947). See also "Law School Development Owes Much to T. Catesby Jones," *University of Virginia Alumni News* 35, no. 5 (February 1947): 5.

14. According to Louisa Brooke Jones, the first objects bought by her husband were a number of Japanese prints (and possibly a pair of Chinese ancestor portraits that later went into the bequest to the Virginia Museum of Fine Arts), purchased at the 1907 Jamestown Exposition, and two paintings that he acquired in 1920 directly from the American artist William Sanger, *Fishing Village at Vigo, Spain* (1917) and *Snow Scene* (1919–20). Louisa Brooke Jones to William Gaines, questionnaire about the Jones collection, February 2, 1965, curatorial files, Virginia Museum of Fine Arts. Later, Jones gradually added a small number of works on paper by American artists, acquired some Chinese ceramics during the 1940s, and owned a few Egyptian and Greek objects.

15. Information on Jones's purchases comes principally from his notebook of acquisitions (Peggy Brooks, New York) and from the checklist in Virginia Museum of Fine Arts, *The T. Catesby Jones Collection* (Richmond: Virginia Museum of Fine Arts, 1948).

16. George L. K. Morris, "On Fernand Léger and Others," *The Miscellany* 1, no. 6 (March 1931): 1.

17. See Saarinen, *Proud Possessers;* W. G. Constable, *Art Collecting in the United States of America: An Outline of a History* (London: Thomas Nelson, 1964), 169–91; A. Deirdre Robson, *Prestige, Profit, and Pleasure: The Market for Modern Art in New York in the 1940s and 1950s* (New York: Garland, 1995); and John O'Brian, *Ruthless Hedonism: The American Reception of Matisse* (Chicago: University of Chicago Press, 1999).

18. Correspondence between Jones and Valentine Dudensing and Pierre Matisse, 1925–39, Pierre Matisse Gallery Archive, MA 5020, Box 116, Folder 19, Pierpont Morgan Library and Museum, New York; Correspondence between Jones and Germain Seligmann and his associate César de Hauke, 1938–45, Jacques Seligmann & Co. Records, 1904–78 (bulk 1913–74), Box 52, Archives of American Art, Smithsonian Institution, Washington, D.C.

19. Alfred H. Barr Jr., "A New Museum" (1929), in *Defining Modern Art: Selected Writings of Alfred H. Barr, Jr.,* ed. Irving Sandler and Amy Newman (New York: Abrams, 1986), 74. On the dynamic that tied innovative collectors and dealers to museums in New York during these years, see Robson, *Prestige, Profit, and Pleasure,* esp. 17–75, and Michael C. FitzGerald, *Making Modernism: Picasso and the Creation of the Market for Twentieth-Century Art* (New York: Farrar, Straus & Giroux, 1995), 190–261.

20. A. Conger Goodyear, "1929–1934," in *Modern Works of Art,* ed. Alfred H. Barr Jr. (New York: Museum of Modern Art, 1934), 9.

21. Barr, "Modern Works of Art," in *Modern Works of Art,* 17.

22. Ibid., *Cubism and Abstract Art* (New York: Museum of Modern Art, 1936), 180–83.

23. *Drawings, Watercolors, Gouaches, and Prints,* unbound supplement to the exhibition catalogue *Pablo Picasso* (Hartford: Wadsworth Atheneum, 1934), cat. 136. For documentation of the inclusion of *Guitar and Fruit Bowl* (known at the time as *Toy Doll* but exhibited in Hartford with the title *Abstraction*), see Alfred H. Barr Jr. to Jones, August 5, 1939, Curatorial Exhibition Files, Exh. #91, Museum of Modern Art Archive, New York.

24. Alfred H. Barr Jr., handwritten dedication in *Art in Our Time* (New York: Museum of Modern Art, 1939), N5020 .N44 1939, Gift of T. Catesby Jones, Special Collections, University of Virginia Library.

25. Valentine Dudensing Ledger Books, vol. 2 (January 1926–February 1931), 147, Museum of Modern Art Archives, New York.

26. Dorothy C. Miller to Jones, March 31, 1941, Donor File, Jones, T. C., Museum Collection Files, Department of Painting and Sculpture, Museum of Modern Art, New York.

27. Louisa Brooke Jones to William Gaines, February 2, 1965.

28. T. Catesby Jones, *Modern French Prints: An Address . . . Delivered on October 19, 1944 at The Grolier Club of New York* (New York: Court Press, 1944), 2.

29. Louisa Brooke Jones to William Gaines, February 2, 1965.

30. Malcolm Gee, "Paris in War and Peace (1914–1945)," in *The Art and Spirit of Paris,* vol. 2, ed. Michel Laclotte (New York: Abbeville, 2003), 1306–7.

31. "Les Expositions à Paris et ailleurs," *Cahiers d'art* 4, nos. 2–3 (March–April 1929): 120. (All translations by the author.) On Bucher and her gallery, see *Jeanne Bucher: une galerie d'avant-garde*, eds. Christian Derouet and Nadine Lehni (Geneva: Skira; Strasbourg: les Musées de la ville de Strasbourg, 1994).

32. Louisa Brooke Jones to Gaines, February 2, 1965.

33. Jean-Émile Laboureur to Jones, June 20, 1931, Letters from French artists to T. Catesby Jones, MSS 2711, Gift of Louisa Brooke Jones, Special Collections, University of Virginia Library. In 1968, Louisa Brooke Jones donated ninety-five etchings by Laboureur and a painting by Lurçat, *Island in the North Sea* (1928), to Vassar College.

34. Louisa Brooke Jones to Gaines, February 2, 1965; Massimo Campigli to Jones, January 19, 1936, curatorial files, Virginia Museum of Fine Arts.

35. Jean Lurçat to Graham Tucker, December 24, 1947, curatorial files, Virginia Museum of Fine Arts. This letter is excerpted in VMFA, *T. Catesby Jones Collection*, n.p.

36. According to information provided by the Jones family, this work is now lost.

37. Charles-Albert Cingria, *Lurçat ou la peinture avec des phares* (Amsterdam: Editions Bladzvranckx, 1929), ND553 .L8 C5 1929, Gift of T. Catesby Jones, Special Collections, University of Virginia Library.

38. Lurçat to Jones, September 25, 1932, Musée départemental de la tapisserie, Aubusson. I thank Michèle Giffault, chief curator at the Musée, for so kindly providing me with copies of this correspondence.

39. Lurçat to Jones, October 11 or 12 [1930 or 1931?], Musée départemental de la tapisserie, Aubusson.

40. Lurçat to Jones, September 25, 1932.

41. Jones reported on this in the 1946 typescript of an article, "Jean Lurçat and the Renaissance of Tapestry." (This article was published in shortened form in 1948; see below, note 44).

42. Lurçat reflects on his days in Aubusson in *Designing Tapestry*, trans. Barbara Crocker (1947; repr., London: Rockliff, 1950), 44–46.

43. Lurçat to Jones, June 1 [1940 or 1941], Musée départemental de la tapisserie, Aubusson.

44. T. Catesby Jones, "Jean Lurçat and the Renaissance of Tapestry," *Magazine of Art* 41, no. 1 (January 1948): 3–4. The full typescript is in the curatorial files of the Virginia Museum of Fine Arts. The *Magazine of Art* published a shortened version of Jones's typescript to coincide with the presentation of a version of the Louvre tapestry exhibition at the Metropolitan Museum of Art.

45. Julien Levy, *Memoir of an Art Gallery* (New York: Putnam, 1977), 85.

46. Robson, *Prestige, Profit, and Pleasure*, 135–50.

47. Pach's collection was auctioned at Parke-Bernet in January 1949. Jones's personal library contains an inscribed copy of Pach's *Raymond Duchamp-Villon* (Paris: Povolozky, 1924), NB548 .D8 P3 1924, Gift of T. Catesby Jones, Special Collections, University of Virginia Library. On Crowninshield, see Lionello Venturi, "The Crowninshield Collection," in *Paintings, Sculptures, Drawings by Modern French Artists . . . Public Auction Sale, October 20 and 21* (New York: Parke-Bernet Galleries, 1943), n.p.

48. T. Catesby Jones, in *Law Class of 1902, University of Virginia: Their Report of Thirty Years Made to their Classmates at the Thirtieth Reunion, June 12 to 14, 1932 at the University of Virginia* (New York: Court Press, [1932]), 58–59.

49. David Keppel to Jones, February 3, 1932; Jones to Keppel, February 5, 1932 (Peggy Brooks, New York). Keppel's letter and Jones's long response of March 14, 1932, were published in G. Watson James Jr., "Donor of Modern Art Analyzes Painting of Past 50 Years," *Richmond Times-Dispatch*, February 22, 1948. Jones's part of the exchange was then republished as "A Letter to a Friend on Modern Art" in VMFA, *T. Catesby Jones Collection*, 7–13.

50. Jones, "Letter to a Friend," 7–8.

51. Ibid., 8–9.

52. Ibid., 9.

53. Ibid.

54. Ibid., 12–13.

55. See Roger Fry, "Art and Life," in *Vision and Design* (London: Chatto & Windus, 1920), 1–10; and Fry, *Cézanne: A Study of His Development* (London: L. & V. Woolf, 1927). Both texts were in Jones's personal library.

56. See Michael Leja, "Modernism's Subjects in the United States," *Art Journal* 55, no. 2 (Summer 1996): 65–72.

57. An undated and unpublished typescript reworks the material in the 1932 letter, eliminating the exchange with Keppel and starting off instead with critical words directed at an article by Lewisohn, perhaps a 1934 essay in which he affirms "What I am principally interested in is: does that painting, as art-lovers say, give me 'a kick'?" Sam Lewisohn, "Is Collecting an Art?" *Parnassus* 6, no. 5 (October 1934): 14. This unpublished typescript made its way to both Jeanne Bucher (Muriel Jaeger, Paris) and Pierre Matisse, Pierre Matisse Gallery Archive, MA 5020, Box 116, Folder 19, Pierpont Morgan Library and Museum, New York.

58. Robert K. Brock, "Thomas Catesby Jones," *Record of the Hampden-Sydney Alumni Association* 10, no. 3 (April 1936): 5. Jones was elected a trustee of Hampden-Sydney College in 1940. In thinking about Jones's remarks as the reverberation of a much larger history of ideas about aesthetic experience in the modern period, I have been guided by Martin Jay, *Songs of Experience* (Berkeley: University of California Press, 2005), 131–69.

59. Jones left Paris one day ahead of France's declaration of war with Germany on September 3, according to Jean Lurçat's recollection. Lurçat to Graham Tucker, December 24, 1947.

60. In 1939 Jones told Alfred Barr that he had left this composition temporarily in Bucher's care so that she might include it in the "museum of living art" that she had founded as part of the Maison de la Culture,

an organization that sponsored artistic and cultural programs for the leftist political alliance known as the French Popular Front. Jones to Barr, September 1, 1939, CUR, Exh. #85, Museum of Modern Art Archives, New York. It seems, however, that Bucher's short-lived initiative had come to an end in May 1938, only months before the Popular Front dissolved itself in the autumn of that same year. See Derouet, "La disponibilité," in *Jeanne Bucher: une galerie d'avant-garde,* 134.

61. Lipchitz describes these works and recounts Jones's acquisition of the 1930 *Harpists* in his autobiography, Jacques Lipchitz with H. H. Arnason, *My Life in Sculpture* (New York: Viking, 1972), 103–4 and 115–16.

62. Receipt from Galerie Jeanne Bucher-Myrbor, January 31, 1940 (Peggy Brooks).

63. Lurçat to Jones, September 8, [1941], Musée départemental de la tapisserie. Jones to Barr, March 5, 1940; Jones to Barr, April 1, 1940; Jones to Barr, October 19, 24, and 29, 1941; Bucher to Jones, typescript, September 25[?], EMH, IV.23, Museum of Modern Art Archives, New York.

64. Jones to Thomas C. Colt Jr., June 27, 1941, curatorial files, Virginia Museum of Fine Arts.

65. Jones, *Modern French Prints: An Address;* T. Catesby Jones, quoted in "Modern French Prints," *Gazette of the Grolier Club* 2, no. 4 (June 1945): 110–15. See also, in the present catalogue, pp. 52–54.

66. T. Catesby Jones, "S. W. Hayter," *Kenyon Review* 7, no. 3 (Summer 1945): 437–39. Louisa Brooke Jones's grandfather, father, and brother attended Kenyon College. In 1931 Jones sponsored a set of stained-glass windows (designed by D'Ascenzo Studios of Philadelphia) in their memory for the Church of the Holy Spirit at the college. He became a Kenyon trustee in 1932. Later Louisa Brooke Jones donated to the Kenyon library, in her husband's honor, a substantial collection of first editions and fine books.

67. André Masson to Max Buhman, registrar at the Virginia Museum of Fine Arts, January 14, 1948, curatorial files, Virginia Museum of Fine Arts.

68. T. Catesby Jones, "André Masson: A Comment," *Kenyon Review* 8, no. 2 (Spring 1946): 224–37; André Masson, *Anatomy of My Universe* (New York: Curt Valentin, 1943).

69. Daniel-Henry [Kahnweiler], "André Masson," trans. Marie Jolas, in *André Masson* (New York: Buchholz Gallery and Willard Gallery, February 17–March 14, 1942), n.p.

70. Jacques Lipchitz to Jones, July 4, 1941, Letters from French Artists, MSS 2711, Special Collections, University of Virginia Library.

71. Gaston Poulain, "Les grands exilés de l'école de Paris," *La dépêche de Paris,* August 28, 1946, 2; Jacques Lipchitz to Jones, August 30, 1946, curatorial files, Virginia Museum of Fine Arts.

72. Bucher had kept her gallery open almost continuously during this period. James Johnson Sweeney to Henri Laugier, June 6, 1945, quoted in Christian Derouet, "À New York," in *Jeanne Bucher: une galerie d'avant-garde,* 163.

73. André Masson to Graham Tucker, January 14, 1947, curatorial files, Virginia Museum of Fine Arts.

74. Howard Devree, "Work by Europeans, Americans," *New York Times,* March 31, 1946.

75. "Bequest of T. Catesby Jones to Virginia Museum of Fine Arts, Richmond, Virginia," undated typescript, T. Catesby Jones Collection, Receipts and Lists, curatorial files, Virginia Museum of Fine Arts.

76. W. Barksdale Maynard, "'Best, Lowliest Style!': The Early-Nineteenth-Century Rediscovery of American Colonial Architecture," *Journal of the Society of Architectural Historians* 59, no. 3 (September 2000): 339–40. See also "Old Blandford Chuch; It was Built in 1737 and Has an Interesting History; Historical Memories Surround It," *New York Times,* February 17, 1896.

77. *The Virginia Landmarks Register,* ed. Calder Loth (Charlottesville: University of Virginia Press, 2000), 376.

78. Louisa Brooke Jones reported that her husband had wanted that sculpture to be used in this way. Louisa Brooke Jones to Michael Agelasto, January 23, 1949, curatorial files, Virginia Museum of Fine Arts. Lipchitz's assertion that Jones had included a similar directive in his will is not borne out by an examination of that document. Lipchitz, *My Life in Sculpture,* 116.

79. Louisa Brooke Jones to Thomas C. Colt, November 4, 1947, curatorial files, Virginia Museum of Fine Arts; photograph of T. Catesby Jones grave (before January 23, 1949), curatorial files, VMFA; Peggy Brooks, e-mail to the author, July 17, 2008, curatorial files, VMFA.

80. Louisa Brooke Jones to Michael Agelasto, January 23, 1949.

T. Catesby Jones, mid-1940s

Although Thomas Catesby Jones was a New Yorker for the last thirty-five years of his life, he chose to leave his collection to two Virginia institutions: the recently opened Virginia Museum of Fine Arts and his venerable alma mater, the University of Virginia. The history of Jones's gifts and their impact on these institutions offers an example of the power of an individual collector, endowed with vision and passion, to create a public legacy. At the same time, it confirms the necessity of receptive institutional partners and forward-thinking leaders to bring the collector's plans to fruition. VMFA holds in its archives a collection of Jones's correspondence with the museum's first director, Thomas C. Colt Jr. These letters provide a particularly valuable first-hand account of just such a partnership between a donor and a beneficiary.

Jones's decision to favor Virginia institutions certainly owed to his deep roots in the state and his lifelong identification as a southerner. A descendant of generations of distinguished Virginians,[1] he was born and

raised in Petersburg and graduated from UVA's law school in 1902. Although the Virginia Museum of Fine Arts did not open its doors until 1936, just ten years before Jones's death, its identity as the official state art museum must have appealed to Jones, whose passion for modern art encompassed a zeal for educating the general public. Jones's choice must have also been informed by his understanding that a museum with larger modern holdings would inevitably cull a collection such as his, comprised primarily of domestic-scaled objects, valuing choice pieces over the collection's integrity.

This is not to say, however, that a New York museum was even an obvious alternative in the early 1940s when Jones was determining the future of his collection. The Museum of Modern Art, although founded in 1929, only began operating at its permanent location on Fifty-third Street in 1939. (Jones had lent work to MoMA during the 1930s, and he gave several works to the museum in March 1941,[2] an arrangement that was already in process before he first engaged with VMFA.) The Solomon R. Guggenheim Museum, then called the Museum of Non-Objective Painting, opened in 1939 but remained in rented quarters on Fifty-fourth Street throughout the 1940s. The Whitney Museum, in operation since 1931, was dedicated exclusively to American art. And the well-established Metropolitan Museum of Art showed little interest in modern works until the early 1950s, after the failure of an agreement with MoMA and the Whitney that would have ceded contemporary art to those museums.

As a distinguished graduate and active alumnus,[3] Jones already had a strong relationship with the University of Virginia. His association with the Virginia Museum of Fine Arts, however, had yet to be developed. It

FROM NEW YORK TO VIRGINIA
GIFTS AND BEQUESTS

John B. Ravenal

effectively began on March 4, 1941, with a letter from Director Colt to Jones at his home address, 53 East Ninety-second Street, New York City. The letter was prompted, Colt explained, by his meeting just the day before with a Michael Agelasto, of Norfolk, who had informed him of Jones and his "splendid collection of Modern Paintings and Sculptures." Colt further mentioned the museum's current temporary-loan exhibition of Walter Chrysler's collection of "Modern Expressionist Art"[4] (fig. 13) and emphasized his particular interest in learning "of a Virginian with a splendid contemporary French Collection."

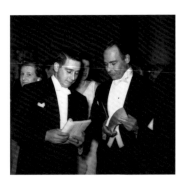

Fig. 13: Colt (right) with Chrysler at VMFA opening of the Chrysler Collection exhibition, January 1941

Three days later, on March 7, Jones replied from his law office in New York,[5] saying he was familiar with Chrysler's pictures and regretted that he would be unable to see them on view in Richmond. He invited Colt, however, to meet with him when the director was next in New York. Three months later, on June 10, Colt informed Jones of his plans to visit the city in six days and of his hopes for "the possible privilege of meeting you and seeing your paintings." They arranged a five-thirty appointment on June 16.

Shortly after his return to Richmond, Colt wrote to thank Jones for the visit, remarking that he was "highly impressed" with Jones's "knowledge and taste in contemporary art." He went on to assure Jones that "we should welcome most happily your collections should you decide to place them in the Museum," a comment suggesting that even at their first meeting the two men had discussed a bequest. Having opened to the public only five years earlier, the museum had very little in the way of modern European art. Its holdings consisted primarily of pre-1900 European art and nineteenth- and early-twentieth-century American art.

To discover an open-minded collector with Virginia roots who was attuned to the key developments in modern French art must have seemed an extraordinary opportunity, and Colt, to his credit, made this relationship a top priority. He confessed to Jones, "We lack objects of the contemporary French school in our collections and the well chosen objects of this important school in your collection would be of the greatest value to us in extending the knowledge and taste of Virginians." Colt also invited Jones to become more closely associated with the museum and sent him several of its publications.

Jones was impressed with the materials, writing, "I was pleased to observe that you have not loaded your walls with a lot of copies and second-rate stuff." As for the disposition of his collection, Jones explained that first he had to determine his family's wishes, but he suspected that they would agree with his desire to avoid a forced sale to pay inheritance taxes. He elaborated:

> I have given much time and love to getting together these things. They represent much of my life and I should not like them to be dissipated merely for the purposes of converting them into dollars with which to pay taxes. Personally, it would give me satisfaction to know that they were being kept in a place such as your Museum, where they would be appreciated and perhaps serve as an inspiration to young artists.

On July 7 Jones wrote Colt of his recent purchase of a drawing (*Jacob and the Angel*, 1939; cat. no. 101, p. 62) by Jacques Lipchitz, who, along with André Breton, André Masson, and Marc Chagall, had recently arrived in New York as a refugee from France. The

drawing was intended as a gift for the museum and arrived on July 12 to Colt's enthusiastic reception: it constituted the first work, he said, of "the contemporary expressionists" in the museum's holdings, and he hoped it would be the beginning of a fine collection.

Early that fall, Jones was ready to give more. He sent a large painting by Massimo Campigli (*The Concert*, 1935, cat. no. 23) as well as three print volumes: Georges Rouault's *The Shooting Star Circus* (Cirque de l'étoile filante, 1938), André Suarès's *Passion* with illustrations by Rouault (1939), and *Architectures*, edited by the designer Louis Süe and the painter and designer André Mare, with original prints by Raymond Duchamp-Villon, André Dunoyer de Segonzac, and Jacques Villon, among others.[6]

Needless to say, Colt responded eagerly, singling out the Rouault works for special praise: "You know that by me and by other members of the staff here, Rouault is considered possibly the greatest contemporary artist, and it seems almost too good to be true that we shall have such a collection of his prints."

Jones replied matter-of-factly, "I have always enjoyed them, but, as I told you sometime ago, I thought the time was rapidly approaching when I should give away the things that I have. I may as well begin now." This seemingly casual sentiment alludes to a motive beyond Jones's enthusiasm for sharing great art with the people of his native state. For many years his health had been failing. A letter written much later by his wife, Louisa, detailed his condition at that time:

> In 1932–3, he had a serious illness and had to spend almost a year away from his legal work. During that time we spent a number of months in Egypt, where he was very ill for several weeks. Then came the War. . . . His health was not very good and he would have liked to retire from his law firm, But the War took away so many of the younger men that all the Senior partners stayed on to carry the work of the office.[7]

No doubt Jones's health lent a particular sense of urgency to resolving the disposition of his collection.

Jones mailed another package to the museum on October 10. It contained a print by Stanley William Hayter (*Maternity*, 1940, cat. no. 73, p. 53), which he advised "should be placed where the light shines through it, because it is really very beautiful. Hayter's work takes a little time to understand, but it is very well worth while." Jones followed up the gift with his first visit to Richmond since meeting Colt.

Later that month, Colt made a second trip to New York and accompanied Jones on his visits to Hayter and Lipchitz in their studios. Colt was no doubt impressed, telling Jones that he would like to bring Hayter to Richmond as a guest speaker at an Artist Evening and offer an exhibition to Lipchitz the following fall.[8] The occasion also likely inspired yet another gift, a carved and painted plaster by Hayter (1941, cat. no. 74, p. 54), a "beautiful little painting," according to Colt.

Near the end of 1941, only nine months after Colt's first letter to Jones, VMFA president, Blythe Walker Branch, invited the collector to join the board of trustees. Jones, however, declined, admitting that he had "about reached the limit" of his contributions for the year and was thus "unable at the present time to meet" the required financial commitment. Nonetheless, he seemed pleased to

have been asked, and would continue his generosity to the museum on his own terms.

With the American entry into World War II, Colt took leave from the museum to join the U.S. Marines, serving as major at the battle of Okinawa and other marine aircraft engagements.[9] Correspondence between the museum and Jones slowed considerably during these years, as Jones, too, was consumed with war-related activities. In addition to responsibilities at his law firm, he served as appeal agent for Draft Board No. 50 in New York City, and in 1944 he was appointed prize commissioner in the U.S. District Court, Southern District of New York, which had jurisdiction over the Atlantic Ocean and its tributary waters.

Colt took up his directorship of the museum again in September 1945, immediately following the war's end.[10] Jones was no doubt glad to have his champion return, and activity quickly resumed. In March 1946 the museum accepted Maurice de Vlaminck's *The Storm* (ca. 1912; cat. no. 272, p. 115) from Jones, and by the end of May, Jones had announced his intention to bequeath his collection to the museum. At the board's annual meeting on June 12, Jones was nominated as a trustee, and this time he accepted. He was appointed to the accessions committee and attended a meeting on November 4. He donated André Derain's *Still Life with Flowers* (ca. 1919–25, cat. no. 34, p. 40) the same month.

Meanwhile, at the University of Virginia, an active exchange with Jones was also underway. On April 17, 1946, university librarian Harry Clemons wrote to Jones: "We are deeply gratified by your inclination to donate to the University of Virginia your collection of modern French prints."[11] The following month, John Canaday—then an art history professor at the university and later an art

critic at the *New York Times*—visited Jones in New York to cultivate his support for the fine arts department, about which Jones had expressed concern.[12] In addition, John Cook Wyllie, curator of rare books at UVA's Alderman Library, wrote to Jones on June 26 about his recent trip to the state capital to see Jones's works: "I took the opportunity the other day when I was in Richmond of stepping in to see the very fine T. Catesby Jones wing of the Museum of Fine Arts, and I send you herewith my congratulations."[13] The Jones bequest, however, did not arrive in Richmond until a year after Wyllie's letter, sometime between late April and early June 1947. In truth, Wyllie likely saw a gallery installation of the pieces that Jones had previously donated, possibly combined with the twenty-five prints he sent for future transfer to UVA as per his bequest.[14] The "T. Catesby Jones wing," then, was either a felicitous stretch or reflects the impression made by an entire gallery or two seen within the context of the museum's rather compact original building (fig. 14)—as Jones's response suggests: "I am glad that you liked my pictures which I have given to Richmond, although I am not aware of the fact that they have dignified them with a wing of the Museum."[15]

At the end of the year, on December 21, 1946, T. Catesby Jones died following a stroke at age sixty-four. His will, dated May 2, 1946, specified the division of his collection: all works located in the country home in Petersham, Massachusetts, and all prints by J.-É. Laboureur went to his wife, Louisa Brooke Jones; all "illustrated books in the French language and books on art or architecture, and all of my etchings, lithographs, and engravings" were given to the University of Virginia; and the remaining paintings, sculpture, and drawings were bequeathed to

Fig. 14: VMFA in 1936, prior to five subsequent additions

the Virginia Museum of Fine Arts. The terms of the will describe these as a "permanent acquisition" and further name the collections, both at UVA and VMFA, as "The Catesby Jones Collection," although from the time of the first related exhibition and publication at VMFA in 1948, it has generally been referred to as the T. Catesby Jones Collection.

On April 10, 1947, UVA librarian Clemons wrote to Philip N. Stern, chairman of the Virginia State Art Commission, requesting permission to accept the T. Catesby Jones bequest to UVA. Stern replied, "The Art Commission at its meeting in Richmond on Friday April 11, approved with pleasure the acceptance of this collection of prints, etchings, and lithographs."[16] Although their decision was never in doubt, a pleasant and appreciative exchange of letters among UVA president John Lloyd Newcomb, Clemons, Wyllie, and Louisa Jones followed.

Meanwhile, Jones's bequest to VMFA was presented to the museum's accessions committee on April 16, 1947, for review and was formally accepted on June 11. In his annual report to the board of trustees and in subsequent newspaper articles, Colt repeatedly emphasized three points. First, the quality of the bequest was "considered by experts to be one of the finest intimate collections of the kind." Second, the bequest significantly broadened the museum's holdings beyond its contemporary American art collections, making the institution "one of the wealthier Museums in the world in the contemporary field."[17]

This claim by Colt, in fact, bears up under scrutiny. Only a handful of sister institutions in the late 1940s could declare equal or superior modern European holdings. These included the Guggenheim and MoMA; the Philadelphia Museum of Art with its

Gallatin Collection, which would be joined by the Arensburg Collection in 1950; the Baltimore Museum of Art, which received the Cone Collection in 1949 and the Sadie A. May Collection between 1928 and 1951; the Wadsworth Atheneum, the country's first public art museum and a contemporary European art mecca during the 1930s and early 1940s; the Art Institute of Chicago, which jump-started its modern European holdings with purchases from the 1913 Armory show it hosted in Chicago; the Carnegie Museum of Art, founded with a mission to collect the "Old Masters of tomorrow" and thus regularly adding to its contemporary holdings since the 1890s; and the Phillips Collection in Washington, D.C. Other established museums of the time—in Boston, New York, Washington, Cleveland, and beyond—still had limited holdings of modern European art. All in all, however, it was reasonable to argue that the T. Catesby Jones Collection vaulted VMFA into the top tier in this field, at least for a time.

Colt's third point proved more complex. In response to prior and perhaps anticipated criticism, he felt it necessary to address a public-perception issue concerning the museum's focus. He began by acknowledging the problem: "I recognize that there are many who are distressed with the Museum's apparent absorption in contemporary art." He then recounted the history of the fledgling institution to remind his audience that a logical consequence of operating with limited funds was the acquisition of works that were affordable, which often meant new art. In addition, he made it clear that most of the museum's private acquisition endowments were restricted to contemporary art. And finally, he emphasized the museum's commitment to all periods of art and his hope

for future private endowments that would replace the reliance on gifts for these non-contemporary areas.

Colt also used the occasion to advocate open-mindedness:

> Nearly every great change in man's art has received the condemnation of the majority that lived during it. Rembrandt was disliked and distrusted in his day. The fact that art changes in any time is an indication of vitality and a chance of greatness, rather than a proof of poverty. Esthetically we cannot safely condemn a thing because it is different from what we know. To appreciate today's art takes the time and the open eyes and mind of a Catesby Jones.[18]

Besides the welcomed addition of modern French art, Jones's bequest also included fifteen ancient, non-Western, and miscellaneous objects. These consisted of an enamel plaque by the self-taught Frenchman Léon Jouhaud, Egyptian fragments and carved figures, Chinese and Japanese portrait paintings, Japanese ceramics, Greek figurines and a red-figured oil jug, and a Russian samovar (cat. nos. 278–292).[19]

Before year's end, several additions to the collection were made that came to be regarded as part of the T. Catesby Jones Collection. Curt Valentin, art dealer and director of the Buchholz Gallery in New York, gave a group of ten prints by André Masson in memory of Jones (cat. nos. 162–171).[20] Valentin also sold VMFA the bronze portrait bust of Jones by Lipchitz (1941, cat. no. 102, p. 65), offering to forgo his one-third commission to help fund the 1948 exhibition catalogue of the collection.[21] In addition Louisa Jones donated two paintings by William Sanger

(cat. nos. 261 and 262)[22] and a work listed in the minutes of the December 2, 1947, accessions committee meeting only as an oil painting by an unknown artist.[23] She also gave a pair of Chinese ancestor portraits (cat. nos. 292 and 293) at the same time.

In her accompanying letter, Mrs. Jones was careful to distinguish these works from her late husband's original bequest: "If the Museum accepts [my gifts], they should of course belong to the T. Catesby Jones Collection, but I think they should be accepted as a gift from me, not as part of the original bequest, both because they do not represent Catesby's developed and mature taste, but also because they are a part of the 'furnishings' at Petersham which were left to me." (She further mentioned that her daughter Mary [Polly] Riley and son-in-law Dick had "wandered into the exhibition of Picasso's early work one day and were thrilled to find Polly's old friend, Picasso's *Woman with Kerchief* [1906, cat. no. 200, p. 97] on the wall. I went in myself to see it the other day and it was good to see how it stood up even in that stunning array of talent.")[24] Three months later, at the March 15, 1948, meeting, the museum accepted another anonymous work for the collection, this time as a gift from Mary Riley. Called simply "a small abstract oil painting by an unidentified French artist," it has since been identified as a work by Russian artist Serge Charchoune (cat. no. 28).

At the time of the Jones bequest, the museum's only other twentieth-century non-American holdings seem to have been Jones's previous gifts along with a small undated oil on panel by André Derain called *Woman's Head,* given by prominent collector Stephen C. Clark. Also in the collection were several miscellaneous pieces more properly seen as late examples of the previous century's concerns:

a 1905 painting of the Champs-Élysées by Jean-François Raffaëlli, and a *Landscape with Cows* by Menaro, about whom very little is known. Thus although rightly welcomed, Jones's collection constituted a leap of faith for the museum into a new area of expertise. Many of the artists were unfamiliar to the staff, so a sudden campaign of information-gathering ensued. In the absence of a painting and sculpture curator, the task fell largely to the director and to the new registrar, Max Buhman.[25] Colt requested details on artists from MoMA director, Alfred H. Barr Jr., and from Curt Valentin, among others, and Buhman wrote to several registrars at museums that had previously borrowed works from Jones's collection. Buhman also contacted a friend, Graham Tucker, from Ashland, Virginia, who was in France at the time and fluent enough in the native language to conduct an interview and exchange of letters with Jean Lurçat about the artist's relationship with Jones.

The first exhibition of the T. Catesby Jones Collection took place from February 26 to April 4, 1948. It appears to have included nearly all the works in the VMFA collection (ninety-eight were apparently shown)[26] and was accompanied by a catalogue that included selections of Jones's writings, an excerpt from Lurçat's letter to Tucker, and a collection checklist annotated with Jones's previously published comments. In his introduction, Colt wrote, "I remarked to Mr. Jones one day that I despaired of Virginia possessing or understanding such works as these in my time. The bequest is Mr. Jones's answer to my despair, and challenge to the State he loved."[27]

Both of Richmond's newspapers included extensive coverage of the event. The *News Leader* reported on the story behind the Lurçat interview and letter, and the *Times-Dispatch*

devoted more than a double-page spread to Jones's own writings on modern art taken from his letters to friend David Keppel.[28] The correspondence, it claimed, was as valuable as the art collection, offering "the open sesame to a whole hearted and genuine appreciation of modern art in this changing world. These manuscripts will bear no editing. Their logic and breadth of appreciation of art from its beginnings to this day, and especially the motivating concepts of the much misunderstood modern masters cannot be briefed."[29] The exhibition also drew national attention. A review in the *New York Times* described it as "a unique collection, built by a man who was friend as well as patron of many of the artists represented. . . . The bequest of such paintings, little known there, opens new frontiers for the Southern museum."[30]

Soon after the exhibition closed, Colt—a "shrewd, affable" director according to a 1940 *Time* article[31]—left the Virginia Museum of Fine Arts.[32] His departure brought to a close an important chapter in the institution's history, but not its enthusiasm for the Jones collection. The museum began actively displaying it both onsite and off. As a State institution, VMFA had always played an active part in organizing temporary loan exhibitions to affiliated museums and universities throughout Virginia, and numerous opportunities quickly arose to share the T. Catesby Jones Collection.

The collection's exhibition history provides a vivid lesson in the evolution of museum practices, which were then rather less encumbered with the standards that underlie current handling and display. At the same time, it conveys the museum's enthusiasm for sharing the collection with the people of Virginia. The Selected Exhibition History in this publication includes some that ran for as little as a week, others that hung in public corridors in colleges,

and one that occupied a "suitably convertible gallery space" in the Hotel Roanoke.[33] Others not on the list include various short-term displays of single works. A particularly innovative method involved the VMFA Art Mobile— semitrucks equipped as art galleries that traveled around the state (figs. 15 and 16).

The inaugural exhibition of UVA's print collection took place the following year, 1949, to coincide with the university's April 13 celebration of Founder's Day, at which UVA president Colgate Darden publicly accepted the Jones bequest.[34] The exhibition was held on the second floor of UVA's Alderman Library in the corridor that led to the rare-book area. The prints were displayed in nineteen aluminum cases totaling approximately one hundred linear feet. Jones had helped in both the selection of the space and the design of the cases.[35] Louisa Jones described the events in a letter to Michael Agelasto, the family friend who had first informed VMFA's director Thomas Colt of Jones's collection:

> Ten days ago, on the 13th, I was in Charlottesville for the opening of Catesby's print collections in Alderman Library. They have been showing some of the prints and books from time to time but it has taken a while to get the proper wall cases that Catesby wanted, hence the delay in opening the collections formally. . . . It is really a long narrow gallery but not too narrow. There is room to move about comfortably and yet you are never too far from the prints. . . . Of course, only a small part of the collections can be shown at one time.

In 1975, the independent prints would be transferred as a "permanent loan" to the University of Virginia Art Museum; the illustrated books, print portfolios, and books on

Fig. 15: *Paris '20: The T. Catesby Jones Collection,* exhibited in VMFA's Art Mobile, 1965

Fig. 16: VMFA Art Mobile, 1959

art and architecture remain in the special collections department of the university library.

In the years that followed, VMFA maintained relations with the Jones family. Director Leslie Cheek and other museum staff members regularly corresponded with Louisa Jones regarding such issues as requests from VMFA and other museums for loans from her personal collection, exhibition plans, publications, and family visits to the museum. She gave one last work during her lifetime. On May 12, 1953, she wrote to Cheek about her donation of an ink-wash painting by Peter Blanc (William Peters Blanc) (cat. no. 9) that she hoped the museum would accept as part of the T. Catesby Jones Collection:

> I have taken rather a liberty with you and the Museum and I want to explain what I have done and how it came about. . . . Peter Blanc is a young artist—still under forty—whom my husband and I have known since his school days and in whose devotion to painting and persistence in following art as a profession my husband took a special interest, as well as in his work. I feel sure that if Catesby had lived a little longer he might have been moved to add one of Peter's pictures to his collection.

When Louisa Brooke Jones died on December 25, 1967, her will did not designate specific works of art for VMFA. Rather, it stipulated that her daughters, Mary (Polly) Catesby Riley and Frances (Peggy) Jones Brooks, were to select the pieces they wanted and the balance was to go to VMFA. (Provision was also made for Jones's son from his first, brief marriage, Catesby T. Jones, to select one work, but he had predeceased his stepmother.)

On February 17, 1968, Peggy Brooks informed VMFA curator Pinkney Near that

she and her sister had made their choices from the twenty-one principal works remaining in the estate and that seven were available to the museum. Near visited the apartment at 200 East Sixty-sixth Street (Louisa Jones's home since the early 1950s) and, soon after his return, forewarned Brooks that the museum might not accept all the remaining works: "our policy is opposed to accepting gifts for which there is not a clear cut need or which unnecessarily duplicate material already owned." Near also wrote a memo to Cheek on March 12 explaining that they were offered seven works and that "the Bauchants and Lurçats duplicate what we have in great quantity now and for this reason I am opposed to accepting them (the tapestry screen does not duplicate, of course, but do you think we could use it?)" Cheek replied on the same memo: "Yes = we could use in new Members' Suite."

That day Near replied to Peggy Brooks that the museum would accept three works: Picasso's *Nude Athlete* (1950, cat. no. 211), Roger de la Fresnaye's study for *Man, Drinking and Singing* (1910, cat. no. 86), and Lurcat's folding screen (1928, cat. no. 114, p. 71). He also accepted Picasso's *Guitar and Glasses,* (1912, fig. 1) and Braque's *Glass of Absinthe* (1911), which she and her sister offered for long-term loan.[36]

In 1970, VMFA opened its major South Wing addition. On January 28, Near wrote a letter to Peggy Brooks and Mrs. Catesby T. Jones (the widowed daughter-in-law of T. Catesby Jones), telling them of the upcoming opening. "In that wing is our redesigned gallery of modern art and in that gallery paintings from the T. Catesby Jones Collection figure very prominently. This collection remains the Museum's greatest strength in the field of twentieth-century European painting."[37]

In fact, the same can still be said today. For both the Virginia Museum of Fine Arts and the University of Virginia Art Museum, the T. Catesby Jones Collections constitute their strongest holdings of European modernism. A combination of serendipity, generosity, and determination guided these works of modern art from Paris to New York to Virginia. Jones's pioneering efforts on behalf of the art of his time and for the benefit of Virginians in perpetuity are still being matched by the enthusiasm and gratitude of staff members and visitors to the institutions honored with his gifts. The T. Catesby Jones Collection continues to highlight the significance of the collector-museum partnership in bringing art to the public.[38]

Notes

References in the above essay not cited below come from original correspondence archived in two locations: the T. Catesby Jones curatorial files of the Virginia Museum of Fine Arts and the Virginia Museum of Fine Arts Directors' Correspondence, 1933–1977, at the Library of Virginia, Richmond (accession 33863, State Government Records Collection, boxes 21, 39, 76, and 78).

1. For details on Jones's ancestry, see pp. 2–3 in this publication.
2. Ibid., pp. 5–6.
3. Jones helped reestablish the Alumni Association in 1937 and served as its president in 1940–41. See Jones's obituary in *University of Virginia Alumni News* 35, no. 5 (February 1947): 51.
4. The artists in Chrysler's collection overlapped substantially with Jones's collection, including Matisse, Picasso, Braque, Lurçat, Rouault, Derain, Gris, and Masson. But Chrysler's collection also included earlier artists, from El Greco to Cezanne, Manet, and Renoir. See Thomas C. Colt Jr., "Jones: Advanced-Guard Adventures," *ArtNews* 47, no. 1 (March 1948): 19, 55–56. In this article Colt opens by describing the importance of VMFA's decision to host this exhibition in cultivating a relationship with Jones.
5. Bigham, Englar, Jones and Houston, Counsellors at Law, 99 Jay Street.
6. *Architectures, recueil publié sous la direction de Louis Süe et André Mare, comprenant un dialogue de Paul Valéry et la présentation d'ouvrages d'architecture, décoration intérieure, peinture, sculpture et gravure contribuant depuis 1914 à former le style français* (Paris: Éditions de la nouvelle revue française,

1921). VMFA records show that this book arrived in 1941 but was removed from the collection in 1944 for unknown reasons and sent to a currently unknown destination.

7. Recent correspondence with Jones's daughter Peggy Brooks has shed further light on Jones's health: "My father had health problems with stomach ulcers through the thirties and high blood pressure, too, but he had not had a stroke until the one from which he died, as far as I know. I do remember that he began to be concerned about the fate of his collection in the early forties, very much in connection with his concerns about leaving enough money for the family, and he wanted to take advantage of the opportunity to make a bequest to a nonprofit institution of his art collection, so that it would not be valued as part of the estate." E-mail to Matthew Affron, March 31, 2008, curatorial files, Virginia Museum of Fine Arts.

8. It has not been possible to determine whether either of these events occurred, though Colt invited Hayter for January 2, 1942.

9. Colt was part of Marine Aircraft Group 22, in Okinawa June 1–22, 1945. See Charles S. Nichols Jr. and Henry I. Shaw Jr., *Okinawa: Victory in the Pacific* (Historical Section, Division of Public Information, Headquarters U.S. Marine Corps, n.d.), Appendix III, *http://www.ibiblio.org/hyperwar/USMC/USMC-M-Okinawa/USMC-M-Okinawa-III.html*. In VMFA's May 1942 *Museum Bulletin,* Colt announced his leave of absence, saying he was "returning to service for which I am trained with the Aircraft Squadrons of the U.S. Marine Corps." Curator Edward Morris Davis was already on duty with the Navy and the curator of education and the director of public relations were expected to depart for service in the near future. The museum was run by an entirely female administration and staff during the remainder of the war.

10. On September 7, Colt wrote the museum trustees that he was relieved of his duties now that the war had ended and was preparing to return. On September 12, his signature appears as secretary on the minutes of the executive committee meeting.

11. Papers of the University Librarian, 1927–74, Accession # RG-12/1/1.681, Box 54, Special Collections, University of Virginia Library.

12. See Wyllie to John Lloyd Newcomb, July 2, 1946, Correspondence Files, 1931–1990s, Accession # RG-12/11/4.021, Box A35-16E, Special Collections, University of Virginia Library.

13. Ibid.

14. These twenty-five prints were accepted as loans at VMFA on March 2, 1946, and sent to UVA on July 9, 1947.

15. Correspondence Files, 1931–1990s, Accession # RG-12/11/4.021, Box A35-16E, Special Collections, University of Virginia Library.

16. Papers of the University Librarian, 1927–74, Accession # RG-12/1/1.681, Box 54, Special Collections,

University of Virginia Library.

17. Virginia Museum of Fine Arts, *Annual Report, 1946–47,* 5.

18. Ibid., 7.

19. The samovar, the Japanese portrait painting, and a piece of Japanese ceramics were later deaccessioned.

20. Valentin also gave several other objects to VMFA in 1946–47, but not in memory of Jones, including John Flannagan's cast stone *Jonah and the Whale* (1937), five etchings and drypoints by Renée Sintenis, and Charles Cutler's granite *Mermaid* (1941).

21. Curt Valentin Papers, III.E.[79], Museum of Modern Art Archives, New York.

22. About the Sanger paintings, Mrs. Jones wrote that her husband "considered them, even in later years, as coming from the best period of William Sanger's work, after visiting Spain and getting a tremendous lift from its scenery and atmosphere. This carried over for a few years—the *Coast of Maine* is a little later and then was unhappily lost in rather muddled thinking and color sense. When we knew him, he was a pitiful, eager little man, the traditional 'starved artist,' and yet with real artistic integrity. He was at that time still married to his very well-known wife, Margaret Sanger of Birth Control fame, and deeply distressed over the recent death of his little daughter Peggy. After his divorce, he married a very pleasant sloppy little woman with incredibly untidy hair, who, I think, made him very happy—which is all to the good, even if his work suffered! Catesby always doubted whether he had staying power."

23. This painting was accepted as a nonaccessioned work, "for use in temporary exhibitions, as study material or for like purpose." It has not been possible to determine its identity or current location.

24. Although it has not been possible to determine the nature of this exhibition, the full name of the organizing institution was the Public Education Association. It existed for the purpose of supporting public education in New York. The association periodically organized exhibitions, which school groups attended. A letter in the files from Mrs. Victor W. Ganz, Chairman of the Art Benefit for the Public Education Association, dated November 21, 1961, again requests Picasso's *Woman with Kerchief,* this time for a city-wide tribute to Picasso on his eightieth birthday, to occur at a half dozen galleries around New York. *Woman with Kerchief* was to be included in the show *1900 to Cubism* at the Knoedler Gallery.

25. Colt was originally hired as curator of painting and sculpture and apparently continued this role in part after becoming director. With the exception of decorative arts curator Edward M. Davis III, who was with the museum from its founding through the 1940s, and exhibitions curator R. R. Roche, hired in 1948, the museum ran for years with consulting curators until Pinkney Near was hired as a full curator in 1958–62 and again in 1965. Priscilla Crum, who worked closely with Valentin in a curatorial

capacity on the acquisition of the Lipchitz portrait bust of Jones, was a VMFA employee from 1944 to 1947, first as assistant in education, then as curator of education, and finally, for five months, as curator. After leaving, she worked at the Minneapolis Art Institute museum and from there moved to Portland to marry Colt, who had become director of the Portland Art Museum.

26. Aline B. Louchheim, "Art Along U.S. 1: Modern Collection to Virginia Museum—Drawings at Fogg—Other Activities," *New York Times,* February 15, 1948.

27. Virginia Museum of Fine Arts, *The T. Catesby Jones Collection* (Richmond: Virginia Museum of Fine Arts, 1948), n.p.

28. For details see pp. 10–12 in this publication.

29. "Donor of Modern Art Analyzes Painting of Past 50 Years: T. Catesby Jones's Letter States His Ideals," *Richmond Times-Dispatch*, February 22, 1948.

30. Louchheim, "Art Along U.S. 1."

31. *Time,* "Argentine Art," January 29, 1940.

32. Colt resigned April 13, 1948, citing internal unrest (his) and financial difficulties. The year before, he had lobbied for pay increases for the entire staff. All were granted except his. He became director of the Portland Museum of Art, Oregon, where he remained until 1956 or 1957, then director of the Dayton Art Institute from 1957 to 1975. The nonprofit Colt House Gallery in Miami, run by his son Christopher, contains some of the Colts' collection. See http://colthousegallery.com/index.html.

33. Virginia Museum of Fine Arts, *Annual Report 1947–1948*, 8.

34. The collection had been officially accepted a year before, on April 11, 1947, but without ceremony. T. Catesby Jones Print Collection Appraiser's Inventory, Correspondence Files, 1931–1990s, Accession # RG-12/11/4.021, Box A35-16E, Special Collections, University of Virginia Library.

35. Ibid. The architects for the cases were Taylor & Fisher. The cases had arrived by March 1948 and were likely installed well before the Founders Day inauguration. In addition, selected works had already been exhibited in the Alderman Library prior to the arrival of the new casework.

36. The Picasso remained at the museum until 1980 when it was removed by the lender and sold to Galerie Beyeler, Basel, which in 1983 resold it to a private collector in New York. The Braque remained at VMFA until May 1989, when it was reclaimed for auction at Christie's. In 1997 it was acquired by the Art Gallery of New South Wales.

37. Near may also have written Mary Catesby Riley, the elder daughter, but no copy exists in the files. She was at that time a doctor and still lived in Baltimore before retiring to Petersham, Massachusetts, where she died in 1999.

38. An e-mail from Jones's daughter Peggy Brooks to Matthew Affron on March 2, 2008, confirms: "I do remember my father's interest in and warm feelings about Thomas Colt. My father gave his collection to the Museum because of Colt's sensitive understanding of what it could do for the Museum of Fine Arts at that time. My father was looking for a place to give his collection where it would be needed and valued and, as I understood it, the Museum then had no other modern paintings or sculpture of the quality of his collection. Of course the Virginia connection was very important to him, but I don't believe he would have made the gift without Thomas Colt's particular appreciation." Copy in curatorial files, Virginia Museum of Fine Arts.

Contributing Authors

MATTHEW AFFRON

KATHERINE EVE BAKER

ELIZABETH T. BROADBENT

LESLIE F. COZZI

CHRISTOPHER C. OLIVER

MELISSA SUE RAGAIN

REBECCA SCHOENTHAL

EMILY SMITH

JESSICA STEWART

JACQUELINE TAYLOR

Note to the Reader

Titles of works of art are those used by the current owner and are given in English. Alternative titles are also noted. Titles of print portfolios are given in English with the original language following in parentheses.

Dates of works of art have been corroborated by inscriptions or other forms of documentation whenever possible.

Dimensions given are of the support; dimensions of prints and drawings are of sheet size. All dimensions are height x width x depth.

Reproductions of prints in this section include a small margin around the image rather than entire sheet.

Translations are by Matthew Affron unless indicated otherwise.

ARTIST ENTRIES

ANDRÉ **BAUCHANT**
1873–1958, French

7

Combat in Château-Renault Forest,
1939
Oil on canvas
56½ x 38 in. (143.5 x 96.6 cm)

André Bauchant's *Combat in Château-Renault Forest* (cat. no. 7) depicts a scene of courtly conflict. The image is both minutely painted and expansive in its sweep, with the richly dressed riders and their horses dominated by the surrounding natural setting and the detail with which it is rendered. The massive tree trunks that split unexpectedly into spidery branches and twigs are among the painter's most characteristic motifs. The title of the painting places the battle near the artist's hometown, Château-Renault, in the Touraine region of central France. Though Bauchant was known to use plates from history books as the basis for works depicting distant lands and times, no such evidence can conclusively connect this scene to a particular historical event.[1]

Bauchant's interest in the natural world began early; as a young man he entered his father's trade of landscape gardening, which he practiced until the outbreak of World War I. In 1914, already past age forty, he was mobilized in the infantry. Three years later he was assigned to an army reconnaissance unit, where he trained in telemetry before being sent to Reims as a draftsman in 1918.

Bauchant returned to gardening after the war, but he also built a studio and took up painting. In 1921 he debuted as a painter, showing nine compositions at the Salon d'Automne in Paris. His work caught the eye of the architect Le Corbusier, who arranged a meeting with art dealer Jeanne Bucher. In 1927 Bucher gave Bauchant, then age fifty-four, his first solo exhibition. By that time he was enmeshed in the world of modern art in Paris.

Bauchant has always been known as a naïf, or modern primitive, and a master of folk painting. He came into the public eye at a moment when the art of self-taught

painters was prized for its eccentric, creative, and fantastical qualities, and for its sincerity. Bauchant was often discussed in the company of Henri Rousseau, the dean of naïve masters, and, in his own generation, among such painters as Camille Bombois and Louis Vivin. Bauchant's work, however, was defined by a distinctive vision, and he was not interested in addressing the more urban trappings of modernity. His paintings were almost always framed, if not defined, by a lushly verdant pastoral landscape with subjects ranging from flower still lifes to genre scenes to ambitious compositions based on mythology, biblical narratives, and ancient and modern history.

The quantity of works by Bauchant in the Jones collection, and the prominence of their display in his home, speaks to the collector's abiding interest in him. Jones cited *Combat* as one of his favorites,[2] and a 1927 series of four paintings depicting the seasons (cat. nos. 3–6) hung in his dining room. Jones lent his still life entitled *Flowers in a Pink Jug* (1928) to an important 1938 exhibition, *Masters of Popular Painting: Modern Primitives of Europe and America,* which was organized by the Museum of Modern Art with the collaboration of both Jeanne Bucher and Wilhelm Uhde, a German dealer who was a proponent of the work of self-taught artists. Two other works by Bauchant, *French Peasant Interior* (1920, cat. no. 2) and an undated *Snow Scene* (cat. no. 8), were included in the Jones bequest, along with his copy of *Les simples vus par Violette,* a limited-edition book containing reproductions of watercolor flower illustrations by Bauchant, which Bucher published in 1937.[3] —JS

7

Notes

1. The canvas has long been known and exhibited with the shorter title *The Combat in the Forest*. The longer title appears on a receipt from Galerie Jeanne Bucher dated January 31, 1940 (Peggy Brooks, New York), and in Maximilien Gauthier, *André Bauchant* (Paris: Editions du Chêne, 1943), pl. 25. The painting has been published repeatedly (by Gauthier and others) with a 1930 date, but it is signed and dated 1939. The 2005 catalogue raisonné of Bauchant's work proposes that this painting was inspired by a print in Adolphe Joanne's *L'histoire de France,* but we have been unable to trace this citation.

2. Thomas C. Colt Jr., with notes by T. Catesby Jones, "Jones: Advance-Guard Adventures," *Art News* 47, no. 1 (March 1948), 19.

3. André Bauchant, *Les simples vus par Violette* (Paris: Éditions Jeanne Bucher, 1937).

GEORGES **BRAQUE**

1882–1963, French

11
Fox, 1911
Drypoint
25 ¹³/₁₆ x 20 ¹/₁₆ in. (65.5 x 50.9 cm)
Published by Daniel-Henry Kahnweiler,
Paris, 1912

16
Still Life, ca. 1932–38
Oil and sand on canvas
9 ⁵/₈ x 18 ¹/₈ in. (24.4 x 46 cm)

T. Catesby Jones's holdings of works by Georges Braque spanned three decades, from 1911 to the 1930s. An important early print from summer or fall of 1911 and three reproductions of images by Braque were included in the University of Virginia gift, and two still-life paintings, one belonging to the mid-1920s and the other executed some ten years later, were bequeathed to the Virginia Museum of Fine Arts.

Fox (cat. no. 11) is the largest and one of the most assured in a series of ten images that make up Braque's first serious essay in printmaking. It is one of two from the set that Daniel-Henry Kahnweiler, his dealer, published in 1912. The subject is a café table at Fox's Bar. Located near the Saint-Lazare train station in Paris, the bar was frequented by members of the city's cubist group. Among the recognizable elements in the print are a tabletop with a drawer, a bottle, a tall drinking glass, and a playing card of the hearts suit, as well as the number *15* (possibly the price in centimes of a drink) written on a slip of paper in a saucer. The name of the bar appears in clearly distinguishable letters, as does "Old Tom," a brand of gin.[1] The overall impression, however, is one of an image broken into an array of subtly shifting geometric planes.[2] Characteristics of the printer's art—the velvety drypoint line, the alternation of cross-hatching with voids articulating the play of light and dark, the pictorial effect of the plate mark—were well matched to Braque's manner of image making.[3] *Fox* surely ranked as one of the prized acquisitions in Jones's extensive collection of prints.

Throughout his career, Braque treated the still life as a means to experiment with form and structure. His interest in this category of work marked his early cubism and continued unabated after World War I. While most

11

of his prewar painting was nearly achromatic, Braque later became more interested in exploring color, and he believed that still life, which involved very closely observed visual relationships, was crucial. The painting of objects close at hand also offered Braque the opportunity to work on tactile effects, an issue of great concern to him: "It is not sufficient to make people see what one has painted," he once wrote, "one must also make them touch it."[4] Braque saw texture as a way to distinguish the character and essential quality of an object, which with color provided a way to consider the relationship between objects rather than just the objects themselves.

Braque sometimes worked on individual canvases over long periods of time, and *Still Life* (cat. no. 16) has never been conclusively dated. However, certain motifs of the painting, especially the sinuous shape at the left (which appears in sketchbook drawings of 1932) and the gray-green pattern of the wallpaper,

16

suggest 1932–38 as a plausible range.[5] Contrasts of black, white, and gray produce an effect close to chiaroscuro, giving the objects—a fruit bowl on the left, a yellow lemon, and a glass on the right—a certain solidity and the space a certain depth. The texture of the table is rendered in markings that imitate wood grain. The incorporation of sand in the oil paint adds a subtle texture to the composition. —JT

Notes

1. Burr Wallen and Donna Stein, *The Cubist Print* (Santa Barbara: University Art Museum, University of California, 1981), 24.

2. This print closely matches a painting executed by Braque in 1911, *Bottles and Glasses* (Kunstmuseum, Berne).

3. Dora Vallier, *Braque: The Complete Graphics, Catalogue Raisonné,* trans. Robert Bononno and Pamela Barr (New York: Gallery Books, 1988), 9.

4. Georges Braque, *Cahier de Georges Braque, 1917–1947* (Paris: Maeght, 1948), 4, quoted in Douglas Cooper, *Edinburgh International Festival, 1956 Catalogue* (Edinburgh: Royal Scottish Academy, 1956), 11.

5. On the 1932 sketchbook, see Nadine Pouillon, ed., *Braque: oeuvres de Georges Braque, 1882–1963,* with Isabelle Monod-Fontaine (Paris: Centre Georges Pompidou, Musée national d'art moderne, 1982), 92–97. The author thanks Marilyn McCully for her suggestions regarding the date of this work.

MASSIMO
CAMPIGLI

1895–1971, Italian

Born Max Ihlenfeld in Germany
Active in Italy and France

20
Water Jugs, 1928
Oil on canvas
39 ½ x 30 ⅝ in. (100.3 x 77.8 cm)

22
The Meeting, II, 1932
Etching and drypoint
12 ¹³⁄₁₆ x 9 ¹³⁄₁₆ in. (32.5 x 25 cm)

Massimo Campigli's oeuvre is dominated by the female form. The images here are no exception, exploring archetypal woman, ancient and modern. *Water Jugs* (cat. no. 20) features a monumental figure performing the task of carrying water, a theme that Campigli often addressed in the late 1920s. She wears a floor-length skirt and is nude to the waist; her torso is rendered in smooth, broad planes. Her nudity calls attention to her gender but does not overtly sexualize the figure. Instead, it serves to present an eternal image of womanhood, as formulated by Campigli through the artistic precedent of the ancient Etruscans. It was, in fact, in 1928 that he discovered the National Etruscan Museum housed in the former papal residence of the Villa Giulia in Rome. The impact would be lasting for Campigli, who consistently infused archaism into his own style.

There are further indications of the theme of timelessness in *Water Jugs.* The woman's eyes, left unpainted with blank canvas visible, appear hollowed out, like the empty sockets of an antique sculpture. The canvas is otherwise heavily worked, its oils built up layer upon layer and then incised or scored. The colors recall the ruddy earth tones of Etruscan art, and the result suggests an ancient wall. Yet in the background of the plain and minimally described piazza, a modern figure encroaches. Her features are hard to make out, but the raised umbrella marks her as contemporary and perhaps even fashionable. The umbrella is surrounded by a crosshatched area of blue pigment, the most striking color in the work.

Campigli specialized in scenes of female activity and interaction, whether archaizing in tone or, as in *The Meeting, II* (cat. no. 22), contemporary. This etching is populated by modern women of fashion. Clad in richly

patterned dresses, hats, and gloves, one holding a parasol or umbrella, they seem to move away from the viewer, toward another female in the picture's background. Though she is indicated only by a wasp-waisted contour,

Noël 1932 M. Campigli

22

her outstretched arms convey an exuberant greeting. No sense of setting is indicated in this image, but it might be read as a contemporary street scene. Campigli's love of patterns is evident; he uses a different one — such as a diamond crosshatch or honeycomb — for each dress.

Although he was born in Berlin, Campigli grew up in Italy, living in both Florence and Milan. In 1919, at age twenty-four, he was sent to Paris as a journalist by the newspaper *Corriere della Sera.* It was there that he began to paint, and in 1929 he showed twenty-nine canvases at Galerie Jeanne Bucher. It is likely that T. Catesby Jones met the artist through Bucher. In the mid-1930s Campigli and Jones shared a friendly correspondence, some of which has been preserved.[1] Jones gave two other paintings by Campigli,

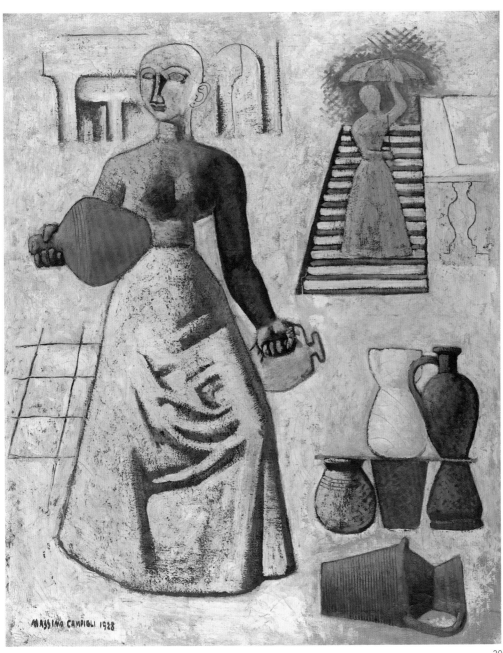

Charity School (1929, cat. no. 21) and *The Concert* (1935, cat. no. 23), to the Virginia Museum of Fine Arts and a drawing (cat. no. 19) to the University of Virginia. —JS

Notes

1. Massimo Campigli to T. Catesby Jones, January 19, 1936; Campigli to Jones, postmarked 1936; Campigli to Jones, n.d., Letters from French Artists to T. Catesby Jones, MSS 2711, Gift of Louisa Brooke Jones, Special Collections, University of Virginia Library. Campigli also inscribed Jones's copy of Pierre Courthion, *Massimo Campigli* (Paris: Éditions des chroniques du jour, [1938]), ND623 .C17 C6 1938, Gift of T. Catesby Jones, Special Collections, University of Virginia Library.

MARC **CHAGALL**

1887–1985, Belarussian

Active in France, Germany, Russia, and United States

24
Walking Man, ca. 1914–20
Pen and ink on paper
6 ⁹/₁₆ x 3 ¹⁵/₁₆ in. (16.6 x 10 cm)

25
The Trough, 1924
Lithograph
22 ½ x 15 ¼ in (57.2 x 38.8 cm)
Published by Jeanne Bucher, Paris

26
The Eiffel Tower, 1943
Etching
17 ⁷/₁₆ x 12 ⁵/₈ in. (44.3 x 32 cm)
From *VVV, Portfolio of Eleven Original Works: Etching, Frottage, Objects,* 1943

These three images belong to three moments in the life and career of Marc Chagall, and each gives expression to the artist's strong attachment to a place and its people. The earlier two works feature his native Russia, while the third is an homage to Paris, where he spent much of his life.

Chagall was born in Vitebsk, Belarus, at that time a part of the Russian Empire. At age twenty-three he moved to Paris, where he established himself as a member of the international avant-garde. After four years he returned to Russia, and sometime between 1914 and 1920 he created *Walking Man* (cat. no. 24).[1] The drawing depicts a man in military uniform, his pose as much a march as a walk. With its distinct contrast of light and dark and its geometric rendering of the body, it is comparable in style to Chagall's other depictions of soldiers made during this Russian period.

25

Although Chagall left Russia again in 1922, the country would forever remain an inspiration for him. In his later years he would acknowledge that "in spirit I was always here."[2] He created *The Trough* (cat. no. 25) in 1924, when he was once again living in Paris. The print, executed in a rough style befitting its rustic theme, is a nostalgic recollection of Vitebsk. The subject, a peasant woman with a pig, conveys an image of simple village life. T. Catesby Jones especially admired Chagall's prints that, like *The Trough,* expressed "the life of his people," calling these "his most interesting work."[3]

From 1941 to 1947, Chagall lived as an exile in New York City. But Paris was always close to his heart, and in 1943, with the etching *The Eiffel Tower* (cat. no. 26), he paid tribute to the city he considered both a "second Vitebsk" and his artistic birthplace.[4] The dreamlike memory of Paris, with its fanciful anthropomorphized tower and incongruous juxtaposition of wild horses with the city's skyline, testifies to the strong streak of fantasy that runs through Chagall's work.

24

This print was originally issued in 1943 by the surrealist-oriented magazine *VVV* as part of a selection of images by American artists and Parisian émigré artists.[5] — ETB

Notes

1. Benjamin Harshav, *Marc Chagall and His Times: A Documentary Narrative* (Stanford: Stanford University Press, 2004), 222.
2. Aleksandr Kamensky, *Chagall: The Russian Years, 1907–1922* (New York: Rizzoli, 1989), 10; Jonathan Wilson, *Marc Chagall* (New York: Nextbook-Shocken, 2007), 231.
3. T. Catesby Jones, *Modern French Prints: An Address . . . Delivered on October 19, 1944 at The Grolier Club of New York* (New York: Court Press, 1945), 28.
4. Chagall, quoted in Florent Fels, *Propos d'artistes* (Paris: La renaissance du livre, 1925), 32.
5. *VVV, Portfolio of Eleven Original Works: Etchings, Frottage, Objects* (New York: VVV, 1943). The other artists were André Breton, Alexander Calder, Leonora Carrington, Max Ernst, David Hare, André Masson, Roberto Matta, Robert Motherwell, Kurt Seligmann, and Yves Tanguy.

26

ANDRÉ **DERAIN**
1880–1954, French

33
Landscape in Provence,
ca. 1919–25
Oil on canvas
18 ¼ x 21 ¾ in. (46.3 x 55.2 cm)

34
Still Life with Flowers, ca. 1919–25
Oil on panel
18 ⅛ x 13 ½ in. (46 x 34.3 cm)

In 1921, artist and critic André Lhote proclaimed André Derain "the greatest living French painter."[1] The remark indicates the considerable esteem that Derain enjoyed in the years after World War I. Seven monographs and a number of national and international exhibitions, including a 1922 show at Joseph Brummer Gallery in New York, reflected the endorsement of critics, artists, and dealers alike. A strong market proved that collectors followed suit. T. Catesby Jones added two paintings by this recognized modernist master to his collection in 1925, just one year after he began acquiring modern French art. He purchased both of these in New York: *Landscape in Provence* (cat. no. 33) from Pierre Matisse and *Still Life with Flowers* (cat. no. 34) from Fearon Galleries.

34

Derain had come to prominence in the decade before the war as a member of the avant-garde fauve group and then as a painter more strongly oriented toward a broad range of historical precedents, from the art of the Middle Ages to the postimpressionism of Paul Cézanne. Neither of the pictures in the Jones bequest is dated, but both can be plausibly assigned to the years between 1919 and 1925. Both exhibit Derain's commitment to French artistic tradition, and in larger terms they typify an interest in reviving the past, a theme that ran through modern French art in the aftermath of World War I. (Maurice de Vlaminck, Derain's friend and one-time fauve companion, contributed to this trend, as his works in the Jones collection demonstrate.) In *Still Life with Flowers,* both the subject and the lavish brushwork recall the work of impressionist master Pierre-Auguste Renoir. *Landscape in Provence* draws on the precedent of the nineteenth-century landscape sketch. Derain commented on the history and the metaphysics of art in his notes for an unfinished treatise entitled "De Picturae Rerum" (On the Nature of Painting), which he drafted in the late 1910s or early 1920s.[2] "Direct connection between light and movement. Direct connection between light and spirit," he proclaimed.[3] Those connections are strongly suggested in the composition *Landscape in Provence.* Movement, both vigorous and calm, enlivens the painting. The insistent uniformity of Derain's brushstrokes and the blurry forms of the trees characterize the wind's movement. The implied winding path through the distant valleys mirrors the turning road in the foreground. The juxtaposition of these motions, or rhythms, was crucial to Derain. As he expressed in his treatise: "Rhythm in All."[4]

Light, too, assumes an important role in *Landscape in Provence.* It is not simply illusionistic light, since it does not create a strong impression of volume or of depth but rather radiates throughout the scene. Furthermore, it exists as a form itself. Derain's

33

painterly marks, particularly emphatic in the patch of white to the right of the road, suggest a materialization of light — a symbol of his sustained search for and confirmation of the spirit he believed resided in all painting. — ES

from darkness of the mind through objective investigation of nature." Rosanna Warren, "A Metaphysic of Painting: The Notes of André Derain," *Georgia Review* 32, no. 1 (1978), 121.

3. Derain, "The Notes," quoted in Warren, "Metaphysic of Painting," 121–22.

4. Ibid., 130.

Notes

1. André Lhote, article in *La nouvelle revue française* (1921), quoted in Elizabeth Cowling and Jennifer Mundy, *On Classic Ground: Picasso, Léger, de Chirico and the New Classicism* (London: Tate Gallery, 1990), 93.

2. This treatise, also referred to as "The Notes," was neither completed nor published. Contextual evidence, citations of various texts, and citations of Derain in other texts provide the evidence for dating the notes. The title "De Picturae Rerum" refers to Lucretius's poem "De rerum natura," which, as Rosanna Warren notes, "celebrated man's delivery

35
Bather, 1918
Lithograph
24 ¾ x 20 in. (62.8 x 50.8 cm)

37
Reclining Nude, 1929
Oil on canvas
18 ⅜ x 21 ½ in. (46.7 x 54.6 cm)

Raoul Dufy is well known for his scenes of modern social life, landscapes, still lifes, and figure studies. Two striking examples from T. Catesby Jones's collection aptly demonstrate the evolution of Dufy's treatment of the female form. *Bather* (cat. no. 35), a 1918 lithograph that Jones purchased from Jeanne Bucher in 1927, portrays a large female figure, at once classically voluptuous and modern in her bathing costume and cap. Her forceful and sturdy presence dominates what looks like a coastal hill town, the abstracted but architectural shapes in the background suggesting both buildings and boats among waves. Though Dufy initially came into the public eye in 1905 as a member of the fauve group, one of the great French avant-garde movements of the early twentieth century,

reflects Dufy's study of the postimpressionist master Paul Cézanne. Cézanne's influence is conspicuous not only in Dufy's choice of subject but also in the stylization of her form and the geometrical simplification of the background. Dufy's monumental bathers are typically positioned with their legs and shoulders twisted on the vertical axis of the body and seated against a maritime landscape. Such figures appeared in his drawings, paintings, and prints as early as 1909 and into the early 1950s.

The painter André Lhote believed that this bather motif was key to understanding a general tendency in Dufy's art: to camouflage a considerable sense of pictorial rigor beneath a light, sweet, and playful style. Indeed, Lhote described one of the versions of *Bather* in his 1950 history of figure painting: "In effect it is one of Dufy's theories . . . that the better one knows something, the more one must use a light touch in applying it. This *Bather* is almost a birth of Venus. . . . The work is not made heavy by any obvious, strong contrivance, nor by any tedious display of knowledge. The painter has no need for an overt demonstration of his considerable know-how."[1]

By the time he painted the oil *Reclining Nude* (cat. no. 37), Dufy had largely abandoned the strict geometry of the earlier lithograph.[2] Here he softly renders a favorite model, employing the sketchy, outline-style brushwork of his mature works. Between 1928 and 1930, Dufy produced a number of analogous paintings of the nude model lying on crumpled drapery. In this instance the focus is entirely on the figure, but the unmodulated blue of the wall behind her is also a clue to the setting; Dufy used the color to represent the interior of his studio in Paris's Montmartre quarter.[3] This classic motif of the studio model reiterates Lhote's assertion. Whereas the sketchiness of the

35

the pure and exuberant colors of that period are not present in the lithograph. The print does display, however, an equivalent pictorial energy in its strong contrasts of black and white. Perhaps most importantly, *Bather*

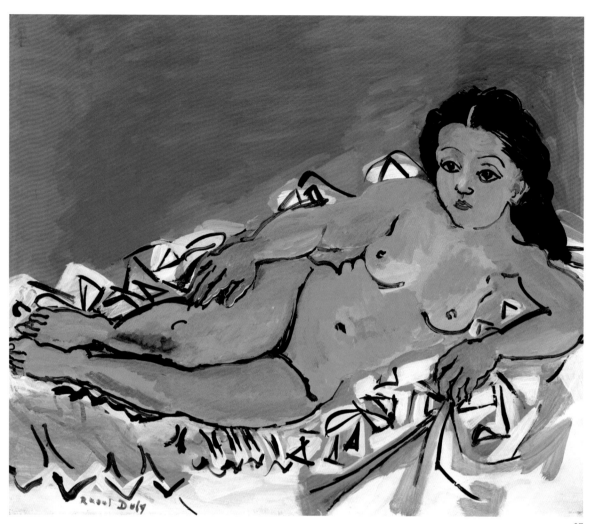

37

figure suggests great simplicity, it is a highly cultivated simplicity that belies not only the artist's pictorial subtlety but also his assiduous study of the history of the nude in art. Dufy's model recalls the entire history of Venus images—Titian's *Venus of Urbino* (1538), the odalisques of the nineteenth-century master J.-A.-D. Ingres, and Édouard Manet's notorious *Olympia* (1863)—and reminds the viewer that the nude is not only a subject of tradition but also a means of innovation in modern art. —RS

Notes

1. André Lhote, *Traité de la figure* (Paris: Librairie Floury, 1950), 249.
2. This work has been published with several dates between 1927 and 1930. The 1929 date, assigned by Maurice Laffaille, is strengthened by the fact that Jones's purchase of the picture was recorded in the dealer's ledger book in January 1930. Maurice Laffaille, *Raoul Dufy: Catalogue de l'oeuvre peint,* III (Geneva: Editions Motte, 1976), cat. 1123; Valentine Dudensing Ledger Books, vol. 2 (January 1926–February 1931), 140, Museum of Modern Art Archives, New York.
3. Dora Perez-Tibi, *Dufy* (New York: Abrams, 1989), 242.

MAX **ERNST**

1891–1976, German

Active in Germany, France,
and United States

From **Natural History** (Histoire
naturelle), Jeanne Bucher,
Paris, 1926
Portfolio of 34 collotype plates after
frottages, 1925
20 ¼ x 13 ½ in. (51.4 x 34.3 cm)

Fig. 17
Plate 1, **The Sea and the Rain**

Fig. 18
Plate 14, **The Chestnut Tree's Take-Off**

Fig. 19
Plate 30, **Escapee**

The publication of *Natural History* was both a turning point in Max Ernst's career and a milestone in early surrealist art. It marks the debut of the technique known as frottage, or the recording of images by laying paper over textured surfaces and rubbing with pencil or charcoal. Although he had experimented with this technique as early as 1921, Ernst dated his discovery of frottage to the summer of 1925 when, gazing at a piece of worn floorboard, he was overcome by a "visual obsession" and began rubbing black lead across sheets of paper placed over the boards.[1]

Ernst's suite of thirty-four images reproduced as collotypes represents a considerable refinement of the basic frottage method. The artist used many different organic source materials, including leaves and pieces of bark, in addition to bits of thread and canvas. The process of transforming natural materials into images of nature produces its own intriguing compositional transformations. Pictorial space is flattened, but at the same time jarring effects of scale can be achieved by setting subjects in relation to spatial markers (ground lines, other figures) without regard to standard perspectival consistency, as Ernst proves. His clever captions lend sometimes humorous and often poetic results, adding yet another level of transformation. The sense of specificity that is tied to the method and materials of the images' production combines suggestively with the timelessness of the portfolio's themes.

Ernst's print portfolio shares its title with Pliny the Elder's ca. 77 AD encyclopedia of the natural world, and indeed, Ernst was much concerned with flora and fauna: many of his paintings of the mid-1920s seem drawn from scientific illustrations, and the almost didactic presentation of the subjects of *Natural History* may have a source in modern ornithological

Fig. 17

and botanical illustrations.[2] Ernst's work, however, is the product of a conscious conflation of fact and fantasy—of the natural order and deviations from it. It is clear that Ernst's *Natural History* ironizes science's attempts to access a purely rational natural order.

Ernst also questioned the notion that the modern artist could have direct creative access to a purely irrational psychic order. "When the surrealists are said to be painters of continually mutable dream reality," he wrote, "this should not be taken to mean that they simply paint their dreams. . . . It means that they move freely, daringly and naturally on the physically and mentally quite real ('surreal'), if still largely undefined frontier between interior and exterior world."[3] The process of traversing this boundary is at the heart of the multilayered transformations at work in *Natural History*.

T. Catesby Jones was likely introduced to the work of Max Ernst by Jeanne Bucher,

who exhibited Ernst's original drawings for *Natural History* in 1926. The published portfolio of the collotype reproductions was only the second work she brought out in her role as a publisher. The acquisition of *Natural History*, the sole work by Ernst that Jones possessed, can be explained by the collector's interest in two aspects of surrealist art: innovation in techniques of representation; and a way of seeing the natural world, from the cosmos to its smallest manifestations, as a rich and imaginative terrain. —MSR

Fig. 18

Notes

1. William Camfield, *Max Ernst: Dada and the Dawn of Surrealism* (New York: Prestel, 1993), 157; Max Ernst, "Beyond Painting," trans. Dorothea Tanning, in *Max Ernst: Beyond Painting* (New York: Wittenborn, Schultz, 1948), 3–8.

2. Charlotte Stokes, "The Scientific Methods of Max Ernst: His Use of Scientific Subjects from *La Nature,*" *Art Bulletin* 62 (September 1980): 453–65.

3. Max Ernst, "What is Surrealism?" (1934), trans. John W. Gabriel, in *Max Ernst, Life and Work: An Autobiographical Collage,* ed. Werner Spies and Julia Drost (London: Thames & Hudson, 2006), 121.

Fig. 19

Of the six works by Juan Gris in Jones's collection, three were bequeathed to the University of Virginia and the Virginia Museum of Fine Arts. A drawing, a collage, and a lithograph, they represent the diversity of the artist's accomplishments. Spanning ten crucial years in Gris's career, they include examples from his cubism of the pre–World War I era to his later engagement with a modernist revival of classicism. These compositions also show the different moods of the artist's work: on the one hand, its complexity, and on the other, its sense of refinement and order.

The 1911 charcoal drawing *Jug and Bottle* (cat. no. 66) is characteristic of the earliest phase of Gris's cubism. While previously published under the title *Abstract,* this drawing is very clearly a preparatory study for the painting *Jug and Bottle* that was rediscovered at auction in 1984 by Douglas Cooper.[1] Long unknown to scholars, the painting is an elegant composition in gray and ocher depicting a glass bottle and an earthenware jug. The drawing exhibits the same fullness of feeling despite its economy of means. Simple forms are illuminated along their contours, which are broken intermittently by shadow. The chiaroscuro effect in the background, which in a more traditional image would help to create a naturalistic representation, here becomes an abstract pattern. Planes are fractured and then rearranged into stable, geometric designs that recall the intersecting planes of a leaded-glass window. Gris balances the formal abstraction of the background with the more representational objects in the center of the composition. Gris's admirers, Gertrude Stein foremost among them, relished the dignity that the artist invested in ordinary kitchenware through such careful depiction. Jones agreed. Referring to Gris's transformative treatment of the motif,

Jones mused, "He has caressed homely things until they have become beautiful things and we forever shall be grateful to him for what he has done."[2]

Gris's interest in still life is reaffirmed in the 1914 collage *Carafe, Glass, and Packet of Tobacco* (cat. no. 67). Here, however, lucidity and legibility of form give way to an arrangement that is dislocated and difficult to read. The work is an intriguing juxtaposition of drawn, painted, and pasted elements, the most legible of which is a glass drawn in the upper left portion of the composition. A second glass object, rendered in charcoal and gouache in prominent lights and darks, has recently

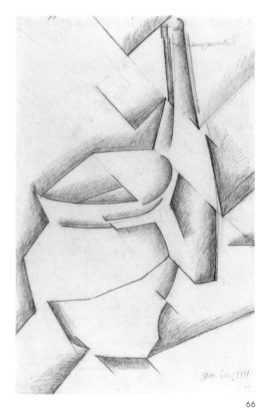

66

been identified as a carafe but may represent a beer mug, as it closely matches the fluted steins in other works by Gris.[3] The packet of tobacco is particularly difficult to decipher. Two adjacent scraps of real tobacco packaging

are affixed to the upper middle area of the collage. The schematic rectangle at the foot of the isometrically projected carafe may represent either the volume of the package separated from its wrapping or a box of matches with a sandpaper edge. The interpretive challenges of this work involve not only identifying individual objects, but determining the composition's overall character.

In complex collages such as this one, Gris created a centrifugal rather than rectilinear arrangement of planes from a basic architecture of various papers pasted concentrically onto the canvas. Thus, rather than forming a grid of prominent verticals and horizontals, contour lines spiral outward. The collage elements are clustered more heavily at the center, giving a feeling of congestion and disarray. Further increasing the complexity here are the multilayered bits of imitation wood grain and striped paper, sometimes painted over but with their textures still discernible. This dense interplay of surfaces obscures the clarity of the individual objects even while enhancing the overall richness of pattern and texture.[4] Gris's use of line, as varied as his choice in materials, provides an additional complication. Black outlines function both to project the silhouettes of objects and, when repeated diagonally across the lower third of the composition, to denote raking light. Drawn passages spill from one fragment of paper onto another, obscuring the coherent identity of each object.

In spring of 1921, Gris made a series of portrait drawings depicting Daniel-Henry Kahnweiler, his longtime dealer and friend; Kahnweiler's wife, Lucie; and other acquaintances. Four of these portraits were published as lithographs by Kahnweiler's Galerie Simon later that year, among them *Brown-Haired Marcelle* (cat. no. 68).[5] This image is indicative

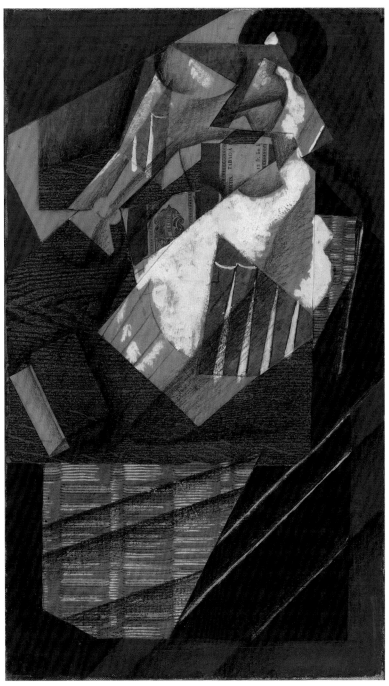

67

of Gris's turn to the more figurative and classical forms of representation that characterized the work of cubist painters in the 1920s, a self-conscious historicism tied to notions of reconstruction and renewal after World War I.[6] Gris compounds those historical allusions in this lithograph, evoking not only the work of J.-A.-D. Ingres, the foremost academic draftsman of nineteenth-century France, but also the hard edges and stylization of antique portrait busts; the sitter's features, printed in emerald green ink on China paper, are treated with lapidary precision. The work is hardly a slavish imitation of past masters, however. It is creative transposition of classic form into a modern medium and needs to be seen as a product of the artist's interest in both the fundamental importance of draftsmanship and an ongoing dialogue with the French tradition. — LFC

68
Brown-Haired Marcelle, 1921
Lithograph
15 ¾ x 12 ¹³/₁₆ in. (40 x 32.6 cm)
Published by Galerie Simon, Paris, 1921

Notes

1. Douglas Cooper, "A Juan Gris Discovery," *Burlington Magazine* 126, no. 971 (February 1984): 91.
2. Gertrude Stein, "Pictures of Juan Gris" (1924), quoted in *Portraits and Prayers* (New York: Random House, 1935), 46; T. Catesby Jones, quoted in Virginia Museum of Fine Arts, *The T. Catesby Jones Collection* (Richmond: Virginia Museum of Fine Arts, 1948), 25.
3. Juan Antonio Gaya-Nuño, *Juan Gris* (Boston: New York Graphic Society, 1975), 247; Gary Tinterow, ed., *Juan Gris* (Madrid: Salas Pablo Ruiz Picasso, 1985), no. 29.
4. This same striated paper reappeared in another work by Gris, *The Newspaper* of 1914, and the same cigarette wrapper is visible in a work entitled *Bottle of Banyuls,* also 1914.
5. A drawing for this print is inscribed in the artist's hand: "To Mlle Marcelle Goyet in friendship Juan Gris." See *Juan Gris: Peintures et dessins, 1887–1927* (Marseille: n.p., 1998), cat. 69.
6. Daniel-Henry Kahnweiler, *Juan Gris: His Life and Work,* trans. Douglas Cooper (New York: Abrams, 1969), 48.

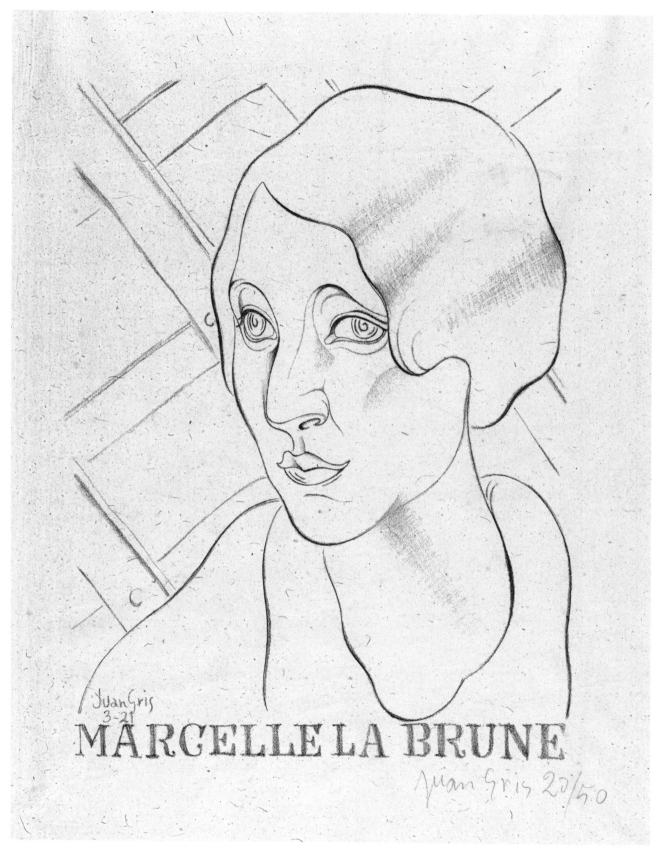

MARCELLE LA BRUNE

MARCEL
GROMAIRE
1892–1971, French

69
Seated Nude, 1925
Etching
16 ⅝ x 13 ¹⁄₁₆ in. (42.3 x 33.1 cm)
Published by Jeaanne Bucher, Paris,
1925

Marcel Gromaire made his public debut when he was only nineteen, showing six paintings at the Paris Salon des Indépendants in 1911. This nascent career was interrupted, however, by six years of military service, and Gromaire would ultimately make his name as a member of the postwar artistic generation. Beginning in the 1920s he developed a considerable international reputation. He had numerous one-artist exhibitions in Paris, and Jeanne Bucher featured him in three group shows, including her gallery's inaugural exhibition of May–June 1925. Valentine Gallery gave Gromaire his first one-artist exhibition in New York in January 1930, and in December 1931, the new Pierre Matisse Gallery, also in New York, exhibited his watercolors as its second show.[1]

Gromaire's favorite topics were modern labor and leisure, scenes of everyday life in the countryside of his native Nord-Pas de Calais region, and female nudes. His style was physical and solid. Without denying the importance of what had been done by great modernist predecessors, namely the postimpressionist Paul Cézanne and the cubist painters, he argued for the necessity of an art that would deal with the world in concrete terms.[2] This principle translated into a socially oriented realism in Gromaire's genre images.

Among the nudes, which make up a vast number of drawings, prints, and paintings, this notion was expressed as a robust sensuality that did not entirely overwhelm a tendency to schematize the body into abstracted component shapes. The style suggested a certain permanence or stable essence beneath exterior appearances. "There are still those imbeciles who believe in chaste nudes," Gromaire wrote in a 1928 journal entry. "At the same time, too many give into the contrary excess and see nothing in the nude apart from easy sexual excitement. The nude is better than that. It is a marvelous incursion of basic forces, the very image of creativity itself."[3]

Seated Nude (cat. no. 69) is an etching after a 1924 ink drawing. It belongs to a 1924–28 series of nudes depicted in interiors with a window onto a landscape. The tangible physicality of the figure is emphasized by the crosshatched shadows and large scale within the compressed space of the room. The image takes its place in Jones's collection alongside compositions depicting nudes in interiors by Dufy, Lurçat, and Matisse. —JT

Notes
1. The best source of information on the artist's career is Marie-Odile Briot, ed., *Marcel Gromaire, 1892–1971* (Paris: Musée d'art moderne de la ville de Paris, 1980).
2. Marcel Gromaire, "L'art, invention du concret" (1934), excerpted in ibid.
3. Marcel Gromaire, *Peinture, 1921–1939,* eds. Marie-Odile Briot and François Gromaire (Paris: Denoël/ Gonthier, 1980), 128.

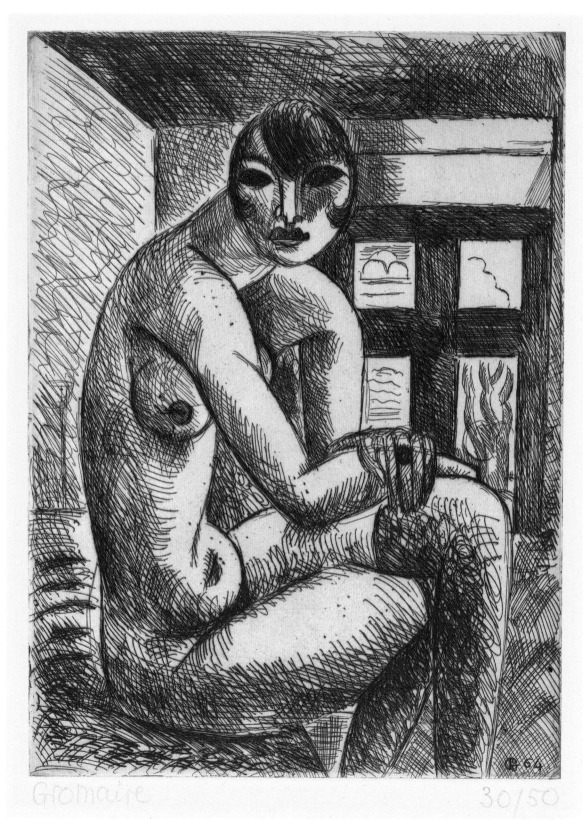

Gromaire 30/50

GROMAIRE 51

STANLEY WILLIAM **HAYTER**

1901–1988, English

Active in England, France, and United States

72
Combat, 1936
Engraving (and scorper), soft-ground etching with texture, and burnisher
21 1/16 x 24 3/16 in. (53.5 x 61.4 cm)

73
Maternity, 1940
Engraving, soft-ground etching with texture, and silkscreen
14 3/4 x 11 7/8 in. (37.5 x 30.2 cm

In fall of 1944, the Grolier Club of New York hosted an exhibition of prints selected from the collection of T. Catesby Jones, one of its members.[1] On October 19, Jones delivered to his fellow bibliophiles and print lovers at the club a lecture entitled "Modern French Prints." In addition to offering a brief history of the School of Paris, he outlined his views on the essential attributes of significant works of art. Chief among these, he said, was the record they provide of the artist's passion for process, meaning a creative involvement with the activity of art making, which Jones believed was as important as the depiction of any particular subject matter.[2]

The same day, English printmaker Stanley William Hayter staged a demonstration of modern printing techniques at the club.[3]

Jones had acquired eight prints by this well-known innovator in engraving and etching. Although the collector's remarks on the importance of process had not specified Hayter, no other artist in Jones's collection better exemplifies those qualities.

To create the impressively large *Combat* (cat. no. 72), arguably one of his greatest prints, Hayter turned to the technique of engraving. The centuries-old practice was Hayter's primary printmaking method during his early career. Engraving, used mainly for reproducing art prints by that time, was diminishing in importance during the photomechanical age.[4] Hayter, however, saw new possibilities and accordingly released the burin line from its merely reproductive function. In place of traditional stiff rows of dots and lozenges,

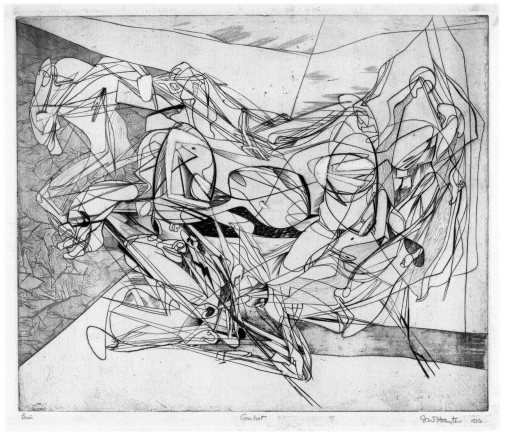

72

the engraved lines in prints such as *Combat* whip vigorously across the paper.

The immediacy and autonomy expressed by these freely moving lines are not inherent properties of engraving, for in practice the technique requires great deliberation and physical force. Hayter's goal, however, was to create a printed image that seemed to have been traced without the limiting control of the conscious mind, an effect the surrealists had achieved through the process known as "automatic drawing."[5] The benefit of this difficult translation, which frequently involved the reworking of the plate over an extended period of time, was the invention of burin lines imbued with incredible force.[6] In Jones's own words, Hayter's gouging and dynamic use of the burin made prints such as *Combat* "aggressive and monumental," "strong and full of power and action."[7]

Though it explores other graphic problems, the color print *Maternity* (cat. no. 73) likewise demonstrates Hayter's interest in expanding the boundaries of printmaking. The first print he made after immigrating to the United States, *Maternity* is Hayter's earliest successful single-plate color printing that remains extant.[8] In Paris during the early 1930s, he had begun to experiment with multicolored printmaking, though these early trials did not produce satisfactory results.[9] His curiosity was piqued again in spring of 1940 while he was teaching at the California School of Fine Arts in San Francisco. With his work space located next to a silkscreen-printing studio,[10] Hayter added this novel technique to his established repertoire, overlaying the tempera colors of the silkscreen with his engraved and etched plate. While he later abandoned this solution for more effective methods, the pursuit of multicolor printing initiated by *Maternity* became Hayter's primary concern after 1945.[11]

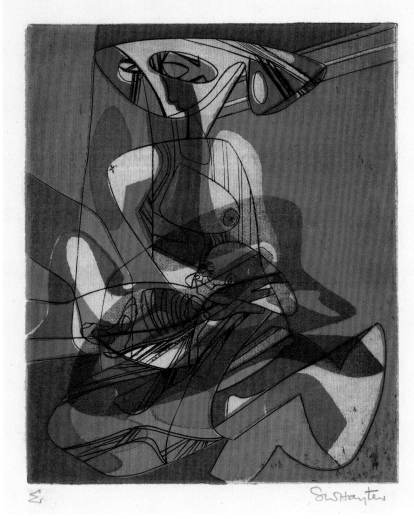

73

74
Composition, 1941
Plaster, carved and impressed with
engraved metal plate; ink; and
water-based paint
12 ¹¹⁄₁₆ x 8 ⅝ in. (32.2 x 21.9 cm)

79
Cronos, 1944
Engraving (and scorper),
soft-ground etching with texture
21 ¹⁄₁₆ x 25 ½ in. (53.5 x 64.7 cm)

Plaster casts of engraved and etched plates, an unusual medium represented in the Jones collection by the 1941 *Composition* (cat. no. 74), in many ways epitomize Hayter's passion for printmaking as a distinct medium. The idea for this curious technique—pouring liquid plaster of paris onto the surface of metal plates and allowing it to set—derived from a brief mention in a nineteenth-century treatise on etching.[12] The method clearly presents Hayter's rejection of the traditional association of the printed line, especially a line engraved using a burin, with painting and drawing.[13] Instead, it highlights the sculptural quality of engraving, since the lines carved into the metal plate by the burin are more visible in the plaster. In his lecture of October 19, 1944, Jones gave special attention to this unique approach. For him, Hayter's "large engravings on plaster" promised an exciting and new way to decorate public spaces.[14]

One of Hayter's most important contributions to modern printmaking was his establishment in 1927 of a Paris studio school known as Atelier 17. He moved the school to New York in 1940 and continued to promote collaborative experimentation in printmaking there. *Cronos* (cat. no. 79) displays nearly all of the graphic developments that sprang from Atelier 17. These include two important techniques that had been revived by Hayter and the school during the 1930s: soft-ground etching, which uses material pressed into a sticky ground to create tonal passages, and *gaufrage*, in which the surface of the plate is carved so deeply that ink cannot adhere, thus creating an embossed area. The print was begun in August 1944, the same month the Museum of Modern Art's bulletin highlighted the seminal exhibition *Hayter and the Atelier 17* (June 27–September 17, 1944), but it was still unfinished when Hayter participated in the Grolier Club meeting of October 1944.[15] During that demonstration, Hayter produced a small engraving that is known as *Grolier*. Jones received two unique proofs of the resultant print (cat. nos. 76 and 77), and like his impression of *Cronos*, both of these sheets bear personal dedications from the artist to the collector, a testament to the friendship that had developed between them. —KEB

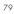

Notes

1. "Modern French Prints," *Gazette of the Grolier Club* 2, no. 4 (June 1945), 110–15.

2. T. Catesby Jones, *Modern French Prints: An Address . . . Delivered on October 19, 1944 at The Grolier Club of New York* (New York: Court Press, 1944), 4–9.

3. Peter Black and Désirée Moorhead, eds. *The Prints of Stanley William Hayter: A Complete Catalogue* (New York: Moyer Bell, 1992), no. 161.

4. Stanley William Hayter, *New Ways of Gravure: Innovative Techniques of Printmaking Taken from the Studio of a Master Craftsman,* rev. ed. (New York: Watson-Guptill, 1981), 195.

5. Hayter, who officially joined the surrealist movement in 1933, referred extensively to the idea of automatic drawing in writing about his compositional processes. In *New Ways of Gravure,* for example, he stated that the "source of the material in *all* my works is unconscious" (132).

6. For his discussion of this process of translation, see Stanley William Hayter, "Of Means," in *Possibilities,* ed. Robert Motherwell (New York, Wittenborn, 1947), 77.

7. Jones, *Modern French Prints,* 38–39.

8. The Greek letter sigma is written on the front of this print. VMFA has used *Sigma* as a title, but we have adopted *Maternity* in conformity with the Hayter catalogue raisonné.

9. Désirée Moorhead, "The Prints of Stanley William Hayter," in *Prints of Stanley William Hayter,* ed. Black and Moorhead, 22.

10. P. M. Hacker, "The Color Prints of Stanley William Hayter," *Tamarind Papers* 14 (1991), 34–35.

11. For further discussion of Hayter's color prints, see Hacker, "Color Prints of Stanley William Hayter," 31–42.

12. Hayter, *New Ways of Gravure,* 126–27.

13. Ibid., 269.

14. Jones, *Modern French Prints,* 39.

15. The plate was begun August 15, with the full edition published after November 10, 1944. See Black and Moorhead, eds., *Prints of Stanley William Hayter,* no. 160. See also *Museum of Modern Art Bulletin* 12, no. 1 (August 1944).

85
Clever Child, 1937
Charcoal and watercolor on
chalk paste–primed ground on
paper on cardboard
22 1/16 x 16 1/16 in. (56 x 40.8 cm)

Clever Child (cat. no. 85) is a portrait of a young girl. Her pale face, with features formed by short, straight strokes of a charcoal line, is framed by blonde curls. The body is a half circle enclosing sharp zigzag lines that schematically suggest limbs. The slightly smiling mouth and relaxed curls give the portrait a light and witty character, and in general the motif is infused with simplicity and straightforwardness. Klee's handling of the media, however, belies this apparent simplicity, even as it bolsters the image's awkwardness, naïveté, and lack of polish. Klee painstakingly applied mixtures of thick paste onto prepared surfaces that included everyday recycled newsprint and wrapping paper to produce a complex image layer.

This portrait exemplifies a characteristic that was essential to Klee's work and to his reputation as a modernist master: associations with notions of the childlike. Throughout his career the artist sustained a fascination with the art of children, regarding it as an example of pure creativity, an art unencumbered by stultifying professional norms. He developed his own formal methods by incorporating such aspects as a lack of three-dimensional modeling, the use of simple lines to represent the essential features of an object, and a disregard for correct proportions. These methods impart a sense of joy and playful activity to *Clever Child,* but their manner of application also demonstrates Klee's distinctive artistic discipline and skill.[1] The format of the portrait also reveals Klee's interest in puppets, masks, and theatrical performance. Its strong masklike quality bears comparison with the hand puppets the artist made for his son Felix between 1916 and 1925.[2]

In addition to *Clever Child,* T. Catesby Jones owned a small watercolor by Klee entitled *The Village Madwoman.* Both were purchased

through Jeanne Bucher.[3] It is clear that the Parisian reception of this Swiss artist was an important factor in Jones's appreciation of his work.[4] Many poets and artists who were part of the surrealist group in Paris greatly admired Klee for his sense of fantasy. André Masson, whose work Jones collected extensively, acknowledged Klee's handling of line as a key to his sense of visual poetry, intuitiveness, and spontaneity.[5] Jones similarly admired Klee's use of a sophisticated repertoire of visual forms. *Clever Child,* he noted, "is a picture of very few lines," but Klee "has presented in those few lines a sophisticated child and has done it in colors which harmonize and stay in our minds. Klee is a poet who deals fancily with us."[6]

Jones's appreciation of Klee also mirrored the artist's reputation in New York. Alfred Barr, director of the Museum of Modern Art, organized a Klee exhibition in 1930, the museum's first one-artist show of a living European artist, and Klee was later seen regularly in important group exhibitions there. Curt Valentin, a dealer with whom Jones had numerous transactions, hosted several large Klee exhibitions at his Buchholz Gallery in the late 1930s and 1940s. Jones lent *Clever Child* to the gallery in November 1944 for its exhibition *The Blue Four: Feininger, Jawlensky, Kandinsky, Paul Klee.* —JT

Notes
1. See "Paul Klee and Children's Art," in *Discovering Child Art: Essays on Childhood, Primitivism and Modernism,* ed. Jonathan Fineberg (Princeton: Princeton University Press, 1998), 95–121; and Josef Helfenstein, "The Issue of Childhood in Klee's Late Work," in ibid., 122–56.
2. Christine Hopfengart, *Paul Klee: Hand Puppets* (Ostfildern: Hatje Cantz, 2006). The author thanks Elizabeth Hutton Turner for her suggestions concerning the interpretation of this image.
3. Virginia Museum of Fine Arts, *The T. Catesby Jones Collection* (Richmond: Virginia Museum of Fine Arts, 1948), 26; Receipt from Galerie Jeanne

85

Bucher, January 31, 1940 (Peggy Brooks, New York). The current whereabouts of the watercolor is unknown. Jones also owned a silkscreen reproduction of an original print by Klee, entitled *A Sensible Man* (1934).

4. In December 1938 *Clever Child* was one of two works by Klee chosen for *Free German Art,* an exhibition organized by members of the German exile community in Paris in response to the infamous *Degenerate Art* show presented by the Nazis in Munich earlier that year.

5. See Ann Temkin, "Klee and the Avant-Garde, 1912–1940," in *Paul Klee,* ed. Carolyn Lanchner (New York: Museum of Modern Art, 1987), 23–25.

6. T. Catesby Jones, quoted in VMFA, *T. Catesby Jones Collection,* 26. See Carolyn Lanchner, "Klee in America," in *Paul Klee,* ed. Lanchner, 83–111; Elizabeth Hutton Turner, "'Our Adopted Ancestor': America's Postwar Embrace of Klee," in *Klee and America,* ed. Josef Helfenstein and Elizabeth Hutton Turner (Ostfildern-Ruit: Hatje Cantz, 2006), 224–37.

MARIE **LAURENCIN**
1885–1956, French

Marie Laurencin's oeuvre is dominated by images of young women, delicately rendered in oil, watercolor, graphite, and lithographic crayon. Even when her trademark soft, pale colors are absent, as they are in the T. Catesby Jones collection lithographs, Laurencin's work is immediately recognizable. In both *Portrait of a Young Girl* (cat. no. 95) and *Juliette* (cat. no. 96), the central figure is enclosed within an area of dark tone that echoes the edges of the sheet. The sitter in *Portrait of a Young Girl* is shown only to the shoulders to emphasize her fine features, which are framed by loose wisps of hair. The figure in *Juliette,* more fancifully clad in a fashionable beribboned hat, appears in nearly three-quarter view at a balcony railing. She turns to address the viewer, hand lifted to her breast. Both figures are recognizable as Laurencin's in the depiction of their facial features: the petite mouth, with lips pursed; exceptionally smooth skin; and exaggerated eyes, always with blackened irises that lend a fantastically doe-eyed appearance.

Laurencin was a prominent figure in the world of modern French art. In the years before World War I, she had a creative and romantic partnership with the poet and art critic Guillaume Apollinaire, then one of the leading supporters of avant-garde art, and she was part of the circle around Pablo Picasso. Two paintings by Laurencin were exhibited in the cubist room at the 1911 Salon des Indépendants in Paris, and she contributed images to the so-called Cubist House at the 1912 Salon d'Automne. Her reputation and her market thrived after the war. In 1930 she was featured in *Vu,* a large-circulation magazine, as one of the three most famous women in France, alongside the novelist Colette and Anna de Noailles, the poet and patron of a famed literary salon in Paris.

Nevertheless, the delicate style and the imagery of adolescent femininity that defined her work also relegated this successful artist to a lesser position in relation to her eminent male counterparts.[1]

95

T. Catesby Jones would certainly have appreciated Laurencin's achievement in the art world of the interwar years and her connections with many of its members. He was drawn to her lithographs, which he saw as responses to the challenge of working with black and white alone. In his 1944 address to the Grolier Club, "Modern French Prints," the collector mentioned Laurencin specifically, noting, "In spite of the tendency of modern critics to regard her as unimportant, you will enjoy the freshness of her lithographs and the fancy which she has packed into them. She has not the power to carry a great theme, but she has the tenderness to deal with delicate things."[2] In addition to lithographs by Laurencin, Jones acquired illustrated books, two of which, Marcel Jouhandeau's

96

Brigitte; ou La belle au bois dormant (1925) and
Jacques de Lacretelle's *Lettres espagnoles* (1926),
he donated to the University of Virginia. —JS

Notes
1. See Gill Perry, *Woman Artists and the Parisian Avant-
 Garde* (Manchester: Manchester University Press,
 1995), 107-15.
2. T. Catesby Jones, *Modern French Prints: An Address . . .
 Delivered on October 19, 1944 at The Grolier Club of
 New York* (New York: Court Press, 1945), 29.

ANDRÉ **LHOTE**
1885–1962, French

100
Expressive Head, ca. 1920–24
Oil on canvas
18 x 14 15/16 in. (45.7 x 37.9 cm)

Expressive Head (cat. no. 100) presents a lively abstract portrait. A young woman is depicted in a dress of brick-red that creates a strong contrast with the composition's predominant earth tones. Tendrils of blonde hair cascade in near-perfect circles to frame her heart-shaped face. With her head cocked, her pointed chin and the sharp line of her nose create a distinct diagonal that cuts across the canvas, almost bisecting it. And yet, despite the evident stylization, this woman's face is decidedly coherent as a modeled form in a relatively three-dimensional pictorial space. *Expressive Head* was one of several works that T. Catesby Jones acquired in his first large purchase of modern French art, at the Salon des Tuileries in Paris in 1924.

The early 1920s witnessed a heated debate on the nature and direction of postwar cubism. Lhote, working as both an art critic and a painter, played a central role. Although he had been associated with the cubist group in exhibitions of 1911 and 1912, Lhote spoke out against the dangers of excessive purism, abstruseness, and inaccessibility in modern art. He demanded a call to order: a return to an earlier style based on the systematic study of nature.[1]

Expressive Head shows that Lhote was interested in not only retrieving what the avant-garde had perhaps rashly swept away, but also giving new life to an old genre. In its composition and title, this portrait recalls the eighteenth-century genre of *tête d'expression* paintings, which artists used to demonstrate their skills in depicting the facial expressions of live models. But in Lhote's time, the same phrase was sometimes attached to the experimental works of modernist painters like Picasso and Matisse. This later use of the term suggested the larger idea that the entire arrangement of a painting, not just the figure, creates its expressivity. So committed was Lhote to the notion of a dialogue with past traditions of figure painting that he eventually wrote a treatise, *Traité de la figure* (1950), that traces the development of depictions of the human form from the Old Masters to the present.[2] — ETB

Notes
1. Christopher Green, *Cubism and Its Enemies: Modern Movements and Reaction in French Art, 1916–1928* (New Haven: Yale University Press, 1987), 9.
2. André Lhote, *Traité de la figure* (Paris: Librarie Floury, 1950).

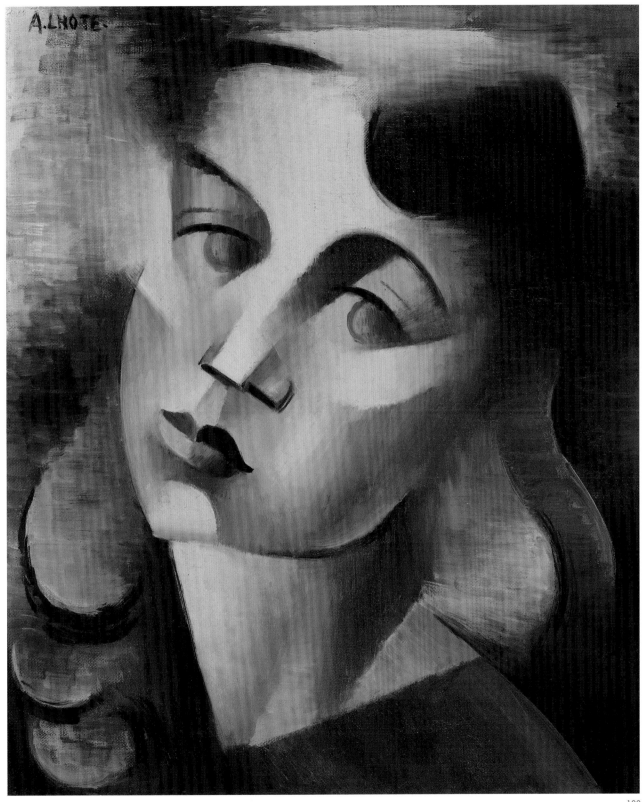

JACQUES **LIPCHITZ**

1891–1973, French

Born Chaim Jacob Lipchitz in Lithuania
Active in France and United States

101
Jacob and the Angel, 1939
Red, white, and black crayon
on green paper
10⅛ x 13 in. (25.7 x 33 cm)

103
Theseus, 1943
Etching, engraving, and aquatint
19¹³⁄₁₆ x 14¹⁵⁄₁₆ in. (50.3 x 38 cm)

T. Catesby Jones first met Jacques Lipchitz in Paris in 1929.[1] As early as 1934, he purchased his first works by the artist: a pair of tabletop bronzes entitled *The Harpist* (1928) and *Pegasus* (1930, fig. 3, p. 1).[2] Both belong to Lipchitz's *Transparents* series (1925–30) of open and flowing sculptures cast in bronze from clay, wax, or plaster constructions. In 1939, Jones acquired another sculpture, *The Harpists* (1930), which eventually became the marker at his grave in Blandford Cemetery, in his hometown of Petersburg, Virginia (figs. 10 and 12, pp. 12 and 14).[3]

The greatest concentration of Lipchitz works in Jones's collection dates from 1939 to 1946, just prior to and during the artist's wartime residence in the United States. These include at least four prints, a bronze portrait of Jones, a chalk drawing, and portfolios containing reproductions of drawings and sculpture by Lipchitz. The drawing *Jacob and the Angel* (cat. no. 101) is a version of the biblical theme that Lipchitz had first adopted in 1931. According to the book of Genesis, Jacob and an angel wrestle to a stalemate, whereupon the angel resigns. In Lipchitz's rendering, the undulating contour lines and dynamic contrast of light and dark convey the force of the contest, and the merging or blending of the figures into a single contoured form adds another degree of intensity. Here, the mortal Jacob seems clearly in control, with the angel in a submissive posture.[4]

After 1930, Lipchitz repeatedly depicted scenes of figures locked in physical struggle. Initially he thought of these as meditations on the sometimes antagonistic qualities of love, but by the middle of the decade his allegories were more pointedly political.[5] Many

101

of Lipchitz's sculptures and drawings deal with mythological subject matter—*Prometheus and the Vulture, Europa and the Bull.* As with his works inspired by the Bible, Lipchitz often transformed the narrative source: these images became allegories of democracy fighting against fascist aggression. In *Theseus* (cat. no. 103), two struggling bodies are locked in combat, partly concealed by strong hatch marks indicating shadow. While it appears that a writhing Minotaur fails to fend off the obscured Theseus, the visual fusion of the two figures complicates the viewer's understanding of the allegory. Lipchitz later stated: "I realized that the monster is also a part of Theseus, as though there were a Hitler in each of us whom we must destroy. Theseus is killing part of himself."[6]

Political events, however, had already precipitated Lipchitz's own flight from France. By early spring of 1940, France's Vichy government had begun instituting anti-Semitic

Portrait Head of T. Catesby Jones,
1941
Bronze
15 ⅝ x 13 ½ x 10 ⅛ in.
(39.7 x 34.3 x 25.7 cm)

102

laws. Lipchitz, a Lithuanian-born Jew, was living in fear. In late May, shortly before the German occupation of Paris, he fled south to Toulouse.[7] Soon after, Varian Fry, an agent of America's Emergency Rescue Committee, contacted Lipchitz from Marseilles and organized his emigration to the United States.[8] The artist arrived in New York in June 1941.

Lipchitz continued producing myth-inspired subjects throughout the war years, but once in New York he added a new theme to his work: "The idea of escape and rescue." He later said of his interest in exile, "I was deeply concerned with the escape of my family and myself but also, I remember that I was frightened about the fate of all my sculptures that I had left behind."[9] However, his dealer Jeanne Bucher took it upon herself to save from Nazi plunder the metal sculptures he had left behind at his home in Boulogne-Billancourt, a suburb of Paris, by removing or burying them in his garden.[10] Lipchitz executed both *Theseus* and *The Road to Exile* (1944, cat. no. 104), another print that Jones acquired, in the studio of Stanley William Hayter, a fellow émigré artist.[11]

On July 4, 1941, less than a month after his arrival in New York, Lipchitz wrote to T. Catesby Jones to thank him for purchasing *12 Drawings for Prometheus* (12 Dessins pour Prométhée, 1940), a portfolio containing an original print and reproductions of drawings on the Prometheus theme. In the same letter, the artist referred to a future project: *Portrait Head of T. Catesby Jones* (cat. no. 102), the first known portrait commission he would execute during his American years. In rendering portrait heads, Lipchitz deviated from the predominant abstraction of his other sculpture, using a refined naturalism to project a strong sense of the sitter's psychological presence. The Jones portrait is no exception.

Lipchitz explained: "I have never believed in the idea of abstract or cubist portraits . . . to me the portrait is rooted in my observation and impression of a specific individual, and, although it is necessary to transform that individual into a work of sculpture, the subject can never be lost sight of."[12] *Portrait Head of T. Catesby Jones* captures the art patron's individuality, while displaying a sense of reserve and stateliness that Louisa Brooke Jones compared, perhaps with a hint of humor, to an imperial Roman portrait head.[13] —CCO

Notes

1. Louisa Brooke Jones to William Gaines, questionnaire, February 2, 1965, curatorial files, Virginia Museum of Fine Arts.
2. *The Harpist* is reproduced in Alan G. Wilkinson, *The Sculpture of Jacques Lipchitz: A Catalogue Raisonné,* vol. 1, *The Paris Years, 1910–1940* (New York: Thames & Hudson, 1996), no. 216; *Pegasus* is published in vol. 2, *The American Years, 1941–1973,* no. 244a, as *Pierrot on Horseback.*
3. Receipt from Galerie Jeanne Bucher, January 1, 1940 (Peggy Brooks, New York).
4. This drawing has been published with the title *The Wrestlers* in Virginia Museum of Fine Arts, *The T. Catesby Jones Collection* (Richmond: Virginia Museum of Fine Arts, 1948), cat. 39. We have adopted the title that was assigned in the aritst's autobiography, *Jacques Lipchitz, My Life in Sculpture,* with H. H. Arnason (New York: Viking, 1972), fig. 129.
5. Lipchitz with Arnason, *My Life in Sculpture,* 100.
6. Ibid., 159.
7. Ibid., 140; Irene Patai, *Encounters: The Life of Jacques Lipchitz* (New York: Funk & Wagnalls, 1961), 291.
8. Patai, *Encounters,* 302.
9. Lipchitz with Arnason, *My Life in Sculpture,* 144.
10. Patai, *Encounters,* 295.
11. "New Directions in Gravure," *Museum of Modern Art Bulletin* 12, no. 1 (August 1944): 14.
12. Lipchitz with Arnason, *My Life in Sculpture,* 10.
13. Louisa Brooke Jones to Gaines, February 2, 1965. For a useful discussion of Lipchitz's heads, see Blandine Chavanne, "Berthe, Jean, Coco et les autres," in *Jacques Lipchitz, collections du Centre Pompidou, Musée national d'art moderne et du Musée des beaux-arts de Nancy,* ed. Brigitte Léal (Nancy: Ville de Nancy, 2004), 36–45.

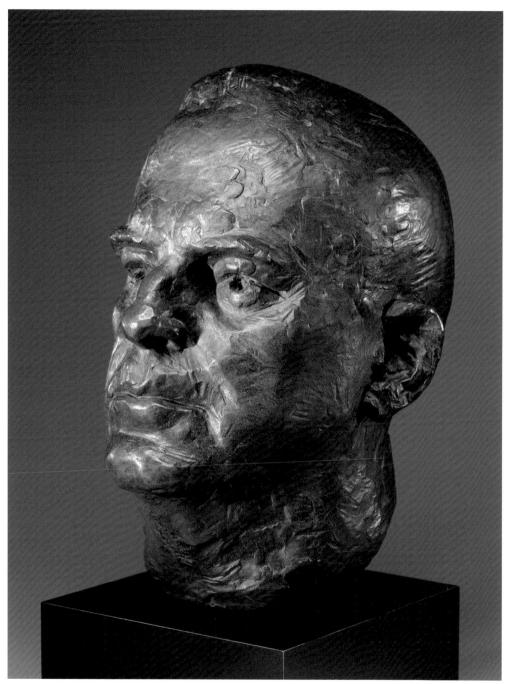

102

105
Reclining Nude, 1919
Gouache on paper
24 ½ x 18 ¾ in. (62.2 x 47.6 cm)

106
Interior with Table, 1922
Gouache on paper
14 ¾ x 17 ⅞ in. (37.5 x 45.4 cm)

T. Catesby Jones had an exceptional interest in the work of Jean Lurçat. The men sustained a strong friendship through two decades, and by the end of Jones's life he would amass the single largest collection in the United States of Lurçat's art. The works include examples from nearly every phase of the artist's career between 1919 and 1945.

Jones first encountered Lurçat through Jeanne Bucher, who exhibited his work often at her Montparnasse gallery. The collector acquired his first two or three compositions by Lurçat during his 1927 trip to Paris. One of these, the gouache *Reclining Nude* (cat. no.

105), bears an inscription indicating that it may have been a gift from Bucher herself. Like other early works, it shows Lurçat trying out styles then current in Paris. There are hints of Matisse, for example, in the arabesque pattern of ironwork at lower right and in the rich coloring. In *Interior with Table* (cat. no. 106) Lurçat displays an artful naïveté in a simplistic laying out of objects on a table and in the stiff illusionism that defines the space of the room. The spare still life set in a boxlike space that recedes to a calm sky recalls interiors painted by Picasso a few years earlier, in 1918 and 1919.

105

LURÇAT 67

108

108
Algerian Woman, 1925
Gouache on paper
20 ⅞ x 14 ¾ in. (53 x 37.5 cm)

107
Tour Eiffel, 1925
Drypoint
18 ½ x 15 ¹/₁₆ in. (47 x 38.3 cm)

109
Smyrna, ca. 1927
Color lithograph
17 ⁷/₁₆ x 22 ⅝ in. (44.3 x 57.4 cm)

120
Wind and Blue Sky, 1930
Oil on canvas
39 ⅞ x 23 ¼ in. (101.3 x 59 cm)

107

In 1924 and 1926 Lurçat traveled extensively in the Mediterranean regions of Algeria, Yugoslavia, and Turkey.[1] There he found subject matter that matched and amplified his interest in strongly colored and highly decorative form. In the 1925 gouache *Algerian Woman* (cat. no. 108) Lurçat updates the traditions of French orientalist painting, which is another indication of his interest in Matisse.

During the same years, Lurçat also produced works in a very different mood. Although he did not identify himself as a surrealist, these works have a strongly poetic emphasis and a dreamlike feeling, as demonstrated in *Tour Eiffel* (cat. no. 107). The print portrays a gigantic female dancer beside the Eiffel Tower. She holds a candle and places a large bird atop the structure. An enigmatic text running up the tower itself begins with the phrase, "Effel tour, Eglise ombilic, Baveuse d'ondes" (Eiffel Tower, Umbilical Church, Spewer of Waves). The idea of writing a message on the vertical axis was timely, for in the same year, the name of the automobile maker Citroën went up in lights on three sides of the tower. Lurçat's inscription also reflects his conception of Paris as a symbol of modernity, for "Effel tour" is an intentional anglicization of the proper French "Tour Eiffel." This type of wordplay was then much in vogue in France as a kind of internationalist, contemporary argot. Furthermore, the phrase "Eglise ombilic" suggests the familiar metaphor of the tower as a modern cathedral celebrating scientific advancement, industrialism, and human ingenuity, while "Baveuse d'ondes" alludes to the large radio antenna at the top of the tower, literally spewing out messages over the air.

Smyrna (cat. no. 109), a lithograph after a 1927 canvas, and the 1930 painting *Wind and Blue Sky* (cat. no. 120) represent Lurçat

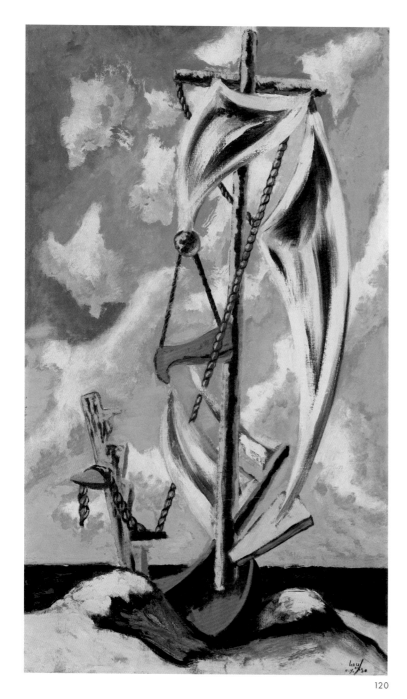

120

109

at the peak of his early renown. Reviewers praised Lurçat's depopulated, mysterious, and exotic landscapes for their balance of decorative subtlety and ethereal poetry. *Smyrna* conveys an atmosphere of quiet desolation; the simple, angular forms of the walls create an ambiguous space with no specific cultural markers, even though the title refers to the ancient Greek ruins at Smyrna in western Turkey.[2] *Wind and Blue Sky* includes several poignant indications of an earlier human presence—the boat, mast, and torn sail. The cruciform wooden poles suggest the sacrifice and pathos of a crucifixion. The precise narrative of the scene, however, remains elusive.

Although Lurçat achieved acclaim in various media, he is usually remembered as a master of the modern tapestry, his focus after World War II. Jones owned several examples of his work in textiles, including the 1928 *Needlepoint Screen* (cat. no. 114). The three connected panels fold like a dressing screen, but since it is finished on only one side, its function is primarily for display. As in medieval and Renaissance tapestries, the color palette is reduced to a relatively small number of bold tones. *Needlepoint Screen* also updates historical motifs, especially medieval ones, with a modern style and design sensibility. In the central panel, a mermaid emerges from the sea, holding a fish in her left hand. A spinelike vine of colored leaves runs up her torso, and she appears translucent, like a jellyfish. Uniformly undulating waves of brown and beige occupy much of the middle panel, representing the sea. The ocean floor is littered with rocks and shells, and the air above is indicated by

jagged lines running through areas of deep purple and maroon. On the side panels, eight amoebalike pods containing fantastical beasts sit on a background of variegated, marbled color, intensifying near the bottom to indicate rock formations, where a single plant grows. Lurçat's animals hearken back to the beasts of medieval marginalia and other art; their arrangement in separate cells evokes a type of structured medieval bestiary. And yet, those same cells have a modern inflection, suggesting views through a microscope. The conflation of medieval and modern zoology mirrors the merging of past and present.

The oil entitled *Bathers* (cat. no. 136) signals Lurçat's return to the human figure, which he saw as a social subject with a foundation in a shared human reality. With strong antifascist and communist sympathies, Lurçat argued vehemently that modern artists should orient their work more directly toward a collective humanity.[3]

136

LURÇAT 71

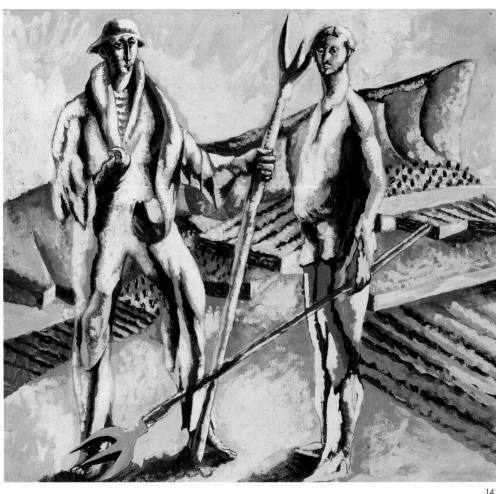

142

142
Two Fishermen, 1938
Gouache on paper
15 ³⁄₈ x 16 ½ in. (39 x 41.9 cm)

146
The Ruins (Les décombres), 1945
Gouache on paper
9 ⁵⁄₈ x 12 ⁷⁄₈ in. (24.4 x 32.7 cm)

Thus, while his images of the previous decade had only alluded to human presence, a painting like *Two Fishermen* (cat. no. 142) commemorates men who are identified as laborers by their clothing and the implements they carry. Offset by the contrasting diagonal lines of the furrowed fields behind them, they appear monumental, like statues, but their outward gaze gives them a sense of psychological directness.

Jones's collection of works by Lurçat ended as it began, with a gift — this time from the artist himself. *The Ruins* (cat. no. 146) is Lurçat's response to the ravages of fascism and war in France.[4] A black sun scorches a barren landscape, with ruins visible in the background. The foreground is

dominated by two chairs, one upturned and resting atop the other. A piece of paper in the lower left corner and the book that rests on the upturned chair bear the titles of two notorious anti-Semitic and antidemocratic pamphlets of the period, *Bagatelles pour un massacre* (1938) by Louis-Ferdinand Céline and *Les décombres* (The Ruins, 1945) by Lucien Rebatet. Lurçat was an outspoken member of the Communist Party and served with Spanish Republican forces in the Spanish Civil War and with the French Resistance during the German occupation. The political implication of his meditation on devastation would have been clear to his contemporaries.

Jones, a conservative Southern Democrat, appreciated Lurçat as a French patriot and

maintained his interest in the artist to the end of his own life in 1946. When the Virginia Museum of Fine Arts solicited a statement for publication in its 1948 exhibition of the Jones collection, Lurçat sent the following appreciation: "I cannot express how strongly I feel that a closer understanding between the American and French peoples has been brought about by the perception of such a man as Catesby Jones."[5] —CCO

Notes

1. Gérard Denizeau and Simone Lurçat, *L'oeuvre peint de Jean Lurçat, catalogue raisonné, 1910–1965* (Lausanne: Acatos, 1998) is the most authoritative text on Lurçat's paintings. The author thanks Gérard Denizeau for his guidance in the interpretation of several works discussed in this entry.

2. Several of his landscapes from those years are designated by their titles as scenes of the ancient city of Smyrna, known by then as Izmir. Fighting between Greek and Turkish forces in 1922 had devastated Izmir. It is not clear that Lurçat intended a commentary on those modern events, for in addition to the invocation of the city's old name, the configuration of buildings is an invention or synthesis of ancient sites in the Aegean and Mediterranean regions rather than an accurate landscape depiction. Lurçat would not make images directly commenting on world conflicts prior to the Spanish Civil War and World War II.

3. Jean Lurçat, "Whither Painting," *Art Front* 2, no. 11 (December 1936): 7.

4. Virginia Museum of Fine Arts, *The T. Catesby Jones Collection* (Richmond: Virginia Museum of Fine Arts, 1948), 31.

5. "Extract from a Letter from Jean Lurçat to Mr. Graham Tucker, Dated December 24, 1947," quoted in VMFA, *T. Catesby Jones Collection*, 4.

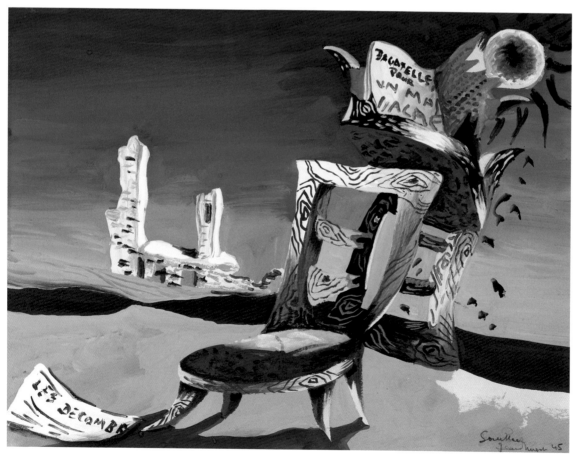

146

ARISTIDE **MAILLOL**
1861–1944, French

147
Nude, ca. 1920–44
Black and white chalk on paper,
handmade by artist
12 ¾ x 8 ⅜ in. (32.4 x 21.3 cm)

By 1920, Aristide Maillol was widely regarded as France's foremost sculptor. His name had become synonymous with drawn and sculpted female nudes, a subject of interest to artists since antiquity. Maillol did not abandon the classical, yet he did stray from certain aspects of its figural idealism. His nudes, for instance, were often bulky and inelegant in pose, departing from the compactness that characterizes much classical nude statuary. Maillol's taste, furthermore, was eclectic. The artist drew inspiration from a range of sources, including archaic Greek sculpture and medieval tapestry, in creating a vision of the female form that was at once idealized and idiosyncratic. Even in a genre as traditional as the female nude, Maillol's eclecticism constitutes the modernity of his outlook.

Although undated, this black and white chalk drawing of a seated female nude (cat. no. 147) can be assigned to the years of Maillol's artistic maturity, between 1920 and 1944. It demonstrates his predilection for balancing not only the old and the new but also the naturalistic and the abstract. The work's format recalls that of a traditional academic nude study, and Malliol used modeling in the conventional way to lend the illusion of solidity and roundness. At the same time, he abandons certain academic notions of correctness in the depiction of the human body to present the figure enclosed in an oval shape. The apparent asymmetry of the thighs can be explained by the model's pose: her legs are parted with her left leg held more tightly against the body. The folds of flesh at the midsection reinforce a sense of physical compression such that her limbs appear flush with the page. This handling makes the subject appear at once flat and volumetric. And though the figure casts a shadow, again emphasizing the illusion of weight and volume, it floats toward the upper left section of the page unanchored to any fixed ground line. The ambiguity of the surrounding space emphasizes the figure's abstraction. This simplification of forms, including the knitting together of empty spaces between limbs to form basic geometric shapes, is also characteristic of Maillol's sculpture.

Commentators have usually recognized two different types of drawings by Maillol. The first category includes drawings sketched from life, which tend to be relatively large in scale and, regardless of their level of finish, were meant as faithful copies of the particulars of each model. The second category comprises works of a more synthetic quality, executed from Maillol's imagination. These often functioned as trial designs for sculptures. Given its departure from literal correctness and its resemblance to the many sculptures that Maillol executed of seated figures with legs crossed, this drawing most likely falls into the second type of Maillol's graphic output.
—LFC

147

LOUIS
MARCOUSSIS
1883–1941, French

Born Ludwig Casimir
Ladislas Markus in Poland
Active in France

150
Viareggio (La dépêche de Toulouse),
1926
Drypoint
19 ½ x 12 ¹⁵⁄₁₆ in. (49.5 x 32.9 cm)
Published by Jeanne Bucher, Paris,
1926

151
The Lighthouse, ca. 1926
Gouache on paper
14 ⅞ x 11 ¾ in. (37.8 x 29.8 cm)

The prominent place that Louis Marcoussis occupied in Jeanne Bucher's stable of artists would have surely recommended him to T. Catesby Jones, whose tastes were frequently guided by this Left Bank entrepreneur. She regularly featured works by the Polish expatriate in exhibitions, beginning with her first show, in 1925.[1] She also funded several of his large-scale experiments in etching and engraving, including the illustrated portfolios *Signpost of the Roads of the Heart* (Indicateur des chemins de coeur, 1928) and *Plates of Salvation* (Planches de salut, 1931). Jones possessed deluxe versions of both.

The earliest of Jones's Marcoussis works is a 1926 drypoint with the title *Viareggio (La dépêche de Toulouse)* (cat. no. 150), which combines the names of an Italian city and a daily newspaper of Toulouse, France. The composition features an assortment of objects organized in front of an ambiguously defined window. The sardine, lemon, and pitcher are traditional still-life motifs; but there is also a clear note of modernity. Marcoussis layers his objects on a newspaper printed with a bold but fragmented headline, strongly recalling the cubism of the years prior to World War I. *Viareggio* also revives certain cubist pictorial devices of the early 1910s, including the double reading of a single form, best showcased in the transformation from newsprint to scaly fish belly at the center of the composition.

Once a part of Bucher's own collection, the undated gouache drawing *The Lighthouse* (cat. no. 151) was purchased by Jones in July 1927.[2] The gouache bears comparison with a 1926 painting by Marcoussis entitled *Toulon* (location unknown), which was executed in the technique of *sous verre,* or painting "under glass." Marcoussis had taken up this ancient practice in 1919.[3] The technique involves painting on the reverse side of a piece of glass, producing colors of particular intensity and reflective quality as well as a dramatic flattening of the composition. All of these characteristics would have appealed greatly to Marcoussis, for they were well suited to his colorful approach to cubism. But *sous verre* is a notoriously unforgiving medium, and for this reason Marcoussis routinely produced gouache studies for works of this type.[4] The striking compositional similarities between *Toulon* and Jones's *Lighthouse* suggest that the gouache may be a direct study for the painting and thus bolster a claim for dating the gouache to ca. 1926.

150

Though the Marcoussis works that Jones acquired vary widely in medium, all are still-life compositions that depict familiar things in vivid and perplexing ways. One object that Marcoussis used repeatedly was the *pain Breton,* a traditional bread from Brittany recognizable by its elongated shape and deep parallel slashes. Marcoussis first introduced this motif after a trip to the region in 1929, and the Breton bread appears in both the oil

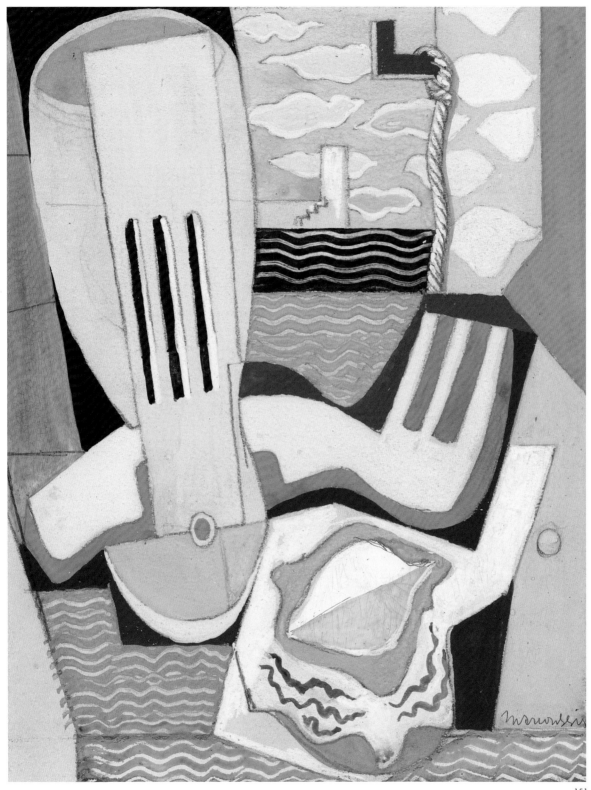

MARCOUSSIS 77

painting *Interior (Pedestal Table with Breton Bread, Balcony)* (cat. no. 152), dated ca. 1929–30, and *The Table* (cat. no. 153), a color etching published by Bucher in 1930.[5] In *Interior,* the bread remains as such, a stable

152

sign for one object. Depicted with ambiguous shadows in *The Table,* however, the bread's form becomes more enigmatic.

Visual ambiguity, which extends to the mysterious light suffusing his works, was a key principle in Marcoussis's art; it generates his visual lyricism by creating a sense of representational poetry and an intense delight in the beauty of the simplest objects. Christened the "darling of the poets" by surrealist writer Paul Éluard, Marcoussis was also known for his close relationships with various other contemporary writers, such as Guillaume Apollinaire and Max Jacob.[6] Jones purchased

portfolios that speak to this close rapport between Marcoussis's visual art and poetry. *Plates of Salvation,* for example, contains a series of ten etchings designed to complement brief passages from Marcoussis's favorite literary figures. In addition, a 1926 poem dedicated to the artist by his good friend Jean Lurçat, one of Jones's favorite artists, captures in verse the visual component of Marcoussis's lyrical approach, especially through its allusions to the ambiguities that pepper his work. Lurçat's panegyric transposes the shifting forms of compositions like *Viareggio* into text. Although not directly connected to this particular image, Lurçat's words highlight the poetic in Marcoussis's art:

> The sky full of stars
> Fish tattooed with stars, full of stars,
> everywhere, eyes, teeth, scales, ballooned
> bellies.[7]

—KEB

Notes
1. This exhibition was organized by Bucher and held at Boutique Pierre Chareau in May and June 1925. *Jeanne Bucher, une galerie d'avant-garde, 1925–1946,* ed. Christian Derouet (Geneva: Skira, 1994), 41.
2. Receipt from Galerie Jeanne Bucher, July 26, 1927 (Peggy Brooks, New York).
3. Jean Lafranchis, *Marcoussis; sa vie, son œuvre, catalogue complet des peintures, fixés sur verre, aquarelles, dessins, gravures* (Paris: Éditions du temps, 1961), 84.
4. Ibid.
5. Ibid., 132–34.
6. This quote is from Paul Éluard's personal dedication to the artist in Marcoussis's copy of Éluard, *Donner à voir* (Paris: Gallimard, 1939), in facsimile in Lafranchis, *Marcoussis,* n.p.
7. Jean Lurçat, untitled poem reprinted in *L'art d'aujourd'hui,* (Autumn, 1926), reprinted in Lafranchis, *Marcoussis,* n.p.

4/20 marcoussis

MARCOUSSIS 79

ANDRÉ **MASSON**

1896–1987, French

Active in France and United States

154
Man and Woman, ca. 1925–30
Oil on canvas
21¾ x 13⅜ in. (55.2 x 33.9 cm)

155
Abstract, ca. 1925–30
Watercolor
24½ x 18⅛ in. (62.2 x 46 cm)

T. Catesby Jones exhibited restrained enthusiasm for surrealism in his 1944 lecture "Modern French Prints," calling the work of some of its adherents "oppressively introspective and Freudian." He objected that they "close[d] all doors of inspiration except that of the subconscious" and often resorted to sexual ideas "in an effort to avoid dullness."[1] Jones nevertheless greatly admired the work of those surrealists who he believed had been able to break through such limitations. One of these was the painter André Masson. With works dating from the late 1920s to the 1940s, including four paintings, twelve prints, and numerous books, Masson figures prominently in Jones's collection. Many of his major themes are represented, as are a number of important stages in his artistic development.

Two of these Masson works, undated but probably belonging to the later 1920s, take up the surrealist theme of sexuality, but without resorting to what Jones would have seen as illustrative or overtly provocative methods. The two figures in the oil painting *Man and Woman* (cat. no. 154) stand for the cosmic dualities—life and death, rationality and irrationality—that Masson believed drive the mental life of humans.[2] But in this work the human body is first and foremost the pretext for an experiment in picture making; the figures are only partly differentiated within the composition's hurried and tangled lines and areas of thickly worked paint.

The result brings to mind one of Masson's signature techniques, the use of scattered areas of glue and sand as the basis for painted compositions. In larger terms, it recalls his interest in fostering the consequences of spontaneity and chance. Such effects, called "automatic" by the surrealists, were used to liberate the image from the demands of

155

imitation, the historical task of painting, in order to approach the unseen, the imagined, and the transitory. "Here a prisoner escaped from Plato's Cave," wrote Masson. "I shall no longer be subject to his condemnation of imitated reality. I would only be a point of intersection, a magnetic needle, a medium."[3]

Abstract (cat. no. 155) takes up a similar motif, but here the watercolor medium stresses both a subtle transparency of color and the calligraphic fluency of line.[4] Though the two figures in the painting are more distinct than those in *Man and Woman,* they are linked by one undulant blue line that represents sky and sea. The man's exposed heart doubles as the bloody pomegranate, Masson's emblem of war and death, but the violent treatment of sexuality that is so often present in his painting is here subdued and made subordinate to a relatively spare set of compositional relationships.

154

A large pastel drawing presents a second important theme in Masson's work of this period: the idea of metamorphosis. The subject or subjects of *Metamorphoses* (cat. no. 156) are difficult to discern, indicated as they are by the few curved lines that comprise the image. The transformative action of metamorphosis is represented by the artist's refusal to produce closed or isolated forms. Images of fish and other animals are suggested, but they never fully appear. Although Masson's interest in the mutability of plant, animal, and human forms was rooted in Ovidian lore and the myth of Narcissus, he presents change not only as transformation, or the placement of

calligraphic freedom he created a picture which has every quality which made the Chinese painting of the Sung period beautiful."[7]

Anatomy of My Universe, Masson's autobiography and artistic manifesto of 1943, had an impact on Jones's interpretation of his art, and Jones drew upon it while drafting his 1946 article. The two large parts of the book—the first concerned with biological themes and the second with signs, myths, and culture—are separated by an "intermezzo" that takes the form of a single image: a reproduction of Masson's 1938 ink drawing *Dream of a Future Desert*.[8] The image in the Jones collection is a 1942 print after that

156

Metamorphoses, 1929
Pastel on prepared paper
21 ³⁄₈ x 42 ¹¹⁄₁₆ in. (54.3 x 108.4 cm)

158

Dream of a Future Desert, 1942
Etching with drypoint
20 ¹⁄₁₆ x 25 ⁹⁄₁₆ in. (50.9 x 64.9 cm)
Published by Buchholz Gallery,
Curt Valentin, New York, 1942

156

humans and animals in a state of flux, but also as fragmentation, violence, and combat.[5]

Jones valued the agonistic dimension of Masson's art. As he explained in a 1946 article, Masson's work was "thoroughly indicative of our modern world—tortured, dramatic, and tragic."[6] But Jones also admired Masson for his ability to balance brutal content with a sense of formal beauty. *Metamorphoses* conveyed a "power to express creation in its most lovable form . . . where with remarkable

drawing (cat. no. 158). Masson's description of the composition follows the book's general emphasis on the animistic basis of the natural world:

An ocean of sulfur mounts the somber earth. In the meadow the weeds are signs of fire. The forest bursts into geysers of sap. The incandescent rocks are diamonds of the hour. The furious gallop of the Saturnal wind changes a tomb into a

sheaf of dust. A vomit of lead undulates on the terrace of temples, covers up the earth, glides to the dead volcano, to the dried up river. On the horizon a black sun oscillates for the last time; an eye veiled by the scythe which destroys the landscape of the world's end.[9]

158

In this apocalyptic vision Masson destroys the labyrinths and other mythical structures that had informed his early work. *Dream of a Future Desert* conveys not only an inner turmoil but the anxious atmosphere of Europe in the later 1930s. It is the most overtly political work by Masson in the Jones collections, sometimes read as an allegory of the Spanish Civil War and the rise of fascism in Europe.[10]

But in addition to its historical pertinence, *Dream of a Future Desert* is a visualization of the irrational "wasteland of infinite desolation," through which Masson believed the artist's own reason must pass.[11] For both Masson and Jones, then, the work was also an allegory of the artist's self-liberation from the shackles of realism.

Anatomy of My Universe also provides many clues for understanding the affinity Jones felt for Masson's work, which he saw as compatible with his own aesthetic sensibility. In the text, Masson identifies himself with two figures of Italian Renaissance humanism, Pico de la Mirandola and Leonardo da Vinci, a comparison that Jones repeated in his article. Such an unexpected alliance presumably fit well with Jones's humanist understanding of Masson as an artist who traversed, and thus overcame, the annihilating effects of modernity.[12]

Masson left France for the United States in 1941. It was around that time that Jones began a correspondence with the artist that touched on their shared concern for the plight of Paris under the German occupation.[13] Jones eventually acquired eight works that date from this American period, which would last until 1947. One of those is a painting, also entitled *Metamorphoses* (1941, cat. no. 157), that builds on Masson's familiar themes and materials even though its closed forms and clean lines suggest a more methodical approach.

Despite such continuities, Masson's American period was marked by two important thematic shifts: an emphasis on portraiture and a fascination with the natural environs of the American Northeast where he resided. The Jones collections feature works of both types. An example of the former is the lithographic portrait of writer Georges Duthuit (cat. no. 161), which was initially included in deluxe editions of Duthuit's long poem *Le serpent dans la galère* (1945) concerning the occupation and liberation of Paris.[14] The tightly framed face in the portrait affects a psychological intensity that is shared by other prints in the Jones collections, such as *The Misanthrope* (1945, cat. no. 162).

In *Improvisation* (cat. no. 164) large areas of medium gray contrast with the thinly engraved lines defining the mouth and eyes. The layered appearance of the drawing causes these features to fluctuate between foreground and background.[15] Such layering also allows birds, flames, and a second face to emerge slowly from the image, drawing attention to the parallels between the production process and subject matter. "I admired the fraternity of the natural kingdoms" and unforeseen "correspondences," wrote Masson, "the grating of torn silk is like the cry of the knife in the bark of the oak."[16] This statement evokes the pictorial effects produced by a combination of techniques that allowed the textures of fabrics and other surfaces to merge with a depicted image. These experimental processes were used at Atelier 17, the printmaking studio overseen by another of Jones's favorite artists, Stanley William Hayter, with whom Masson maintained a loose association.[17]

For Jones, Masson was exceptional among the surrealists for his attention to technical innovation, to craft, and to "relationship." The latter was Jones's word for mechanisms of visual composition, which he regarded as universally expressive, in contradistinction to literal subject matter, which was always specific and therefore limited. In her monograph on Masson, Dawn Ades relates the story of a visitor to the artist's American studio who was scandalized to find him sketching plants.[18] This activity seemed antithetical to the surrealist allegiance to the free psychic flow of inner thought. During his years in America, however, Masson expanded his particular brand of surrealism to include the premeditated and composed as well as the purely imaginary. Masson himself referred to these paintings as telluric, a term that underscored their origin in terrestrial motifs.

Such earthbound painting was part of a new, restorative vision of nature that supplanted the violence of Masson's European paintings. "It may be," wrote Jones, "that Masson turns to human models and to natural objects, like his sons or the leaves and flowers of the lithographs, so as to bring the dreams that have dominated him back to earth and like Antaeus to quicken his imagination with renewed strength."[19] This reference to the mythological figure who drew his great

161

strength from constant contact with the earth repeats the metaphors of control and groundedness at work in Jones's earlier reference to calligraphy. Jones thus ends his 1946 essay with a curiously optimistic adaptation of surrealism, one that paralleled the obsession with triumphant consciousness that characterized contemporary American criticism of New York painting at the same moment.[20] —MSR

Notes

1. T. Catesby Jones, *Modern French Prints: An Address . . . Delivered on October 19, 1944 at The Grolier Club of New York* (New York: Court Press, 1944), 12–13.

2. The ca. 1937–39 inventory of the Jones collection lists an oil painting entitled *Adam and Eve,* though no corroborating evidence links this title to *Man and Woman.* Inventory of the T. Catesby Jones Collection, Early Museum History: Administrative Records, IV, 23, Museum of Modern Art Archives, New York.

3. André Masson, *Anatomy of My Universe.* (New York: Curt Valentin, 1943), prologue, section IV.

4. *Abstract* and *Man and Woman* bear a strong resemblance to *Figure* (1926/1927, Museum of Modern Art, New York), as well as to Masson's drawings for Marcel Jouhandeau, *Ximenès Malinjoude* (Paris: Éditions de la Galerie Simon, 1927).

5. Whitney Chadwick, *Myth in Surrealist Painting, 1929–1939* (Ann Arbor: UMI Research Press, 1980), 35–36.

6. T. Catesby Jones, "André Masson: A Comment," *Kenyon Review* 8, no. 2 (Spring 1946): 226.

7. Ibid.

8. See William Rubin and Carolyn Lanchner, *André Masson* (New York: Museum of Modern Art, 1976), 158.

9. Masson, *Anatomy of My Universe,* n.p.

10. Rubin and Lanchner, *André Masson,* 157.

11. Masson, *Anatomy of My Universe,* prologue, section IV. Also quoted by Jones in "André Masson: A Comment," 228.

12. This reading is indicative of a prevailing American view of the artist in the 1940s. See, for example, Clement Greenberg, "Present Prospects of American Painting and Sculpture," *Horizon* 16 (October 1947): 20–30.

13. See, for example, Masson to Jones, November 20, 1941, curatorial files, Virginia Museum of Fine Arts, wherein the artist requested help in obtaining an affidavit for his friend the psychoanalyst Jacques Lacan to enter the United States.

14. Georges Duthuit, *Le serpent dans la galère* (New York: Curt Valentin, 1945). Jones also owned another collaboration between Masson and Duthuit, the print portfolio entitled *Bestiaire* (New York: Curt Valentin, 1946), which likewise addressed violent upheaval in Europe during World War II.

15. VMFA accessioned this image under the title *Face through the Leaves (Visage á travers les feuilles).* A similar image, referred to by Masson as "my portrait among the leaves," appears in André Masson, *Bestiaire.*

16. Masson, *Anatomy of My Universe,* prologue, section V.

17. Lawrence Saphire, *André Masson: The Complete Graphic Work* (New York: Blue Moon Press, 1990), 168. According to Saphire, *Improvisation* was produced at Atelier 17 using a lift ground of chocolate syrup to produce the white, black, and gray figures.

18. Dawn Ades, *André Masson* (New York: Rizzoli, 1994), 22.

19. Jones, "André Masson: A Comment," 237.

20. For a historical analysis, see Michael Leja, *Reframing Abstract Expressionism: Subjectivity and Painting in the 1940s* (New Haven: Yale University Press, 1993).

164

HENRI **MATISSE**
1869–1954, French

172
Crouching Nude with Eyes Lowered, 1906
Lithograph
17¹³/₁₆ x 11¹/₁₆ in. (45.2 x 28.1 cm)

173
Nude Seen from Behind, ca. 1909
Pen and ink on paper
10½ x 8¹/₁₆ in. (26.7 x 20.5 cm)

Fig. 20: Henri Matisse, *Standing Woman Seen from Behind*, 1909, ink on paper. Museum of Modern Art

T. Catesby Jones was fascinated by Henri Matisse's pictures of women, referring to them as "a monument to womanhood that no other artist has quite equaled."[1] The collector's summation reiterated the long-standing association between Matisse's art and the feminine. Critics saw a connection on more than one level: in the artist's subjects, certainly, but also in his emphasis on "sensation," which was traditionally thought a feminine category. According to this viewpoint, Matisse was an artist who stressed the material reality of paint over abstruse theory, creating visually rich analogues for his sensitive perceptions of nature. In the critical imagination, Matisse would ever remain a creature of feeling, associated with French domestic life and elegance of taste.

The Matisse images in the Jones collections belong to important and well-known moments in three decades of the artist's long career; two of them, both drawings, are dated here for the first time. The selection provides ample evidence of what Jones saw as Matisse's predilection for the feminine. All of them, regardless of medium, handling, viewpoint, or pose, are depictions of the female form.

The earliest is *Crouching Nude with Eyes Lowered* (cat. no. 172), a transfer lithograph of 1906. It is a good example of Matisse's interest in the expressive possibilities of contour drawing. Save for the hair piled atop the model's head, Matisse eschews hatching, shading, or obvious approximations of tone. Only the granular, undulating outline is needed to render the body's silhouette. Thus, even though color is conspicuously absent, part of the composition's visual interest is due to the irreducible contrast achieved between that black line and the white of the paper.

Throughout his career, Matisse returned to the subject of the nude model with her

172

back turned to the viewer. The pen-and-ink *Nude Seen from Behind* (cat. no. 173) is an excellent example of this leitmotif. It shares a remarkable similarity of pose and handling with a group of 1909 sketches of a female model leaning against a wall in the artist's Issy studio. Those renderings served as preparatory works for the first in a celebrated series of monumental bronze reliefs, *Back I–IV* (1913–31). One of these studies, *Standing Woman Seen from Behind* (fig. 20), is now in the collection of the Museum of Modern Art.[2] Though there are some discrepancies between the two poses, both works display vigorous diagonal hatch marks, thickly inked body contours and crevices, and prominent shadows running down the figures' left sides.

During 1917 and 1918, Matisse executed a series of nearly fifty paintings depicting an Italian artist's model about whom very little is known and whose name has been written

173

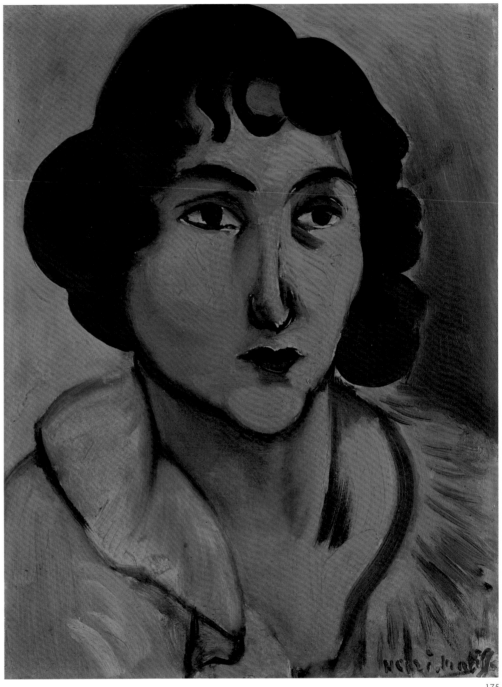

175
Lorette, 1917
Oil on panel
13 ¾ x 10 ⁷⁄₁₆ in. (34.9 x 26.5 cm)

174
Lorette, 1917
Oil on panel
13 ¾ x 10 ⁷⁄₁₆ in. (34.9 x 26.5 cm)

175

at different times as Lorette or Laurette.[3] The series marks a transition in Matisse's art from his relatively severe and abstracted style of the early 1910s to a more naturalistic mode during the subsequent decade. The two Jones *Lorette* portrait heads are variations on a theme.

Matisse focuses on the model's face, giving little attention to background or external details, so that the subject, iconlike, absorbs the entire space of the limited field. Both the figure and the visible space around her are rendered in a palette of pink and green,

which is characteristic of the Lorette series as a whole. The model wears the same ruffled blouse in each work. In all fifty variations, Matisse stresses asymmetries in the model's face and hairstyle, believing these singular traits to be the true source of a likeness.

Some of Matisse's later commentators, contemplating the artist's continuing interest in the features of this particular model, have described the Lorette compositions as the cusp of a transition for Matisse, both personal and artistic, wherein his private life intersected with his more rarified existence as an artist.[4] The series has been compared to a sequence of imaginary love letters, with Matisse repeatedly poring over the features of an exotic muse. Jones recognized the significance of these

works within Matisse's oeuvre, declaring that the artist had himself dubbed the *Lorette* (cat. no. 174) with long hair "one of his finest creations."[5] Of the *Lorette* (cat. no. 175) with hair pulled back, Jones observed with an ebullient tone that despite her somewhat impassive expression, Matisse had "recognized in woman a capacity for tender regard for mankind which should be preserved for all time, and he has preserved it."[6] Jones purchased these two paintings within the span of a year, the *Lorette* with long hair in December 1924 and the other the following October. These very early purchases of such prominent works helped to mark Jones's emergence as a consequential collector of modern French art.

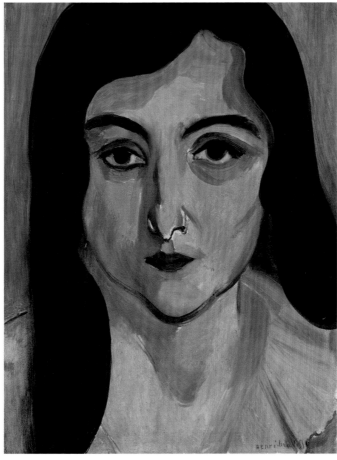

174

Shifting appearances is the more obvious subject of *Two Views of the Same Woman* (cat. no. 176), the earliest of a set of images that Matisse executed after he moved to the Mediterranean city of Nice in 1917. The spare, broken outlines of the drawing demonstrate the remarkable continuity of the artist's emphasis on the expressive potential of line. The sitter can be identified with reasonable certainty as Antoinette Arnaud, a young model whom Matisse sketched extensively in 1918 and 1919. She bears a close resemblance to a model in a more elaborate pencil sketch first reproduced in Matisse's 1920 book *Fifty Drawings* (Cinquante dessins).[7] Antoinette appears from the same angle of view, wears the same hairstyle, and sports the same embroidered blouse in both drawings.

Among the most characteristic products of Matisse's first Nice period, from 1917 to roughly 1931, are images of European models dressed in "Oriental" costume. The 1925 lithographs *Odalisque with Fruit Bowl* (cat. no. 180) and *Odalisque with Red Satin Coulottes* (cat. no. 181) are two of three such works

180

in the Jones set. Matisse depicts his model, Henriette Darricarrère, in harem dress. Alluringly posed on the stage the artist has set for her, she moves into the sexualized role of the odalisque, the folds of her pantaloons inked suggestively between her crossed legs. This particular model is a frequent denizen of the private harem that Matisse constructed in numerous paintings and prints.

176
Two Views of the Same Woman, ca. 1918–19
Pen and ink on paper
10 5/8 x 14 3/8 in. (27 x 36.5 cm)

180
Odalisque with Fruit Bowl, 1925
Lithograph
18 7/8 x 12 15/16 in. (48 x 32.8 cm)

181
Odalisque with Red Satin Culottes, 1925
Lithograph
11 1/4 x 14 5/16 in. (28.6 x 36.4 cm)

182
Interior, Reading, 1925
Lithograph
14 15/16 x 11 in (38 x 28 cm)

176

Between 1922 and 1929 Matisse's primary print medium was lithography. He produced more than twenty lithographs in 1925 alone, including *Interior, Reading* (cat. no. 182). Here a woman is seated in a lively but not florid interior, the hint of a cool breeze blowing in from the open window behind her. The work is evidence of Matisse's long-standing interest in depicting domestic space wherein the figure of the woman becomes a symbol of comfort and repose. Though a relatively unassuming conception, this lithograph can surely be taken as emblematic of Matisse's art as a whole. In 1908, in the most well-known statement of his aims as a painter, Matisse, the armchair visionary, expressed the strong desire to make his work a space of visual repose for the weary (and putatively male) viewer:

> What I dream of is an art of balance, of
> purity and serenity, devoid of troubling
> or depressing subject matter, an art which
> could be for every mental worker, for the
> businessman as well as the man of letters,
> for example, a soothing, calming influence
> on the mind, something like a good arm-
> chair which provides relaxation from
> physical fatigue.[8]

T. Catesby Jones was exactly the kind of viewer that Matisse imagined. Perhaps it should come as no surprise that Jones so highly regarded Matisse's gift for a certain feminine tenderness of expression. —LFC

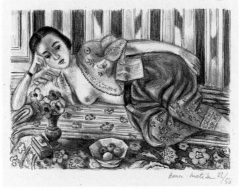

181

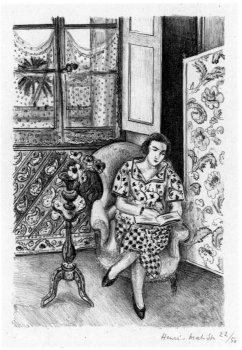

182

Notes

1. T. Catesby Jones quoted in Virginia Museum of Fine Arts, *The T. Catesby Jones Collection* (Richmond: Virginia Museum of Fine Arts, 1948), 33.
2. John Elderfield, *Masterworks from the Museum of Modern Art* (New York: Museum of Modern Art, 1996), 54-61. Alfred Barr, *Matisse: His Art and His Public* (New York: Museum of Modern Art, 1951), 141, illustrates another drawing from the same series.
3. Jack Flam, *Matisse in Transition: Around Laurette* (West Palm Beach, Fla.: Norton Museum of Art, 2006), 9.
4. See, for example, Jack Flam, *Matisse: The Man and His Art, 1869–1918* (Cornell: Cornell University Press, 1986), 441–42, 454.
5. Jones quoted in VMFA, *T. Catesby Jones Collection*, 33.
6. Ibid.
7. Henri Matisse, *Cinquante dessins* ([Paris]: n.p., 1920).
8. Henri Matisse, "Notes of a Painter" (1908), reprinted in Jack Flam, *Matisse on Art* (London: Phaidon, 1973), 38.

186
Portrait of Paresce, ca. 1915–19
Pencil on paper
16⅜ x 10 1/16 in. (41.6 x 25.6 cm)

Amedeo Modigliani and Renato Paresce (1886–1937) met one another as Italian émigrés in Paris in 1912, or soon thereafter. Both men were artists, although Paresce also worked as a journalist. Perhaps to distinguish his two vocations, Paresce adopted the Gallicized first name René in his guise as a painter. This portrait (cat. no. 186) is one of two sketches that Modigliani made of his friend. It has been assigned various dates between 1915 and 1919. Although Modigliani, an inveterate draftsman, often made on-the-spot portraits of his acquaintances in Paris, it is not at all certain that he made this drawing from life, especially since Paresce left Paris for London with the outbreak of World War I.[1] No oil painting of Modigliani's Paresce portrait is known.

Modigliani's portrait sketches are strongly marked by qualities of intimacy and immediacy, and both characteristics are evident in *Portrait of Paresce.* The subject is presented at close range and seems to confront the viewer directly. The artist's typically energetic drawing style is evident here in the pencil lines forming the hand, chin, and pointed nose, as well as the overlapping spirals that crown Paresce's head with curls. At the top of the sheet, Modigliani has scrawled the sitter's name in a casual hand, as he frequently did on sketches.

In addition to the portrait's approachable nature—and complicating the feeling of immediacy—there is an undercurrent of distance, a sort of contemplative inwardness. Modigliani's friend Dr. Paul Alexandre, a member of his circle, explained that the artist "sought to express the inner self of his models," and not merely the physical likeness.[2] Modigliani captured that psychological depth particularly through his distinctive treatment of the eyes. They appear almost vacant, gazing out but simultaneously looking within. Pipe raised to mouth, Paresce sits, forever in thought. —ETB

Notes
1. See Sergio Troisi and Stefano De Rosa, eds., *René Paresce e les Italiens de Paris* (Palermo: Sellerio, 2004), 139. On Modigliani's sketches of his friends, see Annette Kruszynski, *Amedeo Modigliani: Portraits and Nudes* (New York: Prestel, 1996), 30.
2. Paul Alexandre, quoted in Noël Alexandre, *The Unknown Modigliani: Drawings from the Collection of Paul Alexandre* (New York: Abrams, 1993), 91.

186

187
The Frugal Repast, 1904
Etching
26 ⅛ x 20 ¹/₁₆ in. (66.3 x 50.9 cm)

199
Salomé, 1905
Drypoint
23 ⅝ x 20 ³/₁₆ in. (60 x 51.2 cm)

192
The Two Saltimbanques, 1905
Drypoint
18 ⅜ x 13 in. (46.6 x 33 cm)

193
At the Circus, 1905
Drypoint
19 ¼ x 13 ⅛ in. (48.9 x 33.4 cm)

196
The Saltimbanques, 1905
Drypoint
20 x 25 ¹⁵/₁₆ in. (50.8 x 65.9 cm)

T. Catesby Jones placed a special importance on the achievements of Pablo Picasso. In his judgment, the artist was the most brilliant painter of his generation and, along with Matisse, defined the aesthetic of the early twentieth century.[1] Thus, works by Picasso became very much a cornerstone of the collection, and the Jones bequest included many in varied media: seven paintings and drawings, twenty prints, and three illustrated books. Nearly all were made prior to 1924, with the most impressive dating to the period before World War I.

An important print suite marks the chronological beginning of Jones's Picasso holdings. The artist had completed his first serious work in printmaking between late 1904 and early 1906; initially these etchings and drypoints were printed by Auguste Delâtre in very small numbers. In 1913 the dealer Ambroise Vollard acquired fifteen of the plates, had them steel-faced for durability, and republished them in a large edition with the title *The Saltimbanques* (also known as the Saltimbanques Suite).[2]

199

As a group, these prints draw together many threads of Picasso's early career. The famous etching *The Frugal Repast* (cat. no. 187), for example, is a study of poverty and psychological alienation. These themes, common in Picasso's work of the Blue Period (1900–04), are symbolized here by the stylized gauntness of the human form and the suggested blindness of the man at the table. The drypoint entitled *Salomé* (cat. no. 199) explores one of the great motifs of fin-de-siècle modernism, the erotic Salomé, who dances before Herod, the tetrarch of ancient Galilee. Her mother, Herodias, observes impassively, while at the lower right, a kneeling servant holds the reward that Salomé had demanded of Herod: the decapitated head of John the Baptist.

Seven plates in this print suite reflect a theme that emerged in Picasso's art from the end of the Blue Period in 1904 through the Circus or Rose Period (1904–6): the romantic but isolated existence of the wandering acrobats and performers known as *saltimbanques*. The rendering of young acrobats in *The Two Saltimbanques* (cat. no. 192) demonstrates the spare refinement that characterizes

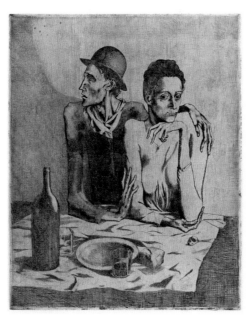

187

the series as a whole. *At the Circus* (cat. no. 193) is one of several 1905 depictions by Picasso of young female trick riders. *The Saltimbanques* (cat. no. 196) presents a circus family—a harlequin watching a child practice on a ball, mothers and children (some carrying firewood), an old woman washing dishes—set against a stark landscape. The latter image corresponds to one of Picasso's preparatory studies for his 1904–5 masterpiece, *Family of Saltimbanques* (National Gallery of Art).[3]

193

196

192

Fig. 21: Sketch on the reverse of *Woman with Kerchief.* VMFA

The dealer Vollard purchased nearly all of the works in Picasso's studio in early 1906, affording the artist a trip to his native Spain with his female companion, Fernande Olivier. The strong current of classicism that ran through the modern art worlds of Paris and Barcelona at the time greatly affected Picasso that summer. From the remote Pyrenean village of Gosól, he explored an ideal of timeless rusticity and Mediterranean classicism, aspects of which emerge in the earthen palette and the serene, masklike physiognomy of *Woman with Kerchief* (cat. no. 200). The large gouache portrait depicts Fernande Olivier in tones of raw sienna, her light-blue kerchief defining the form of her head against the closely related hue of the featureless background. Impassive eyes stare far off to her left: "such eyes as one can never forget," Jones observed, in "a face cleansed of doubt, with a supreme faith in life."[4] The triangle of a rose-colored cloak, with faint charcoal lines that indicate its collar, forms a base for this visage, while neck and body disappear beneath it. A sketch on the reverse of the portrait has recently been discovered (fig. 21). It presents an outdoor setting with groups of figures, some in regional Catalan dress. Both the dancing couple and the woman with a yoke are motifs that appear in Picasso's sketchbook drawings of summer 1906.[5]

The sequence continues with the gouache *Landscape* (cat. no. 201) of 1907. It features a tree springing from the bottom of the sheet with forked branches reaching out to cover the top of the composition. "Schematic tree, decorative, black lines," noted Vincenc Kramář, the Czech art critic and one of Picasso's main patrons before World War I, after viewing the composition in Picasso's first large retrospective at Moderne Galerie in Munich in February 1913. "Resplendent like a painting

on glass. Precious stones. Like a cloisonné. Wants to make a painting like Matisse."[6] The play of yellow-gold with dark red at the bottom of the picture and the areas of malachite

201

blue and Veronese green above, which suggest atmosphere and foliage, amazed Kramář. Describing this composition years later, Jones made a similar connection, referring not to Matisse but rather to the artists' group he led. For Jones, *Landscape* was "almost a unique example of Picasso's excursion into the realm of the fauve before he took up cubism."[7] Violent color, however, is only part of the picture's experimental style. Graphic contrasts, aggressive brushwork, a geometric framework, and a flattened pictorial space—these are hallmarks of Picasso's early cubism. Indeed, the composition belongs to a group of abstract landscapes that was roughly contemporaneous with Picasso's *Les demoiselles d'Avignon* of 1907 (Museum of Modern Art).[8]

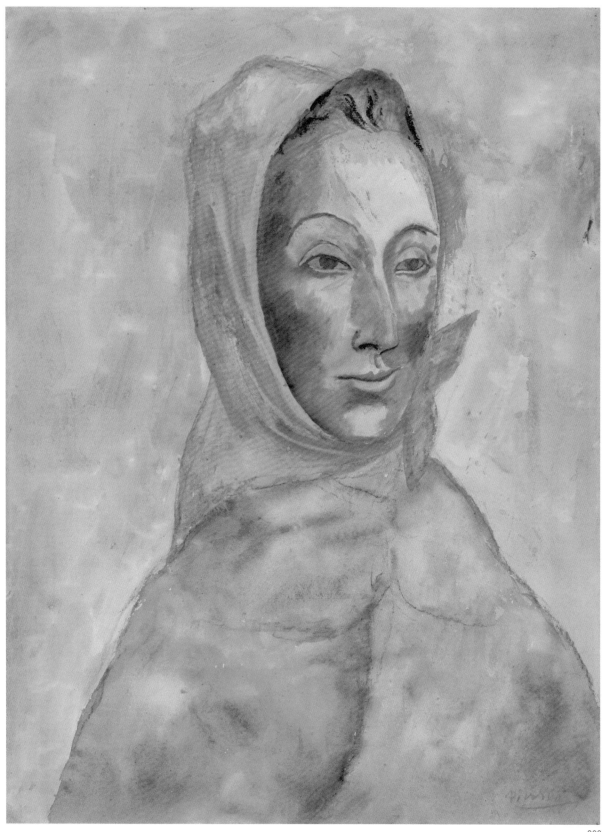

PICASSO 97

202

Still Life (Wineglass and Newspaper),
1914
Oil and sand on canvas
20 5/8 x 17 1/4 in. (52.4 x 43.8 cm)

203

Pierrot as Orchestra Conductor,
ca. 1920–23, after 1920 gouache
by Picasso
Pochoir
12 3/16 x 9 7/16 in. (31 x 24 cm)
Published by Paul Rosenberg, Paris,
ca. 1920–23

204

**Guitar and Sheet Music on a
Pedestal Table,** ca. 1920–23,
after 1920 gouache by Picasso
Pochoir
9 x 11 1/2 in. (22.8 x 29.2 cm)
Published by Paul Rosenberg, Paris,
ca. 1920–23

207

The Banjo Player, 1921
Gouache on paper
10 5/8 x 8 3/8 in. (27 x 21.3 cm)

208

Fish, Fruit Bowl, Bottle, 1922
Peinture à l'essence and
graphite on paper
5 1/2 x 4 5/16 in. (13.9 x 10.9 cm)

210

Guitar and Fruit Bowl, ca. 1924–25
Pastel on blue paper
4 3/4 x 6 1/16 in. (12.1 x 15.4 cm)

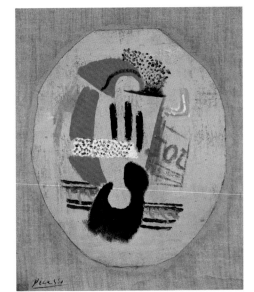

202

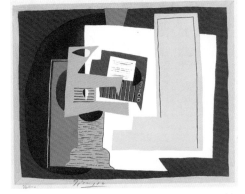

204

210

Two still-life paintings completed Jones's holdings in Picasso's prewar work. One of these, *Guitar and Glasses* (1912, fig. 1, p. 1), remained with the family at the time of the 1947 bequests. The other is *Still Life (Wineglass and Newspaper)* (cat. no. 202). The composition's centerpiece, a fluted goblet, is defined by a gray-blue patch at its edge and a white strip of stippled colors suggesting the sparkle of reflected light. A second area of dotted color above the glass creates a background wallpaper pattern. At right is a fragment of folded newspaper, with the first three letters of the word *journal* visible. The straight but broken line of a decorated table edge, covered by the brown shadow of the goblet, marks the bottom of the arrangement. Picasso painted the image on a piece of canvas that was cut into a rough oval (the straight edge at its crest may be the top of that cut-out canvas). He affixed it to a rectangular canvas with a more open weave, producing the effect of a frame within a frame—or an oval picture hung on a wall.

Picasso's art of the first half of the 1920s is represented in Jones's collection by cubist compositions as well as classical and more traditionally figurative works—a demonstration of the artist's inclination to change styles and even to work in several simultaneously. Two stenciled gouaches (based on 1920 gouache drawings by Picasso) belong to a set of ten that was likely produced by dealer Paul Rosenberg, with the artist's sanction, in about 1920–23.[9] *Guitar and Sheet Music on a Pedestal Table* (cat. no. 204) turns the simplicity and brightness of the stencil technique into a means of abstraction. *Pierrot as Orchestra Conductor* (cat. no. 203) features a character from the Italian commedia dell'arte, a theatrical tradition from which Picasso often drew. (He had brought a cubist manner to

203

207

208

commedia dell'arte figures in his costumes and sets for Serge Diaghilev's ballet *Pulcinella* in 1920.) Two additional works on paper, *The Banjo Player* (cat. no. 207) and *Fish, Fruit Bowl, Bottle* (cat. no. 208) typify Picasso's crisply designed and spatially complex cubism of the early 1920s. *Guitar and Fruit Bowl* (cat. no. 210), a drawing in pastel on blue-toned

23/50

209

paper (the paper is now extremely faded), has been exhibited and published with the title *Toy Doll* and with a tentative date of 1925. Jones saw this drawing as "a picture of Picasso's own writing table with the toy doll which was his mascot."[10] In fact the subject is the same as in certain still-life sketches and drawings of 1924 featuring a guitar and a fruit bowl; and Picasso worked with pastel in 1924. For this reason, we have revised the title and the date to *Guitar and Fruit Bowl,* ca. 1924–25.[11]

Picasso had many reasons for working simultaneously in modernist and classical manners. This strategy addressed his interest in the manipulation of historical styles and also supported his view that different artistic purposes call for different expressive means.[12] The linear style in which he rendered the classical nudes for the 1921 lithograph *The Horseman* (cat. no. 205) as well as the draped figure in *Woman and Child* (cat. no. 209) of 1923 connect Picasso to the classical and neoclassical artistic traditions that stretched from antiquity to the nineteenth century to his own day. Later etchings made to illustrate or accompany literary works—Balzac's *Le chef d'oeuvre inconnu* (1931), Ovid's *Metamorphoses* (1931), and Aristophanes's *Lysistrata* (1934)—provided Jones with examples of

7-3-21-

37/50 Picasso

PICASSO 101

Fig. 22
Dream and Lie of Franco I, 1937
Etching with aquatint
15 ⅛ x 22 ½ in. (38.4 x 57.2 cm)

Fig. 23
Dream and Lie of Franco II, 1937
Etching with aquatint
15 ⅛ x 22 ½ in. (38.4 x 57.2 cm)

Fig. 22

Picasso's classicism of the following decade (all bequeathed to UVA's library though not included in this exhibition or book).

Dream and Lie of Franco I and *II* (figs. 22 and 23), two nine-part compositions accompanied by the facsimile of a handwritten prose poem by Picasso, was released in a very large edition in 1937 to support the cause of the Spanish Republic in the ongoing Spanish Civil War. The central and recurring figure is the "evil-omened polyp" to whom Picasso refers in his text. This violent, obscene, burlesque monster symbolizes the leader of the nationalist insurgency, Francisco Franco, who mutates hideously from scene to scene. Reading from right to left, Franco appears as vicious soldier, attacker of true Spanish traditions, and enemy of culture. The four final vignettes denounce the suffering of women and children in Spain.[13] Jones's special enthusiasm for Picasso and his passion for modern printmaking only partly explain the inclusion of this extraordinary work in his collection. The presence of *Dream and Lie of Franco,* like certain politically charged works by André Masson and Jean Lurçat that Jones acquired, confirms the collector's strong interest in the response of artists to the great conflicts and struggles of the world.[14] —MA

Notes
1. T. Catesby Jones, quoted in Virginia Museum of Fine Arts, *The T. Catesby Jones Collection* (Richmond: Virginia Museum of Fine Arts, 1948), 33; Jones, "A Letter to a Friend on Modern Art" (1932), in VMFA, *T. Catesby Jones Collection,* 10.
2. It appears that the drypoint entitled *The Watering Place* (1905) was missing when the *The Saltimbanques* came to the University of Virginia. Louise Savage and John Cook Wyllie, "T. Catesby Jones Print Collection Appraisers' Inventory," August 2, 1947, Correspondence Files, 1931–1990s, Accession # RG-12/11/4.021, Box A35-16E, Special Collections Dept., University of Virginia Library.
3. See E. A. Carmean Jr., *Picasso: The Saltimbanques* (Washington, D.C.: National Gallery of Art, 1980).
4. Jones, quoted in VMFA, *T. Catesby Jones Collection,* 34. There are sketches related to this portrait in Picasso's Catalan Notebook of 1906. See Douglas Cooper, *Picasso: carnet catalan* (Paris: Berggruen, 1958), 10, 47, 70.
5. See Pierre Diax and Georges Boudaille, *Picasso: The Blue and Rose Periods, A Catalogue Raisonné, 1900–1906,*

trans. Phoebe Pool (London: Evelyn, Adams & Mackay), cat. D.XV.29; and Brigitte Léal, *Musée Picasso: Carnets, catalogue des dessins,* vol. 1 (Paris: Reunion des musees nationaux, 1996), cat. 6.

6. His notes on the picure are excerpted in *Vincenc Kramář: Un théoricien et collectionneur du cubisme à Prague* (Paris: Réunion des musées nationaux, 2002), 226–27.

7. Jones to Alfred H. Barr Jr., September 1, 1939. Curatorial Exhibition Files, Exh. #91, Museum of Modern Art Archive, New York.

8. Pierre Daix and Joan Rosselet, *Picasso: The Cubist Years, 1907–1916,* trans. Dorothy S. Blair (Boston: New York Graphic Society, 1979), 23–27, 202.

9. The author thanks Michael C. FitzGerald for information on the probable circumstances for the production of the prints (e-mail communication, January 16, 2008). Recent publications have given them dates ranging from ca. 1920 to ca. 1923; see *Vincenc Kramář: From Old Masters to Picasso* (Prague: National Gallery, 2000), 76–77; *Vincenc Kramář: un théoricien et collectionneur,* cats. 86–95;

and Michael FitzGerald, *Picasso and American Art* (New York: Whitney Museum of American Art, 2006), 85–86, 94–95.

10. Typescript entitled "Bequest to Virginia Museum of T. Catesby Jones," curatorial files, Virginia Museum of Fine Arts.

11. The author thanks Marilyn McCully for her advice on the title and date (e-mail communication, February 22, 2008).

12. See Alexandra Parigoris, "Pastiche and the Use of Tradition, 1917–1922," in Elizabeth Cowling and Jennifer Mundy, *On Classic Ground: Picasso, Léger, de Chirico, and the New Classicism, 1910–1930* (London: Tate Gallery, 1990), 296–308.

13. Note that Picasso did not correct for the image reversal that occurs in this form of printmaking.

14. See his commentary on Picasso's *Guernica* (1937) and on André Masson's work in response to the European political situation of the 1930s: Jones, "André Masson: A Comment," *Kenyon Review* 8, no. 2 (Spring 1946), 232.

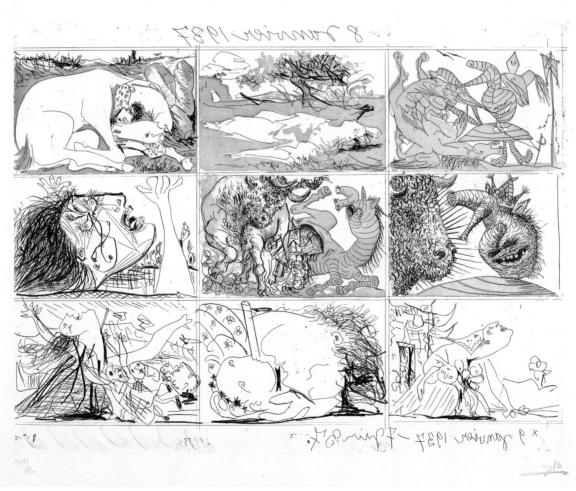

Fig. 23

GEORGES **ROUAULT**

1871–1958, French

230–235 from **The Shooting Star Circus** (Cirque de l'étoile filante), Ambroise Vollard, Paris, 1938

235
Madame Carmencita, 1935
Plate IX
Etching and aquatint
17 ¾ x 13 ¼ in. (45.1 x 33.6 cm)

In the 1930s, Georges Rouault's already considerable reputation was further enhanced by the success of his printmaking. In New York there was great interest in his prints, part of a larger vogue for the modern graphic arts, and Rouault was rewarded with exhibitions at the Museum of Modern Art in 1939, as well as in Washington, D.C., and San Francisco the following year. T. Catesby Jones purchased prints from Rouault's books *City Outskirts* (La petite banlieue, 1929) and *Père Ubu's Reincarnations* (Les réincarnations du Père Ubu, 1932), as well as the print *De profundis* (1927) from the series *Miserere.* But the highlights of Jones's Rouault collection are two complete books, *The Shooting Star Circus* (Cirque de l'étoile filante, 1938) and *Passion* (1939), both published by Ambroise Vollard, the artist's dealer in Paris. Jones acquired these together in 1939 through New York dealer Pierre Matisse, son of the artist.[1]

Circus and *Passion* are exceptional for the luxurious quality of their Montval paper and hand-stitched bindings. Each book contains a loose folio of seventeen etchings with color aquatint in addition to black-and-white woodcuts throughout the body of the text. The copperplates were executed by Rouault and printed by Roger Lacourière, while the woodcuts were executed by Georges Aubert, who had also worked with Rouault on *Père Ubu's Reincarnations.* The small holes at the edges of the paper are traces of a color-printing technique that dates to the eighteenth century and involves the use of pins to align printing plates and paper. At least seven different color plates were involved, although the precise number is difficult to determine. Rouault's signature inky blacks, used to great effect in the folio prints, were most likely produced by pouring acid directly onto the plates, without aid of a brush or

other implement. The circus prints feature extremely strong blacks and have relatively few gradations of color, an intentionally garish effect that Rouault thought suitable for the theme. For *Passion,* on the other hand, he used a full arsenal of texture, line, and color. Vivid color is a constant, but in illustrating this familiar narrative, the artist also included greater detail. There are more gradations of color and passages of textures produced by a toothed instrument in addition to the deep, heavy black outlines.

The circuses that were so popular in France during the Second Empire and the Third Republic left a lasting impression on a young Rouault. However, his obsession with the subject—there are an astonishing 169 separate treatments of it in his oeuvre—also has deep roots in nineteenth- and twentieth-century art and literature. As a painter, Rouault emphasized the pathetic humanity of the road-show clown, who generally lived an impoverished and lowly existence and employed humor often based more on blunt or bawdy comedy than on crafty tricks. Rouault's depictions cause the viewer to reckon with the misery endured by those whose job it was to make others smile, and also to understand the figure as a paradoxical symbol for the sad state of the human condition. In a 1905 letter to the philosopher and symbolist poet Édouard Schuré, Rouault described his interest in the clown and his costume as the "contrast between brilliant and scintillating things made to amuse us, and this infinitely sad life," and he expressed pity for the performer caught in the private moment. He furthermore expressed the universal import of this tragic figure, saying, "we are all of us clowns."[2]

Each of the three plates from *Circus* presents a portrait of the performer in costume, not performing but posed in solitary reflection:

ROUAULT 105

230
The Little Dwarf, 1934
Plate IV
Etching and aquatint
17 ¼ x 13 ¼ in. (43.8 x 33.6 cm)

234
Weary Bones, 1934
Plate VIII
Etching and aquatint
17 ⅜ x 13 ¼ (44.1 x 33.6 cm)

230

a strategy that subtly serves to heighten the sense of alienation, absurdity, and pathos that Rouault sought. This is particularly noticeable in the rendering of *Madame Carmencita* (cat. no. 235), revealed in all of her grotesque finery, and in *The Little Dwarf* (cat. no. 230). Here Rouault convincingly expresses a sense of the small man's physical discomfort and social alienation by keeping him in the extreme foreground of the image and compressing

his body to fit the space of the page. *Weary Bones* (cat. no. 234) is the aging clown, past his prime yet continuing to perform because it is all he knows to do.

Rouault was a devout Catholic all his life, and *Passion* is an example of the centrality of Christian themes in his art. He apprenticed with symbolist painter Gustave Moreau and in the early part of his career followed his master by focusing on religious subjects.

234

ROUAULT 107

248–252 from **Passion,**
text by André Suarès; Ambroise
Vollard, Paris, 1939

248
Christ and the Holy Woman, 1936
Plate IV
Color etching and aquatint
17 ½ x 13 ¼ in. (44.4 x 33.6 cm)

244
**Frontispiece (Christ at the Gates
of the City),** 1935
Frontispiece
Color etching and aquatint
17 ⅜ x 13 ⅛ (44.1 x 33.3 cm)

252
Ecce Dolor, 1936
Plate VIII
Color etching and aquatint
17 ½ x 13 ⅛ (44.4 x 33.3 cm)

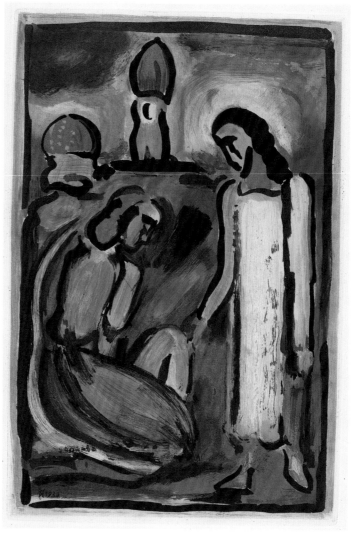

248

(Rouault later became the director of the Musée Gustave-Moreau in Paris.) Active in the Catholic revival in French intellectual life during the century's early decades, he was influenced by a number of others in that circle, particularly his close friend and neighbor Jacques Maritain, the preeminent Catholic philosopher and noted humanist. Rouault was also affected by novelist and essayist Léon Bloy and novelist and art critic Joris Karl Huysmans, at whose artists' colony located near the historic Ligugé Abbey he briefly stayed during 1901. *Passion* was begun in the 1930s, when Rouault produced his greatest

number of religious works. The three plates from the book illustrate familiar elements of the Christ story: *Frontispiece (Christ at the Gates of the City)* (cat. no. 244), *Christ and the Holy Woman* (cat. no. 248), *Ecce Dolor* (Behold Suffering) (cat. no. 252).

A common theme that runs through *Circus* and *Passion* is suffering and salvation. In depicting Christ, Rouault repeatedly focuses on humiliation as a means of humanizing the deity. The images resound with the experiential, not the exalted or even the theoretical. Likewise, in the circus images Rouault attempts to get beyond the costume and

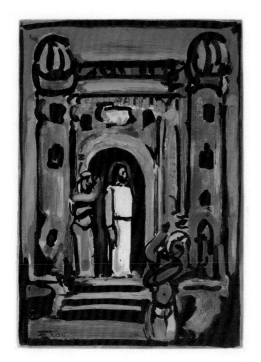

244

artifice of the clown to reveal his human side, however degraded and pathetic. But the theme of salvation through suffering is important as well in the modernist myth of the tormented artist, and this was certainly part of T. Catesby Jones's understanding of Rouault. Succinctly and emotively summing up the tensions in Rouault's work, between the sacred and the secular, the pathetic and the profane, Jones remarked that "laughter and tears are always near the surface with him, and indeed, a strongly mystical spirit permeates all his work."[3] — RS

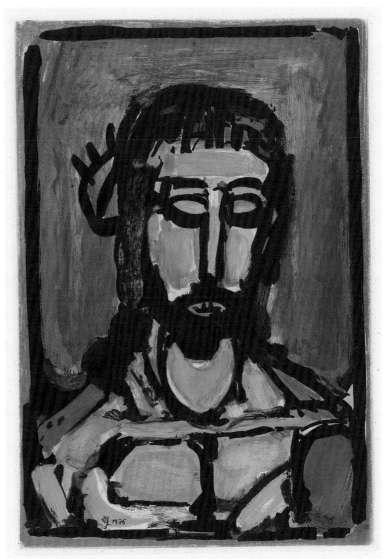

252

Notes
1. Pierre Matisse to Jones, May 15 and May 22, 1939; Jones to Matisse, May 18, 1939, Pierre Matisse Gallery, Archives, MA 5020, Box 116–19, Folder PMG Client: Jones, T. Catesby, 1926–1939, Pierpont Morgan Library and Museum, New York.
2. Georges Rouault, "Lettre à Édouard Schuré" (1952), reprinted in *Sur l'art et sur la vie* (Paris: Gallimard, 1971), 150.
3. T. Catesby Jones, *Modern French Prints: An Address . . . Delivered on October 19, 1944 at The Grolier Club of New York* (New York: Court Press, 1944), 20.

At age sixteen, Jacques Villon took up the tools of printmaking under the tutelage of his maternal grandfather, a shipbroker from Rouen who had occupied himself in retirement with the arts of engraving and etching.[1] Villon spent the next six decades perfecting his gifts in the graphic arts, and his printmaking underwent numerous shifts in style and technical approach. Many commentators break his long career into discrete periods: an early phase beginning in 1895 indebted to postimpressionism, particularly that of Henri de Toulouse-Lautrec; a cubist era from 1910 to 1914; a period of highly abstract graphic works beginning in 1919; and a return to the depiction of recognizable objects in illusionistic spaces during the 1930s.[2] The works of this final period, which lasted until Villon abandoned printmaking in the 1950s, do not simply reproduce nature but instead present strongly formal arrangements of stylized solid objects. T. Catesby Jones collected works from every phase except the first. He chose those that captured the accomplishment of an artist whom he considered a "true craftsman," bringing together prints that displayed numerous instances of Villon's "exquisite touch."[3]

The Laden Table (cat. no. 267) of 1913 is the earliest print by Villon in the Jones collection. The motif is rendered with a sophisticated balance of velvety drypoint passages and more hard-edged etched lines, and it is a perfect example of Villon's approach to image making during his pre–World War I cubist period. Following an early career as a newspaper illustrator, Villon began in 1910 to search for new and more analytical methods of representation.[4] His quest was not a solitary one; he was part of a group of young avant-garde artists who met weekly at his studio in the Paris suburb of Puteaux. They discussed

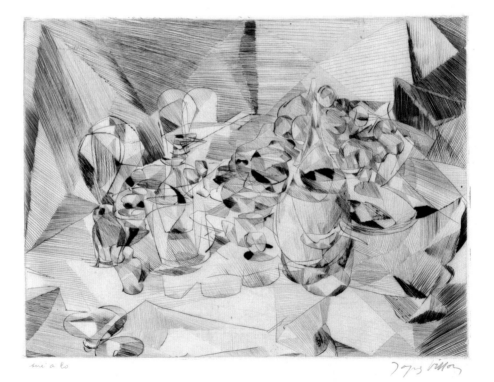

267

topics such as modernist picture-making methods, new concepts in mathematics (including theories of the fourth dimension), and ideas about the nature of creative intelligence. The writings of philosopher Henri Bergson, in particular, informed their views on the latter subject. Villon later commented: the "need to observe life and catch it on the wing" gave his art "a special graphism that might be related to Bergson's 'line of intention.'"[5] A concept Villon fashioned from Bergson's ideas about movement, time, and consciousness, this "line of intention" could also be thought of as an object's contour line that manifests its physical form but remains connected to its boundless and unqualifiable inner life.[6] Described by the artist as a kind of tightrope,[7] the serpentine cord that unifies the still-life objects in *The Laden Table* encapsulates this concept; the items appear to jostle one another and vibrate across shared and overlapping borders.

In 1912, a year before Villon made *The Laden Table,* he had drawn a naturalistic if somewhat abbreviated drawing of his father entitled *Man Reading.*[8] A year after his father's death in 1925, Villon produced another portrait of him, now lost, but rendered it in oil in the highly abstracted visual idiom he was using at the time: the forms in the drawing were translated into a series of flattened planes that adhered to the picture plane.[9] Four years later he again took up the motif, this time in the form of an etching, *Man Reading* (cat. no. 268). Villon was certainly capable of creating a literal, true copy of a preexisting image; using his skill with aquatint and lithography, he supported himself from 1922 to 1930 by producing prints that faithfully replicated paintings by contemporaries for Bernheim-Jeune Gallery in Paris. The *Man Reading* etching, however, is not a direct copy of the 1925

268

oil painting, for neither the painting's exact composition nor its brushstrokes are imitated. Instead, the forms of the oil are translated into the visual language of black-and-white intaglio printmaking, here as intersecting planes of carefully drawn hatched lines.[10]

The 1930s saw two important changes in Villon's printing practice. In addition to the increase in verisimilitude of form and space, Villon introduced a new approach to the etched line. Whereas his works of the 1920s had been characterized by closely set hatched

lines to define planes, Villon's new method involved a series of superimposed veils of tightly crossed lines that delineate illuminated forms without the use of visible contour lines. *Still Life with a Samovar* (cat. no. 270), an etching and drypoint from 1931, is an example of this technique, the complexity of which could have required up to fifteen immersions in an acid bath to achieve the numerous tones.[11] The skill required to execute this kind of composition through a matrix of linear webs can be understood as proof for the accolades Jones bestowed on the artist as a "true craftsman" of the printed line. —KEB

270
Still Life with a Samovar, 1931
Etching and drypoint
13¾ x 10¹¹⁄₁₆ in. (35 x 27.2 cm)

Notes

1. Daniel Robbins, *Jacques Villon* (Cambridge: Fogg Art Museum, 1976), 25.
2. Donna Stein, "Villon," in *The Cubist Print,* by Burr Wallen and Donna Stein (Santa Barbara: University Art Museum, University of California, 1981), 33–34; Rebecca Cureton, "Jacques Villon," *Early 20th Century French Graphics: the T. Catesby Jones Collection* (Charlottesville: Bayly Art Museum, University of Virginia, 1989), 41.
3. T. Catesby Jones, *Modern French Prints: An Address . . . Delivered on October 19, 1944 at The Grolier Club of New York* (New York: Court Press, 1944), 25–26.
4. "Till about 1910 I painted as the birds sing, following my instinct, without thinking too much." Villon, quoted in Dora Vallier, *Jacques Villon, oeuvres de 1897 à 1956* (Paris: Éditions cahiers d'art, 1957), 117.
5. Villon, quoted in Innis H. Shoemaker, *Jacques Villon and His Cubist Prints* (Philadelphia: Philadelphia Museum of Art, 2001), 32.
6. Vallier, *Jacques Villon,* 29.
7. Ibid.
8. Robbins, *Jacques Villon,* 60–62.
9. Ibid.
10. Shoemaker, *Jacques Villon and His Cubist Prints,* 4.
11. For Villon's discussion of this technique, see Colette de Ginestet and Catherine Pouillon, *Jacques Villon: les estampes et les illustrations, catalogue raisonné* (Paris: Arts et métiers graphiques, 1979), 208.

epreuve d'artiste Jaq Villon

VILLON 113

MAURICE DE
VLAMINCK
1876–1958, French

272
The Storm, ca. 1912
Oil on canvas
23 ½ x 28 ¾ in. (59.7 x 73 cm)

273
Head of a Woman, 1922
Color woodcut
22 ⁵⁄₁₆ x 18 ¹⁄₁₆ in. (56.6 x 45.9 cm)
Published by Galerie Simon,
Paris, 1922

Maurice de Vlaminck began painting as an adolescent in the 1890s, and by 1905 he had become a core member of the fauve group. From its beginning his art was defined by a robust, impetuous, and larger-than-life style and artistic persona. Vlaminck favored the expressive over the intellectual and his oeuvre reflects this preference.

The Storm (cat. no. 272) is the earliest work by Vlaminck in Jones's collection.[1] It demonstrates the importance that Vlaminck placed on the artistic precedent of the great postimpressionist painter Paul Cézanne.[2] The composition registers Cézanne's impact first in its distinctive brush marks, most noticeable in the hatchlike strokes that define the landscape, particularly in the painting's foreground. Their insistency renders the artist's hand plainly visible and their materiality calls as much attention to the medium as to the subject it articulates.

Vlaminck also draws on the Cézannist principle of *passage,* or the breaking down of boundaries separating adjacent forms and the creation of modeled transitions between them. In *The Storm,* Vlaminck's understanding of this lesson is revealed in the juxtaposition of deliberate, singular marks with the colored forms of roofs and walls, as well as in the rhythm that results as the eye moves across the surface of the canvas. Similarly, Vlaminck's emphasis on visual patterns brings the composition to life—perhaps more than the storm itself does.[3]

Vlaminck embraced the woodcut medium as a vehicle for the style and expressive effects he sought.[4] In *Head of a Woman* (cat. no. 273), a color woodcut of 1922, a woman's face—appearing as a rough-edged mask—floats against a brown and black background. Short, incised marks indicate the contours of the face and neck and delineate areas of hair. Thicker, more rounded gouges fill out the hair and merge with even-broader marks to define the background. The stark contrast between the expanse of white and the textured field of marks makes a vivid visual impact.

Both of these works resonate with T. Catesby Jones's philosophy as a collector. "The men working in this new spirit," he remarked about the modern French artists whose works he collected, "laid emphasis upon the medium—the brush, pencil or burin. New meaning was driven home by the artist's feeling that every stroke of the pencil should be a sincere record of an aesthetic experience at the moment of execution."[5] For Vlaminck, as for Jones, the brush and the knife were the tools of a focused engagement with the pictorial means of art. —ES

273

Notes
1. *The Storm* is listed with the date ca. 1912 in an early inventory of the Jones collection and comparison with other works from the years 1910–14 further supports this date. Inventory of the T. Catesby Jones Collection, Early Museum History: Administrative Records, IV.23, Museum of Modern Art Archives, New York.

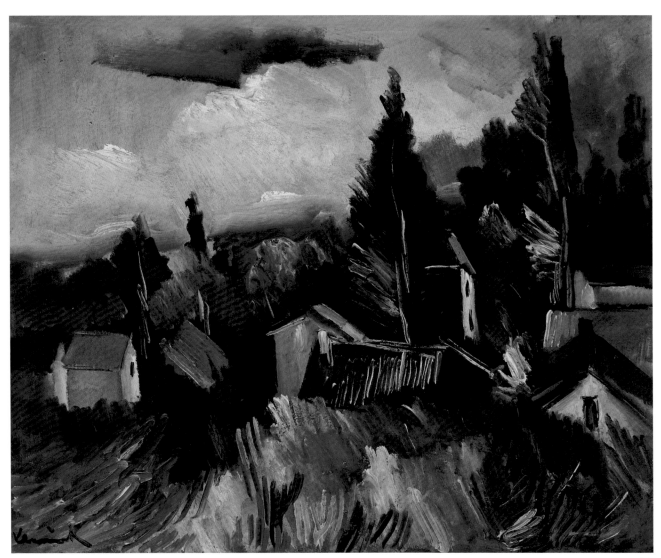

272

2. Vlaminck became intensely drawn to Cézanne in 1907, the year of two important memorial Cézanne exhibitions in Paris. See John Elderfield, *The "Wild Beasts": Fauvism and Its Affinities* (New York: Museum of Modern Art, 1976), 117–18.

3. For a discussion of Cézanne's technique and its importance for artists in the early twentieth century, see Richard Shiff, "Mark, Motif, Materiality, The Cézanne Effect in the Twentieth Century," in *Cézanne: Finished, Unfinished,* ed. Felix Baumann (Ostfildern-Ruit: Hatje Cantz, 2000), 99–123.

4. Riva Castleman, *Prints of the Twentieth Century, A History* (London: Thames and Hudson, 1988), 17.

5. T. Catesby Jones, *Modern French Prints: An Address . . . Delivered on October 19, 1944 at The Grolier Club of New York* (New York: Court Press, 1944), 5–6.

Note to the Reader

The following catalogue includes all works given by T. Catesby Jones and other members of the Jones family to the Virginia Museum of Fine Arts and those works in the 1947 bequest to the University of Virginia that were accessioned by the University of Virginia Art Museum in 1975. A gift made to VMFA by Curt Valentin in memory of T. Catesby Jones is also included.

Many books and print portfolios from T. Catesby Jones remain in the Albert and Shirley Small Special Collections Library at the University of Virginia; although several prints from portfolios are included in the publication and exhibition (see entries on Ernst and Picasso), they are not included in the following catalogue, which comprises solely the collections at VMFA and UVAM.

All works in UVAM's collection came through Jones's bequest and share the same credit line: T. Catesby Jones Collection.

Works in VMFA's collection arrived at numerous times and from several sources. Most were accessioned in 1947 and, unless otherwise noted, bear the following credit line: T. Catesby Jones Collection.

Reproductions of prints and drawings in the catalogue are often cropped to the image.

A dagger (†) indicates works included in the full exhibition at the University of Virginia Art Museum and in the Artist Entries of this book. Subsequent venues exhibited a selection of these works.

Dimensions given are of the support; dimensions of prints and drawings are of sheet size. All dimensions are height x width x depth.

All visible signatures and markings made by the artist on the front of the work are noted.

Provenance cites transactions involving T. Catesby Jones (TCJ) for works that appear in the Artist Entries when known. Information about purchases was gathered from *The T. Catesby Jones Collection* (Virginia Museum of Fine Arts, 1948); Jones's logbook (Peggy Brooks, New York); and archives of the galleries from which Jones acquired works of art.

Published cites reproductions in catalogues raisonné of works featured in the Artist Entries where applicable; in some cases other publications are noted.

ILLUSTRATED CATALOGUE

PAUL WAYLAND BARTLETT

1865–1925, American

1
Young Blackbird, 1895
Bronze
3¾ x 3⅝ x 2¼ in.
(9.5 x 9.2 x 5.7cm)
Signed between bird's feet: *P.B.*
VMFA, 47.10.88

ANDRÉ BAUCHANT

1873–1958, French

2
French Peasant Interior, 1920
Oil on canvas
13 x 19 ¼ in.
(33 x 48.9 cm)
Signed and dated l.r.:
 Bauchant 1920
VMFA, 47.10.6

3
Spring, 1927
Oil on canvas
38 x 51in.
(96.5 x 130.8 cm)
Signed and dated l.r.:
 A Bauchant 1927
VMFA, 47.10.1

4
Summer, 1927
Oil on canvas
40¾ x 53¼ in.
(103.5 x 135.2 cm)
Signed and dated l.r.:
 A Bauchant 1927
VMFA, 47.10.2

5
Autumn, 1927
Oil on canvas
41 x 54 in.
(104.1 x 137.1 cm)
Signed and dated l.r.:
 A Bauchant 1927
VMFA, 47.10.3

6
Winter, 1927
Oil on canvas
40⅜ x 52¼ in.
(102.5 x 132.7 cm)
Signed and dated l.r.:
 A. Bauchant 1927
VMFA, 47.10.4

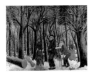

7†
Combat in Château-Renault Forest, 1939
Oil on canvas
56½ x 38 in.
(143.5 x 96.6 cm)
Signed and dated l.l.:
 A. Bauchant 1939
VMFA, 47.10.5

PROVENANCE

TCJ purchase from Galerie
 Jeanne Bucher, Paris, 1939

PUBLISHED

Gauthier, Maximilien. *André
 Bauchant.* Paris: Éditions du
 Chêne, 1943. Pl. 25.
Vierny, Dina. *André Bauchant:
 catalogue raisonné.*
 Wabern: Benteli, 2005.
 Cat. 30-06.

8
Snow Scene,1920–30
Oil on wood panel
21⅞ x 15⅝ in.
(55.5 x 39.6 cm)
VMFA, 47.10.94

RAINEY BENNETT

1907–1998, American

9
Christmas Card, 1939
Gouache on paper
4¹⁵⁄₁₆ x 24 in.
(12.5 x 60.9 cm)
Signed and dated l.r.:
 *Paintings by Rainey Bennett
 & Book by Ann Bennett 1939*
UVAM, 1975.43.74

WILLIAM PETERS BLANC

Born 1912, American

10
The White Fence, 1952
Ink wash on paper
14¹⁵⁄₁₆ x 19¾ in.
(37.9 x 50.2 cm)
Signed l.c.: *Blanc*
Gift of Mrs. Louisa Brooke
 Jones for the T. Catesby
 Jones Collection
VMFA, 53.27

GEORGES BRAQUE

1882–1963, French

11†
Fox, 1911
Drypoint
25¹³⁄₁₆ x 20¹⁄₁₆ in.
(65.5 x 50.9 cm)
Signed l.r.: *G Braque*
Inscribed l.l.: *No. 67*
Published by Daniel-Henry
 Kahnweiler, Paris, 1912
UVAM, 1975.43.98

PUBLISHED

Engelberts, Edwin. *Georges
 Braque: oeuvre graphique
 original.* Geneva: Musée
 d'art et d'histoire, 1958.
 Cat. 5.
Vallier, Dora. *Braque:
 The Complete Graphics,
 Catalogue Raisonné.*
 Translated by Robert
 Bononno and Pamela Barr.
 New York: Gallery Books,
 1988. Cat. 6.

12
Still Life, ca. 1920
Pochoir
10¹³⁄₁₆ x 14³⁄₁₆ in.
(27.5 x 36 cm)
UVAM, 1975.43.10

13
Still Life, ca. 1920
Pochoir
10¹³⁄₁₆ x 14⅛ in.
(27.5 x 35.8 cm)
UVAM, 1975.43.11

14
Still Life, 1920
Pochoir
10⅞ x 14 in
(27.7 x 35.5 cm)
UVAM, 1975.43.12

15
Still Life, Fruit, ca. 1924–25
Oil and sand on canvas
7¾ x 25¹¹⁄₁₆ in.
(19.7 x 65.3 cm)
Handwritten on back:
 *This painting was purchased
 from Valentine Dudensing
 about 1926, when he had
 the shop on 44th, I gave it
 to LBJ [Louisa Brooke Jones]
 at that time. T.C.J.*
VMFA, 47.10.7

16†
Still Life, ca. 1932–38
Oil and sand on canvas
9⅝ x 18⅛ in.
(24.4 x 46 cm)
Signed l.l.: *G Braque*
VMFA, 47.10.8

17
Still Life, ca. 1935
Pochoir
11³⁄₁₆ x 14 in.
(28.4 x 35.6 cm)
Signed l.r.: *G. Braque*
VMFA, 47.10.9

GERALD M. BURN
1882–1963, English

18
Trafalgar Square, n.d.
Etching and drypoint
10⅜ x 15¾ in.
(26.3 x 40 cm)
Signed l.r.: *Gerald M. Burn*
UVAM, 1975.43.4

MASSIMO CAMPIGLI
1895–1971, Italian
Born Max Ihlenfeld in Germany
Active in Italy and France

19
Title unknown, ca. 1930
Conté crayon on paper
11¹⁄₁₆ x 8¹⁵⁄₁₆ in.
(28.1 cm x 22.7 cm)
Signed l.l.: *M. CAMPIGLI;*
in pencil under signature:
*with every good wish for the
new year*
UVAM, 1975.43.76.d

20†
Water Jugs, 1928
Oil on canvas
39½ x 30⅝ in.
(100.3 x 77.8 cm)
Signed and dated l.l.:
Massimo Campigli 1928
VMFA, 47.10.11

PROVENANCE
TCJ purchase, 1930

21
Charity School, 1929
Oil on canvas
32 x 39⁹⁄₁₆ in.
(81.3 x 100.5 cm)
Signed and dated l.l.:
Massimo Campigli 1929
VMFA, 47.10.10

22†
The Meeting, II, 1932
Etching and drypoint
12¹³⁄₁₆ x 9¹³⁄₁₆ in.
(32.5 x 25 cm)
Signed and dated l.r.:
Noël 1932 M Campigli
UVAM, 1975.43.76.c

PUBLISHED
Meloni, Francesco and Luigi
Tavola. *Campigli: Catalogo
ragionato dell'opera grafica
(Litografie e incisioni),
1930–1969.* Livorno:
Edizioni Graphis Arte,
1995. Cat. 8.

23
The Concert, 1935
Oil on canvas
38¼ x 75¼ in.
(97.2 x 191.1 cm)
Signed and dated l.l.:
Massimo Campigli 1935
VMFA, 41.15.1

MARC CHAGALL
1887–1985, Belarussian
Active in France, Germany,
Russia, and United States

24†
Walking Man, ca. 1914–20
Pen and ink on paper
6⁹⁄₁₆ x 3¹⁵⁄₁₆ in.
(16.6 x 10 cm)
Signed l.r.: *Chagall*
UVAM, 1975.43.8

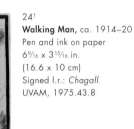

25†
The Trough, 1924
Lithograph
22½ x 15¼ in.
(57.2 x 38.8 cm)
Signed l.r.: *Marc Chagall*
Inscribed l.l.: *30/10*
Published by Jeanne Bucher,
Paris, 1925
UVAM, 1975.43.94

PUBLISHED
Meyer, Franz, and Hans
Bolliger. *Marc Chagall: His
Graphic Work.* New York:
Abrams, 1957. No. 29.
Mourlot, Fernand. *The
Lithographs of Chagall.* Vol.
1. Translated by Maria Jolas.
Monte Carlo: André Sauret;

New York: George Braziller,
1960. No. 25.
Gauss, Ulrike, ed. *Marc
Chagall, The Lithographs: La
Collection Sorlier.* Ostfildern-
Riut: Gerd Hatje, 1998. No. 25.

26†
The Eiffel Tower, 1943
Etching
17⁷⁄₁₆ x 12⅝ in.
(44.3 x 32 cm)
Signed l.r.: *Marc Chagall*
From *VVV, Portfolio of Eleven
Original Works: Etching,
Frottage, Objects,* 1943
UVAM, 1975.43.9

PUBLISHED
Meyer and Bolliger. No. 106.
Kornfeld, Eberhard W., ed.
*Marc Chagall: Catalogue
raisonné de l'oeuvre gravé.*
Vol. 1. Berne: Editions
Kornfeld et Klipstein, 1971.
Cat. 85.

J. CHAMPCOMMUNAL

27
Head of a Man, 1907
Etching and aquatint
13 x 10¾ in.
(33 x 27.3 cm)
Signed and dated l.l.:
*To Mr Catesby Jones J.
Champcommunal Paris 1907*
UVAM, 1975.43.78.d

SERGE CHARCHOUNE
1888–1975, Russian
Active in France, Spain, and
Germany

28
Abstract Painting, ca. 1925–30
Oil on canvas
8¹⁄₁₆ x 8¾ in.
(20.5 x 22.2 cm)
Signed l.r.: *Charchoune*
Gift of Mrs. Richard L. Riley for
the T. Catesby Jones Collection
VMFA, 48.6.1

HONORÉ DAUMIER
1808–1879, French

29
"What an obstacle this hussy from the fifth floor is. Wearing a bonnet! And two cups for a penny's worth of milk! Good Lord! Old mother Capitaine, what a crowd this morning," 1840
Lithograph, second state
10⅛ x 14 in.
(25.7 x 35.5 cm)
From *Parisian Types* (Types Parisiens), *Le Charivari*, September 9, 1942; first state published in *Caricature* 2, no. 12, March 22, 1840
UVAM, 1975.43.5

30
Meeting of learned men who experiment with new foodstuffs, 1856
Lithograph
9¹⁵⁄₁₆ x 13⅞ in.
(25.2 x 35.3 cm)
Dated l.r.: *23 Octobre 1856*
From *Eaters of Horse Meat* (Les hippophages), *Le Charivari*, October 23, 1856
UVAM, 1975.43.6

HERMINE DAVID
1886–1971, French
Active in France and United States

31
The Photographer, ca. 1923
Tempera on watercolor board
18¾ x 23⅝ in.
(47.6 x 60 cm)
VMFA, 47.10.12

32
Bakery in the South, 1923
Tempera on watercolor board
18⁷⁄₁₆ x 24¼ in.
(46.8 x 61.6 cm)
Signed and dated l.l.:
 Hermine David / 1923
VMFA, 47.10.13

ANDRÉ DERAIN
1880–1954, French

33†
Landscape in Provence, ca. 1919–25
Oil on canvas
18¼ x 21¾ in.
(46.3 x 55.2 cm)
Signed l.r.: *Derain*
VMFA, 47.10.14

PROVENANCE
TCJ purchase from Pierre Matisse, October 1925

34†
Still Life with Flowers, ca. 1919–25
Oil on panel
18⅛ x 13½ in.
(46 x 34.3 cm)
Signed l.r.: *Derain*
Gift of T. Catesby Jones
VMFA, 46.27.1

PROVENANCE
TCJ purchase from Fearon Galleries, January 1925

RAOUL DUFY
1877–1953, French

35†
Bather, 1918
Lithograph
24¾ x 20 in.
(62.8 x 50.8 cm)
Signed l.r.: *Raoul Dufy*
Inscribed l.l.: *24/100*
UVAM, 1975.43.86

PROVENANCE
TCJ purchase from Galerie Jeanne Bucher, 1927

36
Bay at Juan-les-Pins, ca. 1926
Lithograph
17¹³⁄₁₆ x 24⅞ in.
(45.2 x 63.2 cm)
Signed l.r.: *Raoul Dufy*
Inscribed l.r.: *47[?]/50*
UVAM, 1975.43.95

37†
Reclining Nude, 1929
Oil on canvas
18⅜ x 21½ in.
(46.7 x 54.6 cm)
Signed l.l.: *Raoul Dufy*
VMFA, 47.10.15

PUBLISHED
Tériade, E. "Raoul Dufy et le nu." *Cahiers d'art* 4 (May 1929). P. 127.
Maurice Laffaille. *Raoul Dufy: catalogue raisonné de l'oeuvre peint.* Vol. 3. Geneva: Editions Motte, 1976. No. 1123.
Setford, David F. *Raoul Dufy: Last of the Fauves.* West Palm Beach: Norton Museum of Art, 1999. Cat. 49.

38
The Sea, ca. 1925–31
Watercolor on paper
19¾ x 26 in.
(50.2 x 66 cm)
Signed l.r.: *Raoul Dufy*
VMFA, 47.10.16

ANDRÉ DUNOYER DE SEGONZAC
1884–1974, French

39
Fernande with Crossed Hands, 1923
Etching
10¹¹⁄₁₆ x 8¹³⁄₁₆ in.
(27.2 x 22.4 cm)
Signed l.r.: *a. Dunoyer de Segonzac*
Inscribed l.l.: *10/100*
UVAM, 1975.43.64

40
Fernande with Crossed Hands, 1923
Etching
10⅞ x 6⁹⁄₁₆ in.
(27.6 x 16.6 cm)
Signed l.r.: *a. Dunoyer de Segonzac*
Inscribed l.l.: *61/75*
UVAM, 1975.43.65

41
Versailles, the Large Poplars, 1924
Etching
10⅛ x 7¼ in.
(25.7 x 18.5 cm)
Signed l.r.: *a. Dunoyer de Segonzac*
Inscribed l.l.: *23[?]/75*
UVAM, 1975.43.63

EMMET EDWARDS
1906–1981, American

42
Abstract, 1939
Watercolor on paper
14¼ x 22⅝ in.
(36.2 x 57.5 cm)
Signed and dated l.r.: *Emmet
 Edwards 1939;* signed and
 dated l.r. on mat: *Emmet
 Edwards 1939*
VMFA, 47.10.17

ERNST FIPPERER

43
Street Scene, n.d
Etching and drypoint
12⅝ x 9¹⁵⁄₁₆ in.
(32 x 25.2 cm)
Signed l.r.: *Ernst Fipperer*
Inscribed l.l.: *54/250*
UVAM, 1975.43.78.b

ANDRÉ FRAIGNEAU
1905–1991, French

44
Bridge, 1929
Gouache on paper
9 x 12¼ in.
(22.8 x 31.1 cm)
Signed l.r.: *Cette gouache de
 Fraigneau pour T. Catesby
 Jones, Noel 29*
VMFA, 47.10.25

45
Illustration for *Ulysses,* n.d.
Gouache with india ink on
 ribbed paper
9 x 13⅝ in.
(22.9 x 34.6 cm)
VMFA, 47.10.18

46
Illustration for *Ulysses,* n.d.
Gouache with india ink on
 Vidalon paper
8¼ x 10⁹⁄₁₆ in.
(20.9 x 26.8 cm)
Signed l.r.: *Fraigneau*
VMFA, 47.10.19

47
Illustration for *Ulysses,* n.d.
Gouache on Vidalon paper
8¼ x 10½ in.
(20.9 x 26.7 cm)
Signed l.r.: *Fraigneau*
VMFA, 47.10.20

48
Illustration for *Ulysses,* n.d.
Brush and ink on thin bond
8³⁄₁₆ x 10½ in.
(20.8 x 26.7 cm)
Signed l.r.: *Fraigneau*
Inscribed u.r.: *3*
VMFA, 47.10.21

49
Illustration for *Ulysses,* n.d.
Brush and ink
8¼ x 10½ in.
(20.9 x 26.7 cm)
Signed c.r.: *Fraigneau*
Inscribed u.r.: *2*
VMFA, 47.10.22

50
Illustration for *Ulysses,* n.d.
Brush and ink
8¼ x 10½ in.
(20.9 x 26.7 cm)
Signed l.r.: *Fraigneau*
Inscribed u.r.: *2*
VMFA, 47.10.23

51
Landscape, n.d.
Gouache on drawing paper
8¼ x 11⅜ in.
(20.9 x 28.9 cm)
Signed l.r.: *Fraigneau*
VMFA, 47.10.24

52
Landscape, n.d.
Gouache
9 x 12¼ in.
(22.9 x 31.1 cm)
Signed l.r.: *Fraigneau*
VMFA, 47.10.26

OTHON FRIESZ
1879–1949, French

53
A Street in Honfleur, n.d.
Oil on canvas
17¼ x 14⅛ in.
(43.8 x 35.9 cm)
VMFA, 47.10.27

DEMETRIOS GALANIS
1880–1966, Greek
Active in France

54
The Hunt, n.d.
Wood engraving
14 x 9¹⁄₁₆ in.
(35.5 x 23 cm)
Signed l.r.: *D. Galanis*
Inscribed l.l.: *41/50*
UVAM, 1975.43.77.a

55
Still Life, n.d.
Mezzotint
8¹¹⁄₁₆ x 9¼ in.
(22 x 23.5 cm)
Signed l.r.: *D. Galanis*
Inscribed l.l.: *2/15*
UVAM, 1975.43.77.b

56
**Landscape at Bazarnes-sur-
Yonne,** n.d.
Wood engraving
9 x 13⅞ in.
(22.8 x 35.3 cm)
Signed l.r.: *D. Galanis*
Inscribed l.l.: *22/25*
UVAM, 1975.43.77.c

57
Still Life, n.d.
Wood engraving
9¼ x 11¾ in.
(23.5 x 29.8)
Signed l.r.: *D. Galanis*
Inscribed l.l.: *3/25*
UVAM, 1975.43.77.d

58
Nudes, n.d.
Wood engraving
14 x 9⅛ in.
(35.5 x 23.2 cm)
Signed l.r.: *D Galanis*
Inscribed l.l.: *17/25*
UVAM, 1975.43.77.e

59
Still Life, n.d.
Wood engraving
8⁹⁄₁₆ x 12¹⁄₁₆ in.
(21.7 x 30.7 cm)
Signed l.r.: *D. Galanis*
Inscribed l.l.: *11/20*
UVAM, 1975.43.77.f

60
Bridge over the Yonne, n.d.
Wood engraving
8¾ x 14 in.
(22.2 x 35.5 cm)
Signed l.r.: *D. Galanis*
Inscribed l.l.: *5/25*
UVAM, 1975.43.77.g

61
Landscape, n.d.
Wood engraving
13¾ x 13¼ in.
(35 x 33.7 cm)
Signed l.r.: *D Galanis*
Inscribed l.l.: *27/50*
UVAM, 1975.43.77.h

62
Still Life with Fish, n.d.
Wood engraving
11 x 13⁹/₁₆ in.
(28 x 34.4 cm)
Signed l.r.: *D Galanis*
Inscribed l.l.: *41/50*
UVAM, 1975.43.77.i

63
Still Life, n.d.
Lithograph
20⅞ x 16⁹/₁₆ in.
(53 x 42 cm)
Signed l.r.: *D. Galanis*
Inscribed l.l.: *23/25*
UVAM,1975.43.104

64
Palais des Papes, n.d.
Lithograph
25⅜ x 17¹³/₁₆ in.
(64.5 x 45.2 cm)
Signed l.r.: *D. Galanis*
Inscribed l.l.: *18/25*
UVAM, 1975.43.105

FRANCISCO DE GOYA
1746–1828, Spanish

65
Because She was Susceptible,
1799
Aquatint and etching
12⅛ x 7¹³/₁₆ in.
(30.8 x 19.8 cm)
From *Los Caprichos* (1799),
fourth [?] edition, 1878
UVAM, 1975.43.7

JUAN GRIS
1887–1927, Spanish
Born José Victoriano
Gonzaléz Pérez
Active in Spain and France

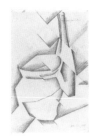

66†
Jug and Bottle, 1911
Charcoal on paper
19 x 12⅜ in.
(48.3 x 31.4 cm)
Signed and dated l.r.:
Juan Gris / 1911
VMFA, 47.10.29

PROVENANCE
TCJ purchase from Galerie
Jeanne Bucher, 1940

PUBLISHED
Kahnweiler, Daniel-Henry.
*Juan Gris, His Life and
Work.* Translated by Douglas
Cooper. New York: Abrams,
1969. Ill. 223.
Tinterow, Gary, ed. *Juan Gris.*
Madrid: Salas Pablo Ruiz
Picasso, 1985. Cat. 112.

67†
**Carafe, Glass, and Packet of
Tobacco,** 1914
Pasted paper, gouache, and
charcoal on canvas
18¼ x 10⅝ in.
(46.4 x 27 cm)
Signed on reverse: *Juan Gris*
VMFA, 47.10.28

PROVENANCE
TCJ purchase from Buchholz
Gallery, New York

PUBLISHED
Juan Gris. Buchholz Gallery,
1944. Cat. 18.
Gaya-Nuño, Juan Antonio.
Juan Gris. Boston: New York
Graphic Society, 1975. No.
297.
Cooper, Douglas, and
Margaret Potter. *Juan
Gris: Catalogue raisonné
de l'œuvre peint.* Paris:
Berggruen, 1977. Cat. 106.
Tinterow, Gary. No. 29.

68†
Brown-Haired Marcelle, 1921
Lithograph
15¾ x 12¹³/₁₆ in.
(40 x 32.6 cm)
Signed l.r.: *Juan Gris*
Inscribed l.r.: *20/50*
Published by Galerie Simon,
Paris, 1921
UVAM, 1975.43.90

MARCEL GROMAIRE
1892–1971, French

69†
Seated Nude, 1925
Etching
16⅝ x 13¹/₁₆ in.
(42.3 x 33.1 cm)
Signed l.l.: *Gromaire*
Inscribed l.r.: *30/50*
Published by Jeanne Bucher,
Paris, 1925
UVAM, 1975.43.3

PUBLISHED
Gromaire, François. *L'oeuvre
gravé de Marcel Gromaire.*
Vol. 1. Lausanne/Paris:
Bibliothèque des arts, 1976.
Cat. 64.

KIYOSHI HASEGAWA
1891–1980, Japanese
Active in Japan and France

70
Landscape, n.d.
Etching
9⁷/₁₆ x 12¾ in.
(24 x 32.4 cm)
Signed l.r.: *Kiyoshi-Hasegawa*
UVAM, 1975.43.78.c

STANLEY WILLIAM HAYTER
1901–1988, English
Active in England, France, and
United States

71
Street, 1930
Engraving
15¾ x 11¹³/₁₆ in.
(40 x 30 cm)
Signed l.r.: *S W Hayter*
Inscribed l.l.: *49/50*
Published by Jeanne Bucher,
Paris
UVAM, 1975.43.28

72†
Combat, 1936
Engraving (and scorper), soft-
ground etching with texture,
and burnisher
21¹/₁₆ x 24³/₁₆ in.
(53.5 x 61.4 cm)
Signed and dated l.r.:
S W Hayter 1936
Inscribed l.l.: *essai*
UVAM, 1975.43.81

PUBLISHED

Hacker, P. M. S., ed. *The Renaissance of Gravure: The Art of S.W. Hayter.* Oxford: Clarenden Press, 1988. Cat. 17.

Black, Peter, and Désirée Moorhead, eds. *The Prints of Stanley William Hayter: A Complete Catalogue.* New York: Moyer Bell, 1992. Cat. 102.

73†

Maternity, 1940

Engraving, soft-ground etching with texture, and silk-screen

14¾ x 11⅞ in.

(37.5 x 30.2 cm)

Signed l.r.: *SW Hayter;*

Inscribed l.l.: Σ

Gift of T. Catesby Jones

VMFA, 41.17.1

PUBLISHED

Hacker. Cat. 25.

Black and Moorhead. Cat. 132.

74†

Composition, 1941

Plaster, carved and impressed with engraved metal plate; ink; and water-based paint

12¹¹⁄₁₆ x 8⅝ in.

(32.2 x 21.9 cm)

Signed and dated l.r.: *Hayter 41*

Gift of T. Catesby Jones

VMFA, 41.17.2

PUBLISHED

Black and Moorhead. Cat. 139 (as *Mirror*).

75

Laocoön, 1943

Engraving (and scorper), and soft-ground etching with texture

15¼ x 25⅜ in.

(38.8 x 64.4 cm)

Signed and dated l.r.: *S W Hayter 43*

Inscribed l.l.: *10/30*

Published by Marian Willard Gallery, New York

UVAM, 1975.43.82

76

Grolier, 1944

Engraving

12¹⁵⁄₁₆ x 10¹⁄₁₆ in.

(32.8 x 25.6 cm)

Signed and dated l.r.: *SWH 21.10.44;* and u.l.: *For T. Catesby Jones*

Inscribed l.l.: *2nd state*

UVAM, 1975.43.29

77

Grolier, 1944

Engraving

11½ x 9 in.

(29.2 x 23.3 cm)

Signed and dated l.r.: *SWH 21.10.44;* and u.l.: *For T. Catesby Jones*

Inscribed l.l.: *3rd State, 1st Proof;* and l.c.: *Face, Figure-Mask*

UVAM, 1975.43.30

78

Principle of Flight, 1944

Engraving (and scorper), soft-ground etching

19½ x 13¹⁄₁₆ in.

(49.5 x 33.2 cm)

Signed and dated l.r.: *S W Hayter 44*

Inscribed l.l.: *11/30*

Published by George Wittenborn, New York

UVAM, 1975.43.83

79†

Cronos, 1944

Engraving (and scorper), soft-ground etching with texture

21¹⁄₁₆ x 25½ in.

(53.5 x 64.7 cm)

Signed and dated l.r.: *S W Hayter 44*

Inscribed l.l.: *15/50*

UVAM, 1975.43.84

PUBLISHED

Hacker. Cat. 42.

Black and Moorhead. Cat. 160.

EUGENE HIGGINS

1874–1958, American

80

The Mountebanks, 1874

Etching

9¾ x 11⁹⁄₁₆ in.

(24.8 x 29.4 cm)

Signed l.r.: *Eugene Higgins*

UVAM, 1975.43.80

JEAN HUGO

1894–1984, French

81

Interior, 1926

Gouache on paper

10½ x 14 in.

(26.7 x 35.6 cm)

Signed l.l.: *Jean Hugo*

VMFA, 47.10.30

82

In the Beginning, 1943

Engraving

15⅛ x 12¹⁵⁄₁₆ in.

(38.4 x 32.8 cm)

Signed and dated l.r.: *Hugo 1943*

Inscribed l.l.: *1/XXX*

UVAM, 1975.43.26

83

Title unknown, 1943

Engraving

8¾ x 11¾ in.

(22.2 x 29.8 cm)

Signed and dated l.r.: *Hugo 1943*

Inscribed l.l.: *3/XXV*

UVAM, 1975.43.27

PAUL KLEE

1879–1940, Swiss

Active in Switzerland and Germany

84

A Sensible Man, 1934

Silk-screen reproduction of original print

21¼ x 15¾ in.

(53.9 x 40 cm)

Signed c.l.: *Klee*

Dated l.l.: *1934*

Titled l.r.: *Ein Verstandiger*

VMFA, 47.10.32

85†

Clever Child, 1937

Charcoal and watercolor on chalk paste–primed ground on paper on cardboard

22¹⁄₁₆ x 16¹⁄₁₆ in.

(56 x 40.8 cm)

Signed l.r.: *Klee*

VMFA, 47.10.31

PROVENANCE

TCJ purchase from Galerie Jeanne Bucher, 1939

PUBLISHED

Paul Klee: Catalogue Raisonné. Vol. 7, *1934–1938.* Edited by Paul Klee Foundation, Museum of Fine Arts, Berne. London: Thames and Hudson, 2003. Cat. 7049.

ROGER DE LA FRESNAYE
1885–1925, French

86
Study for **Man, Drinking and Singing,** 1910
Pencil on paper
8 1/16 x 4 13/16 in.
(20.5 x 12.2 cm)
Signed l.r.: *R. de la Fresnaye*
Gift of the Estate of Mrs.
 Louisa Brooke Jones for the
 T. Catesby Jones Collection
VMFA, 68.10.2

87
Horses, ca. 1918
Wash drawing and *chine collé*
14 3/16 x 17 13/16 in.
(36 x 45.2 cm)
Signed l.r.: *R de la Fresnaye*
UVAM, 1975.43.79

JEAN-ÉMILE LABOUREUR
1877–1943, French

88
Bookplate with Reading Woman, 1924
Engraving
10 7/8 x 8 1/2 in.
(27.6 x 21.6 cm)
Signed l.l.: *laboureur*
UVAM, 1975.43.73.a

89
Bookplate with Reading Woman, 1924
Engraving
5 1/2 x 3 3/4 in.
(14 x 9.5 cm)
UVAM, 1975.43.73.b

JEAN-FRANCIS LAGLENNE
1899–1962, French

90
Title unknown, n.d.
Drypoint
12 x 8 7/8 in.
(30.5 x 22.5 cm)
Signed l.r.: *Laglenne*
Inscribed l.l.: *épreuve d'artiste*
UVAM, 1975.43.75

JULIUS J. LANKES
1884–1960, American

91
Blue Ridge Cabin, 1927
Woodcut
5 7/8 x 7 3/8 in.
(15 x 18.8 cm)
Signed l.r.: *J. J. Lankes*
UVAM, 1975.43.35

92
Vermont Farmhouse, 1927
Woodcut
6 x 7 7/8 in.
(15.3 x 20 cm)
Signed l.r.: *J. J. Lankes*
Inscribed in unknown hand l.l.:
 R. Frost's home
UVAM, 1975.43.39

93
Mountain Church, n.d.
Woodcut
5 7/8 x 7 7/8 in.
(15 x 20 cm)
Signed l.r.: *J. J. Lankes*
UVAM, 1975.43.38

MARIE LAURENCIN
1885–1956, French

94
The Creole Woman, 1924
Lithograph
22 3/16 x 14 7/8 in.
(56.3 x 37.8 cm)
Signed l.r.: *Marie Laurencin*
Inscribed l.l.: *97/100*
Published by Galerie
 Flechtheim, Dusseldorf
UVAM, 1975.43.87

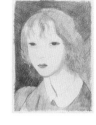

95†
Portrait of a Young Girl, 1925
Lithograph
10 13/16 x 8 7/8 in.
(27.4 x 22.6 cm)
Signed l.r.: *Marie Laurencin*
Inscribed l.l.: *19/100*
From deluxe edition of *L'art
 d'aujourd'hui* 2, no. 8, 1925
UVAM, 1975.43.36

PUBLISHED
Marchesseau, Daniel. *Marie
 Laurencin: catalogue raisonné
 de l'oeuvre gravé.* Tokyo:
 Kyuryudo, 1981. Cat. 76.

96†
Juliette, 1925
Lithograph
15 1/4 x 11 1/8 in.
(38.7 x 28.2 cm)
Signed l.r.: *Marie Laurencin*
From *Le portefeuille des
 peintre–graveurs
 indépendants pour 1925,
 I: lithographies,* Albert
 Morancé, Paris, 1925
UVAM, 1975.43.37

PUBLISHED
Marchesseau. Cat. 78.

HENRI LAURENS
1885–1954, French

97
Valencia, ca. 1927
Etching
12 13/16 x 19 5/16 in.
(32.5 x 49 cm)
Signed l.r.: *Laurens*
Inscribed l.l.: *74/100*
UVAM, 1975.43.33

98
Two Nudes, ca. 1929
Etching
11 11/16 x 19 3/8 in.
(29.7 x 49.2 cm)
Signed l.r.: *Laurens*
Inscribed l.l.: *47/10*
UVAM, 1975.43.34

LÉOPOLD-LÉVY
1882–1966, French

99
Landscape, n.d.
Drypoint
13³⁄₁₆ x 19 in.
(33.5 x 48.3 cm)
Signed l.r.: *Leopold-Levy*
Inscribed l.l.: *47/50*
UVAM, 1975.43.40

ANDRÉ LHOTE
1885–1962, French

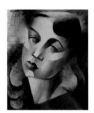

100†
Expressive Head, ca. 1920–24
Oil on canvas
18 x 14¹⁵⁄₁₆ in.
(45.7 x 37.9 cm)
Signed u.l.: *A Lhote*
VMFA, 47.10.33

PROVENANCE
TCJ purchase at Salon des
Tuileries, 1924

PUBLISHED
*Salon des Tuileries, Paris
1924, Au palais de bois à
la porte Maillot.* Paris: n.p.,
1924. Cat. 981.

JACQUES LIPCHITZ
1891–1973, French
Born Chaim Jacob Lipchitz
in Lithuania
Active in France and United
States

101†
Jacob and the Angel, 1939
Red, white, and black crayon
on green paper
10⅛ x 13 in.
(25.7 x 33 cm)
Signed and dated u.r.:
Lipchitz / 39
Gift of T. Catesby Jones
VMFA, 41.14.1

PUBLISHED
Lipchitz, Jacques. With H. H.
Arnason. *My Life in
Sculpture.* New York: Viking
Press, 1972. Fig. 129.

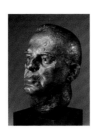

102†
**Portrait Head of T. Catesby
Jones,** 1941
Bronze
15⅝ x 13½ x 10⅛ in.
(39.7 x 34.3 x 25.7 cm)
Signed on reverse: *J Lipchitz*
Museum Purchase, General
Endowment Fund Income
VMFA, 47.18.1

PUBLISHED
Wilkinson, Alan G. *The
Sculpture of Jacques Lipchitz:
A Catalogue Raisonné.* Vol.
2, *The American Years,
1941–1973.* New York:
Thames & Hudson, 2000.
Cat. 351.

103†
Theseus, 1943
Etching, engraving, and aquatint
19¹³⁄₁₆ x 14¹⁵⁄₁₆ in.
(50.3 x 38 cm)
Signed l.r.: *à Monsieur
Catesby Jones en toute
amitié J Lipchitz*
Inscribed l.l.: *Épreuve d'essai*
UVAM, 1975.43.97

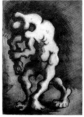

104
The Road to Exile, 1944
Etching, engraving, and aquatint
22¹³⁄₁₆ x 18⁹⁄₁₆ in.
(58 x 47.2 cm)
Signed l.r.: *A Monsieur
Catesby Jones en toute
amitié J Lipchitz*
Inscribed l.l.: *Épreuve d'éssai*
UVAM, 1975.43.99

JEAN LURÇAT
1892–1966, French

105†
Reclining Nude, 1919
Gouache on paper
24½ x 18¾ in.
(62.2 x 47.6 cm)
Signed and dated l.r.: *Lurçat
1919*
VMFA, 47.10.53

PUBLISHED
Denizeau, Gérard, and Simone
Lurçat. *L'oeuvre peint de
Jean Lurçat, catalogue
raisonné, 1910–1965.*
Lausanne: Acatos, 1998.
Cat. 1919-9.

106†
Interior with Table, 1922
Gouache on paper
14¾ x 17⅞ in.
(37.5 x 45.4 cm)
Signed and dated l.r.: *Lurçat
1922*
VMFA, 47.10.47

PUBLISHED
Denizeau and Lurçat. Cat.
1922-27.

107†
Tour Eiffel, 1925
Drypoint
18½ x 15¹⁄₁₆ in.
(47 x 38.3 cm)
Signed l.r.: *J Lurçat*
Inscribed l.l.: *30/50*
UVAM, 1975.43.31

108†
Algerian Woman, 1925
Gouache on paper
20⅞ x 14¾ in.
(53 x 37.5 cm)
Signed and dated l.l.: *Lurçat 25*
VMFA, 47.10.44

PUBLISHED
Denizeau and Lurçat. Cat.
1925-50.

109†
Smyrna, ca. 1927
Color lithograph
17⁷⁄₁₆ x 22⅝ in.
(44.3 x 57.4 cm)
Signed l.r.: *J Lurçat*
Inscribed l.l.: *47/50*
UVAM, 1975.43.103

110
Four Fruits, 1927
Oil on wood panel
10¼ x 13¾ in.
(26.1 x 34.9 cm)
Signed and dated c.l.: *Lurçat 27*
VMFA, 47.10.35

111
Fruit and Sunrise, 1927
Oil on wood panel
15 x 15½ in.
(38.1 x 39.3 cm)
Signed c.r.: *Lurçat*
VMFA, 47.10.36

112
The Blue Cloth, 1927
Oil on canvas
16¼ x 10⅝ in.
(41.2 x 27 cm)
Signed l.l.: *Lurçat*
VMFA, 47.10.39

113
Greek Wrestlers, 1928
Oil on canvas
18³⁄₁₆ x 25¾ in.
(46.2 x 65.4 cm)
Signed and dated l.r.: *Lurçat 28*
VMFA, 47.10.42

114†
Needlepoint Screen, 1928
Wool on three panels
Each panel: 77 x 29 in.
(195.6 x 73.7 cm)
Signed and dated l.r.: *JL 1928*
Gift of the Estate of Mrs.
 Louisa Brooke Jones for the
 T. Catesby Jones Collection,
VMFA, 68.10.3.1–3

115
Three Figures, 1929
Oil on canvas
15 x 24 in.
(38.1 x 61 cm)
Signed and dated c.r.: *Lurçat 29*
VMFA, 47.10.41

116
Three Figures, 1929
Gouache on paper
19 x 25⅝ in.
(48.3 x 65.1 cm)
Signed and dated l.r.:
 Lurçat / 29
VMFA, 47.10.54

117
The Côte des Landes, 1930
Oil on canvas
38 x 51 in.
(96.5 x 129.5 cm)
Signed and dated l.l.: *Lurçat 30*
VMFA, 47.10.34

118
Battle of Trafalgar, 1930
Oil on canvas
11 x 16 in.
(27.9 x 40.6 cm)
Signed and dated l.l.: *Lurçat
 1930*
VMFA, 47.10.37

119
Nude, 1930
Oil on wood panel
13¾ x 9½ in.
(34.9 x 24.1 cm)
Signed and dated l.l.: *Lurçat 30*
VMFA, 47.10.38

120†
Wind and Blue Sky, 1930
Oil on canvas
39⅞ x 23¼ in.
(101.3 x 59 cm)
Signed and dated l.r.: *Lurçat
 NY / 30*
VMFA, 47.10.40

PUBLISHED
*Painting in Paris from American
 Collections.* New York:
 Museum of Modern Art,
 1930. Pl. 49.
*Modern Works of Art: Fifth
 Anniversary Exhibition.* New
 York: Museum of Modern
 Art, 1934. Cat. 101.
Denizeau and Lurçat. Cat.
 1930-89.

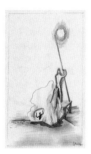

121
The Dry Island, 1930
Pencil on paper
11¼ x 7½ in.
(28.6 x 19 cm)
Signed l.r.: *Lurçat*
VMFA, 47.10.57

122
Masts and Ropes, 1930
Drypoint
12⅜ x 9¹¹⁄₁₆ in.
(31.5 x 24.6 cm)
Signed l.l.: *Lurçat*
UVAM, 1975.43.76.a

123
Catesby Jones Christmas Card,
 1930
Drypoint
8³⁄₁₆ x 28³⁄₁₆ in.
(20.8 x 28.2 cm)
Signed l.l.: *Lurçat*
UVAM, 1975.43.76.b

124
European Nobility, 1931
Collotype reproduction of
 1931 pen drawing
12⅞ x 17¹¹⁄₁₆ in.
(32.7 x 45 cm)
Signed and dated l.r.:
 Lurçat 1931
From *P. P. C.,* Jeanne Bucher,
 Paris, 1933
UVAM, 1975.43.32.a

125
The Sovereign Individual, 1931
Collotype reproduction of
 1931 pen drawing
12¹⁵⁄₁₆ x 17¹³⁄₁₆ in.
(32.8 x 45.2 cm)
Signed and dated l.r.:
 Lurçat 1931
From *P. P. C.,* Jeanne Bucher,
 Paris, 1933
UVAM, 1975.43.32.b

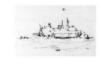

126
The Lyre, 1931
Collotype reproduction of
 1931 pen drawing
12¹³⁄₁₆ x 17¹¹⁄₁₆ in.
(32.6 x 45 cm)
Signed and dated l.r.:
 Lurçat 1931
From *P. P. C.,* Jeanne Bucher,
 Paris, 1933
UVAM, 1975.43.32.c

127
A Star without a Barn, 1931
Collotype reproduction of
 1931 pen drawing
12¾ x 17¾ in.
(32.5 x 45.3 cm)
Signed and dated l.r.:
 Lurçat 1931
From *P. P. C.,* Jeanne Bucher,
 Paris, 1933
UVAM, 1975.43.32.d

128
After This We Begin Again, 1931
Collotype reproduction of
 1931 pen drawing
12¹⁵⁄₁₆ x 17¹¹⁄₁₆ in.
(32.8 x 44.9 cm)
Signed and dated l.r.:
 Lurçat 1931
From *P. P. C.,* Jeanne Bucher,
 Paris, 1933
UVAM, 1975.43.32.e

129
The Raft of the Medusa, 1931
Collotype reproduction of
　1931 pen drawing
12¹¹/₁₆ x 17¹¹/₁₆ in.
(32.3 x 45 cm)
Signed and dated l.r.:
　Lurçat 1931
From *P. P. C.,* Jeanne Bucher,
　Paris, 1933
UVAM, 1975.43.32.f

130
**Latest Monuments to the
Victims of Idealism,** 1931
Collotype reproduction of
　1931 pen drawing
12¹³/₁₆ x 17⁵/₈ in.
(32.5 x 44.8 cm)
From *P. P. C.,* Jeanne Bucher,
　Paris, 1933
UVAM, 1975.43.32.g

131
S.O.S.!, 1931
Collotype reproduction of
　1931 pen drawing
12³/₄ x 17³/₄ in.
(32.5 x 45.3 cm)
Signed and dated l.r.:
　Lurçat 1931
From *P. P. C.,* Jeanne Bucher,
　Paris, 1933
UVAM, 1975.43.32.h

132
The Sovereign Individual, 1931
Pen and ink on paper
13¹/₈ x 19¹/₈ in.
(33.3 x 48.6 cm)
Signed and dated l.r.: *Lurçat,
　1931*
Inscribed l.c.: *"Le Seigneur
　Individu";* l.r.: *Original*
VMFA, 47.10.55

133
European Nobility, 1931
Pen and ink on paper
13¹/₄ x 19¹/₁₆ in.
(33.6 x 48.4 cm)
Signed and dated l.r.: *Lurçat,
　1931*
Inscribed l.c.: *"Noblesses
　Europennes";* l.r.: *Original*
VMFA, 47.10.56

134
Landscape, 1932
Gouache on paper
13 x 26 in.
(33 x 66 cm)
Signed and dated l.r.:
　Lurçat 1932
VMFA, 47.10.48

135
Study, 1932
Gouache on paper
8⁷/₈ x 11 in.
(22.5 x 27.9 cm)
Signed l.r.: *Lurçat*
VMFA, 47.10.49

136†
Bathers, 1934
Oil on Masonite
20 x 31 in.
(50.8 x 78.7 cm)
Signed and dated l.r.: *Lurçat 34*
VMFA, 47.10.95

PUBLISHED
Denizeau and Lurçat. Cat.
　1934-1.

137
Hunters, 1934
Oil on canvas
16 x 29¹/₂ in.
(41.6 x 74.9 cm)
Signed and dated l.r.: *Lurçat 34*
VMFA, 47.10.96

138
Figures and Rocky Shore, 1935
Oil on Masonite
20 x 24 in.
(50.8 x 60.9 cm)
Signed and dated l.r.: *Lurçat 35*
VMFA, 47.10.97

139
Marine, 1936
Gouache on paper
12¹/₂ x 19¹/₄ in.
(31.7 x 48.9 cm)
VMFA, 47.10.52

140
Prophetic Landscape, 1936
Oil on canvas
33⁷/₈ x 56¹/₄ in.
(86.1 x 142.8 cm)
Signed and dated u.r.:
　Lurçat 1936
VMFA, 47.10.99

141
Bathers and Emerald Sea, 1936
Oil on canvas
20¹/₄ x 24 in.
(51.4 x 60.9 cm)
VMFA, 47.10.98

142†
Two Fishermen, 1938
Gouache on paper
15³/₈ x 16¹/₂ in.
(39 x 41.9 cm)
Signed and dated l.r.: *Lurçat 38*
VMFA, 47.10.45

PUBLISHED
Denizeau and Lurçat. Cat.
　1938-19.

143
Beach Scene, 1939
Gouache on paper
11¹/₂ x 22⁷/₈ in.
(29.2 x 58.1 cm)
Signed, dated, and inscribed l.r.:
　*Lurçat /1939 / Pour Victor,
　Mai 1939*
VMFA, 47.10.46

144
Fighting Figures, 1939
Gouache on paper
10³/₈ x 15¹/₈ in.
(26.3 x 38.4 cm)
Signed and dated l.r.: *Lurçat 39*
VMFA, 47.10.50

145
Fighting Figures, 1939
Gouache on paper
12¹/₈ x 15 in.
(30.8 x 38.1 cm)
Signed, dated, and inscribed l.r.:
　*Pour mi amis aout 1939 /
　Catesby Jones / J. Lurçat*
VMFA, 47.10.51

146†
The Ruins (Les décombres),
　1945
Gouache on paper
9⁵/₈ x 12⁷/₈ in.
(24.4 x 32.7 cm)
Signed and dated l.r.: *Lurçat 45*
VMFA, 47.10.43

PUBLISHED
Denizeau and Lurçat. Cat.
　1945-9.

ARISTIDE MAILLOL
1861–1944, French

147†
Nude, ca. 1920–44
Black and white chalk on
　paper, handmade by artist
12³/₄ x 8³/₈ in.
(32.4 x 21.3 cm)
Signed in circle below
　drawing: *M*
VMFA, 47.10.65

148
Crouching Woman Seen from the Back (second plate), 1925
Lithograph
11 x 8⁷⁄₈ in.
(28 x 22.6 cm)
Signed in circle l.r.: *M*
Inscribed l.l.: *19/100*
From deluxe edition of *L'Art d'aujourd'hui* 2, 1925
UVAM, 1975.43.44

KURT MAINZ

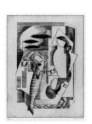

149
Head of Woman, 1924 or earlier
Drypoint
11⁷⁄₈ x 8³⁄₈ in.
(30.2 x 21.1 cm)
Signed l.r.: *Mainz*
Inscribed l.l.: *3/12*
UVAM, 1975.43.72.a

LOUIS MARCOUSSIS
1883–1941, French,
Born Ludwig Casimir Ladislas
Markus in Poland
Active in France

150†
Viareggio (La dépêche de Toulouse), 1926
Drypoint
19¹⁄₂ x 12¹⁵⁄₁₆ in.
(49.5 x 32.9 cm)
Signed l.r.: *Marcoussis*
Inscribed l.l.: *30/50*
Published by Jeanne Bucher, Paris, 1926
UVAM, 1975.43.47

PUBLISHED

Lafranchis, Jean. *Marcoussis: sa vie, son œuvre, catalogue complet des peintures, fixés sur verre, aquarelles, dessins, gravures.* Paris: Éditions du Temps, 1961. G. 40.
Milet, Solange. *Louis Marcoussis: catalogue raisonné de l'œuvre gravé.* Copenhagen: Forlaget Cordelia, 1991. Cat. 45.

151†
The Lighthouse, ca. 1926
Gouache on paper
14⁷⁄₈ x 11³⁄₄ in.
(37.8 x 29.8 cm)
Signed l.r.: *Marcoussis*
VMFA, 47.10.66

PROVENANCE

TCJ purchase from Galerie Jeanne Bucher, Paris, 1927

PUBLISHED

Lafranchis. D. 64.

152†
Interior (Pedestal Table with Breton Bread, Balcony), ca. 1929–30
Oil on canvas
13¹⁄₄ x 7⁵⁄₈ in.
(33.6 x 19.4 cm)
VMFA, 47.10.67

PUBLISHED

Lafranchis. P. 199.

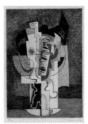

153†
The Table, 1930
Color etching
17¹¹⁄₁₆ x 12³⁄₈ in.
(45 x 31.5 cm)
Signed l.r.: *Marcoussis*
Inscribed l.l.: *4/20*
Published by Jeanne Bucher, Paris, 1930
UVAM, 1975.43.46

PUBLISHED

Lafranchis. G. 62.
Milet. Cat. 52.

ANDRÉ MASSON
1896–1987, French
Active in France and United States

154†
Man and Woman, ca. 1925–30
Oil on canvas
21³⁄₄ x 13³⁄₈ in.
(55.2 x 33.9 cm)
Signed on reverse:
André Masson
VMFA, 47.10.70

155†
Abstract, ca. 1925–30
Watercolor
24¹⁄₂ x 18¹⁄₈ in.
(62.2 x 46 cm)
Signed l.l.: *André Masson*
VMFA, 47.10.71

156†
Metamorphoses, 1929
Pastel on prepared paper
21³⁄₈ x 42¹¹⁄₁₆ in.
(54.3 x 108.4 cm)
Signed l.l.: *André Masson*
VMFA, 47.10.69

PROVENANCE

TCJ purchase from Jeanne Bucher, Paris

PUBLISHED

Alfred H. Barr Jr. *Cubism and Abstract Art.* New York: Museum of Modern Art. No. 200.

157
Metamorphoses, 1941
Gouache (or tempera), sand, and pastel on canvas
28¹⁄₄ x 23³⁄₄ in.
(71.7 x 60.3 cm)
Signed and dated: l.l.: *André Masson 1941*
VMFA, 47.10.68

158†
Dream of a Future Desert, 1942
Etching with drypoint
20¹⁄₁₆ x 25⁹⁄₁₆ in.
(50.9 x 64.9 cm)
Signed l.r.: *André Masson*
Published by Buchholz Gallery, Curt Valentin, New York, 1942
UVAM, 1975.43.89

PUBLISHED

Saphire, Lawrence. *André Masson: The Complete Graphic Work.* Vol. 1. New York: Blue Moon Press, 1990. Cat. 90.

159
Meditation, 1945
Lithograph
11 x 14³⁄₁₆ in.
(28 x 36 cm)
Signed l.r.: *André Masson*
Inscribed l.l.: *5/30*
Published by Buchholz Gallery, Curt Valentin, New York, 1945
UVAM, 1975.43.1

160
Sleep, 1945
Lithograph
11 x 13 11/16 in.
(28.2 x 34.7 cm)
Signed l.r.: *André Masson*
Inscribed l.l.: *5/30*
Published by Buchholz Gallery,
 Curt Valentin, New York, 1945
UVAM, 1975.43.2

161†
Portrait of Georges Duthuit, 1945
Lithograph
13 3/16 x 9 15/16 in.
(33.5 x 25.2 cm)
Signed l.l.: *André Masson*
From deluxe edition of *Georges
 Duthuit, Le serpent dans la
 galère,* Buchholz Gallery, Curt
 Valentin, New York, 1945
UVAM, 1975.43.45

PUBLISHED
Saphire. Cat. 111.

162
The Misanthrope, 1945
Soft-ground etching and aquatint
12 1/2 x 10 in.
(31.7 x 25.4 cm)
Signed l.r.: *André Masson*
Inscribed l.l.: *22/30*
Published by Buchholz Gallery,
 Curt Valentin, New York
Gift of Curt Valentin in memory
 of T. Catesby Jones
VMFA, 47.15.1

163
Rodeo, 1945
Soft-ground etching
12 11/16 x 19 1/2 in.
(32.2 x 49.5 cm)
Signed l.r.: *André Masson*
Inscribed l.l.: *28/50*
Published by Buchholz Gallery,
 Curt Valentin, New York
Gift of Curt Valentin in memory
 of T. Catesby Jones
VMFA, 47.15.2

164†
**Improvisation (Face through
the Leaves),** 1945
Aquatint and engraving
12 3/4 x 10 1/4 in.
(32.4 x 26 cm)
Signed l.r.: *André Masson*
Inscribed l.l.: *22/30*
Published by Buchholz Gallery,
 Curt Valentin, New York
Gift of Curt Valentin in memory
 of T. Catesby Jones
VMFA, 47.15.4

PUBLISHED
Saphire. Cat. 94.

165
Apparition, 1945
Lithograph
14 1/4 x 11 in.
(36.2 x 27.9 cm)
Signed l.r.: *André Masson*
Inscribed l.l.: *5/30*
Published by Buchholz Gallery,
 Curt Valentin, New York
Gift of Curt Valentin in memory
 of T. Catesby Jones
VMFA, 47.15.6

166
Meditation, 1945
Lithograph
11 x 13 15/16 in.
(27.9 x 13.9 cm)
Signed l.r.: *André Masson*
Inscribed l.l.: *7/30*
Published by Buchholz Gallery,
 Curt Valentin, New York
Gift of Curt Valentin in memory
 of T. Catesby Jones
VMFA 47.15.7

167
Wheat (The Seeded Earth),
 1945
Lithograph
13 x 9 7/8 in.
(33 x 25.1 cm)
Signed l.r.: *André Masson*
Inscribed l.l.: *15/30*
Published by Galerie Louis
 Leiris, Paris
Gift of Curt Valentin in memory
 of T. Catesby Jones
VMFA, 47.15.10

168
At the Theater, 1946
Soft-ground etching and aquatint
15 x 19 3/8 in.
(38.1 x 49.2 cm)
Signed l.r.: *André Masson*
Inscribed l.l.: *13/30*
Published by Galerie Louis
 Leiris, Paris
Gift of Curt Valentin in memory
 of T. Catesby Jones
VMFA, 47.15.3

169
Nude (The Source), 1946
Lithograph
19 1/2 x 25 1/2 in.
(49.5 x 64.8 cm)
Signed l.r.: *André Masson*
Inscribed l.l.: *22/30*
Published by Galerie Louis
 Leiris, Paris
Gift of Curt Valentin in memory
 of T. Catesby Jones
VMFA, 47.15.5

170
Portrait of Curt Valentin, 1946
Lithograph
21 3/8 x 17 5/8 in.
(54.3 x 44.8 cm)
Signed l.r.: *André Masson*
Inscribed l.l.: *11/30*
Published by Galerie Louis
 Leiris, Paris
Gift of Curt Valentin in memory
 of T. Catesby Jones
VMFA, 47.15.8

171
Childhood, 1946
Lithograph
17 3/4 x 12 1/2 in.
(45.1 x 31.7 cm)
Signed l.r.: *André Masson*
Inscribed l.l.: *19/35*
Published by Galerie Louis
 Leiris, Paris
Gift of Curt Valentin in memory
 of T. Catesby Jones
VMFA, 47.15.9

HENRI MATISSE
1869–1954, French

172†
**Crouching Nude with Eyes
Lowered,** 1906
Lithograph
17 13/16 x 11 1/16 in.
(45.2 x 28.1 cm)
Signed l.l.: *H M*
Inscribed l.l.: *11/25*
UVAM, 1975.43.42

PUBLISHED
Duthuit-Matisse, Marguerite, and
 Claude Duthuit. With Françoise
 Garnaud. *Henri Matisse,
 catalogue raisonné de
 l'oeuvre gravé.* Vol. 2. Paris:
 C. Duthuit, 1983. Cat. 394.

173†
Nude Seen from Behind,
 ca. 1909
Pen and ink on paper
10 1/2 x 8 1/16 in.
(26.7 x 20.5 cm)
Signed l.r.: *Henri Matisse*
VMFA, 47.10.74

174†
Lorette, 1917
Oil on panel
13 3/4 x 10 7/16 in.
(34.9 x 26.5 cm)
Signed l.r.: *Henri Matisse*
VMFA, 47.10.72

175†
Lorette, 1917
Oil on panel
13¾ x 10⁷⁄₁₆ in.
(34.9 x 26.5 cm)
Signed l.r.: *Henri Matisse*
VMFA, 47.10.73

PROVENANCE
TCJ purchase from Pierre
Matisse, October 1925

176†
**Two Views of the Same
Woman,** ca. 1918–19
Pen and ink on paper
10⁵⁄₈ x 14³⁄₈ in.
(27 x 36.5 cm)
Signed l.r.: *Henri Matisse*
VMFA, 47.10.76

177
Sketch of Woman with Violin,
ca. 1921–25
Pen and ink on paper
14½ x 10½ in.
(36.8 x 26.7 cm)
Signed l.r.: *Henri Matisse*
VMFA, 47.10.75

178
Odalisque with a Necklace,
1923
Lithograph
11¹⁵⁄₁₆ x 18⁷⁄₁₆ in.
(30.4 x 46.8cm)
Signed l.r.: *Henri Matisse*
Inscribed l.l.: *48/50*
UVAM, 1975.43.48

179
Girl with Brown Curls, 1924
Lithograph
10⁵⁄₈ x 8¹⁵⁄₁₆ in.
(27 x 22.7 cm)
Signed l.r.: *Henri Matisse*
Inscribed l.l.: *19/100*
UVAM, 1975.43.43

180†
Odalisque with Fruit Bowl,
1925
Lithograph
18⁷⁄₈ x 12¹⁵⁄₁₆ in.
(48 x 32.8 cm)
Signed l.r.: *Henri Matisse*
Inscribed l.r.: *21/50*
UVAM, 1975.43.49

PUBLISHED
Duthuit-Matisse and Duthuit.
Cat. 466.

181†
**Odalisque with Red Satin
Culottes,** 1925
Lithograph
11¼ x 14⁵⁄₁₆ in.
(28.6 x 36.4 cm)
Signed l.r.: *Henri Matisse*
Inscribed l.r.: *22/50*
UVAM, 1975.43.50

PUBLISHED
Duthuit-Matisse and Duthuit.
Cat. 456.

182†
Interior, Reading, 1925
Lithograph
14¹⁵⁄₁₆ x 11 in.
(38 x 28 cm)
Signed l.r.: *Henri Matisse*
Inscribed l.r.: *22/50*
UVAM, 1975.43.51

PUBLISHED
Duthuit-Matisse and Duthuit.
Cat. 457.

183
Sleeping Dancer, 1927
Lithograph
20 x 25⁷⁄₈ in.
(50.8 x 65.7 cm)
Signed l.r.: *Henri Matisse*
Inscribed l.r.: *47/50*
UVAM, 1975.43.91

EDGAR JAMES MAYBERY
1887–1964, English

184
Tower Bridge Monmouth, n.d.
Etching
11½ x 9⅛ in.
(29.2 x 23.2 cm)
Signed l.r.: *E J Maybery*
UVAM, 1975.43.72.b

185
Chepstow Castle, n.d.
Etching
9¹⁄₁₆ x 9¹³⁄₁₆ in.
(23 x 25 cm)
Signed l.r.: *E J Maybery*
UVAM, 1975.43.72.d

AMEDEO MODIGLIANI
1884–1920, Italian
Active in France

186†
Portrait of Paresce, ca.1915–19
Pencil on paper
16³⁄₈ x 10¹⁄₁₆ in.
(41.6 x 25.6 cm)
Signed l.r.: *Modigliani*
Inscribed u.l.: *PARESCE*
VMFA, 47.10.77

PABLO PICASSO
1881–1973, Spanish
Active in Spain and France

187–199 from *The Saltimbanques*
(Les saltimbanques), Ambroise
Vollard, Paris, 1913, after steel
facing of plate.

PUBLISHED
Bloch, Georges. *Pablo Picasso:
catalogue de l'oeuvre gravé
et lithographié, 1904–1967.*
Berne: Kornfeld et Klipstein,
1968. Cats. 1–7, 9–10, 12–15.

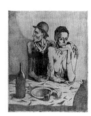

187†
The Frugal Repast, 1904
Etching
26⅛ x 20¹⁄₁₆ in.
(66.3 x 50.9 cm)
UVAM, 1975.43.85

188
The Dance, 1905
Drypoint
12¹⁵⁄₁₆ x 19⅛ in.
(32.8 x 48.6 cm)
UVAM, 1975.43.13

189
The Mother's Grooming, 1905
Etching
19¹⁄₁₆ x 12¹⁵⁄₁₆ in.
(48.4 x 32.8 cm)
UVAM, 1975.43.14

190
Saltimbanque at Rest, 1905
Drypoint
18⁹⁄₁₆ x 13 in.
(48 x 33 cm)
UVAM, 1975.43.16

191
Head of a Man, 1905
Drypoint
18¼ x 12⅞ in.
(47 x 32.7 cm)
Signed and dated u.l.: *Picasso
2–05*
UVAM, 1975.43.17

192†
The Two Saltimbanques, 1905
Drypoint
18⅜ x 13 in.
(46.6 x 33 cm)
Signed and dated in plate u.l.:
Picasso 1905
UVAM, 1975.43.18

193†
At the Circus, 1905
Drypoint
19¼ x 13⅛ in.
(48.9 x 33.4 cm)
UVAM, 1975.43.19

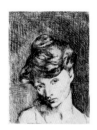

194
Head of a Woman, 1905
Etching
19⁷⁄₁₆ x 13 in.
(49.4 x 33 cm)
UVAM, 1975.43.20

195
The Poor Ones, 1905
Etching
19¼ x 13⅛ in.
(48.9 x 33.4 cm)
UVAM, 1975.43.23

196†
The Saltimbanques, 1905
Drypoint
20 x 25¹⁵⁄₁₆ in.
(50.8 x 65.9 cm)
Signed and dated in plate l.r.:
Picasso 1905
UVAM, 1975.43.88

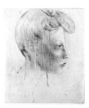

197
Head of a Woman in Profile,
1905
Drypoint
26 x 20¹⁄₁₆ in.
(66 x 51 cm)
UVAM, 1975.43.100

198
The Bath, 1905
Drypoint
26 x 20¹⁄₁₆ in.
(66 x 51 cm)
Signed and dated in plate u.r.:
Picasso 1905
UVAM, 1975.43.101

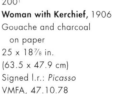

199†
Salomé, 1905
Drypoint
23⅝ x 20³⁄₁₆ in.
(60 x 51.2 cm)
Signed and dated in plate u.r.:
Picasso 1905
UVAM, 1975.43.102

200†
Woman with Kerchief, 1906
Gouache and charcoal
on paper
25 x 18⅞ in.
(63.5 x 47.9 cm)
Signed l.r.: *Picasso*
VMFA, 47.10.78

PROVENANCE
TCJ purchase from Valentine
Dudensing, New York, 1929

PUBLISHED
Daix, Pierre, and Georges
Boudaille. With Joan
Rosselet. *Picasso, the Blue and
Rose Periods: A Catalogue
Raisonné, 1900–1906.*
Translated by Phoebe Pool.
London: Evelyn, Adams &
Mackay, 1967. No. XV. 45.

201†
Landscape, 1907
Gouache on paper mounted
on cardboard
25½ x 19⅝ in.
(64.8 x 49.8 cm)
Signed on back of cardboard
mount: Picasso
VMFA, 47.10.79

PROVENANCE
TCJ purchase from Galerie
Jeanne Bucher, Paris, 1939

PUBLISHED
Daix, Pierre, and Joan Rosselet.
*Picasso: The Cubist Years,
1907–1916.* Translated by
Dorothy S. Blair. New York:
New York Graphic Society,
1979. No. 59.

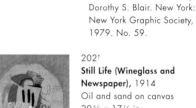

202†
**Still Life (Wineglass and
Newspaper),** 1914
Oil and sand on canvas
20⅝ x 17¼ in.
(52.4 x 43.8 cm)
Signed l.l.: *Picasso*
VMFA, 47.10.83

PUBLISHED
Daix and Rosselet. No. 744.

203†
**Pierrot as Orchestra
Conductor,** ca. 1920–1923,
after 1920 gouache by Picasso
Pochoir
12³⁄₁₆ x 9⁷⁄₁₆ in.
(31 x 24 cm)
Signed l.l.: *Picasso*
Inscribed l.l.: *23/100*
Published by Paul Rosenberg,
Paris, ca. 1920–23
UVAM, 1975.43.24

204†
**Guitar and Sheet Music on a
Pedestal Table,** ca. 1920–23,
after 1920 gouache by Picasso
Pochoir
9 x 11½ in.
(22.8 x 29.2 cm)
Signed l.l.: *Picasso*
Inscribed l.l.: *23/100*
Published by Paul Rosenberg,
Paris, ca. 1920–23
UVAM, 1975.43.25

205†
The Horseman, 1921
Lithograph
9 x 11¹/₁₆ in.
(22.9 x 28.1 cm)
Signed and dated l.l.: *Picasso
7-3-21*
Inscribed l.l.: *37/50*
From *Four Lithographs* (Quatre
lithographies), Marius de
Zayas, Paris, 1923; Galerie
Simon, Paris, 1928
UVAM, 1975.43.15

PUBLISHED
Bloch. Cat. 40.

206
On the Beach, II (3 Nudes),
1921
Lithograph
10¹/₈ x 12³/₈ in.
(25.7 x 31.5 cm)
Signed l.l.: *Picasso*
Dated l.r.: *8-3-21*
Inscribed l.l.: *37/50*
From *Four Lithographs* (Quatre
lithographies), Marius de
Zayas, Paris, 1923; Galerie
Simon, Paris, 1928
UVAM, 1975.43.22

207†
The Banjo Player, 1921
Gouache on paper
10⁵/₈ x 8³/₈ in.
(27 x 21.3 cm)
Signed u.l.: *Picasso*
VMFA, 47.10.81

208†
Fish, Fruit Bowl, Bottle, 1922
Peinture à l'essence and graphite
on paper
5¹/₂ x 4⁵/₁₆ in.
(13.9 x 10.9 cm)
Signed u.r.: *Picasso*
VMFA, 47.10.80

209†
Woman and Child, 1923
Lithograph
11¹/₄ x 14¹⁵/₁₆ in.
(28.5 x 38 cm)
Signed l.r.: *Picasso*
Inscribed l.l.: *23/50*
Published by Galerie Simon,
Paris, 1923
UVAM, 1975.43.21

PUBLISHED
Bloch. Cat. 66.

210†
Guitar and Fruit Bowl,
ca. 1924–25
Pastel on blue paper
4³/₄ x 6¹/₁₆ in.
(12.1 x 15.4 cm)
Signed l.l.: *Picasso*
VMFA, 47.10.82

211
Nude Athlete, 1950
Watercolor (pen and wash)
10¹/₄ x 13³/₄ in.
(26 x 34.9 cm)
Signed l.l.: *Picasso*
Gift of the Estate of Mrs.
Louisa Brooke Jones for the
T. Catesby Jones Collection
VMFA, 68.10.1

PHILIP PLATT

212
Landscape with Stone Barn, n.d.
Engraving, drypoint, and
aquatint
9¹/₄ x 11¹³/₁₆ in.
(23.5 x 30 cm)
Signed l.r.: *Philip Platt*
Inscribed l.l.: *For Mr Catesby
Jones*
UVAM, 1975.43.52

213
Brick Wall, n.d.
Aquatint and drypoint
11¹¹/₁₆ x 14¹¹/₁₆ in.
(29.7 x 37.3 cm)
Signed l.r.: *Philip Platt*
Inscribed l.l.: *First Proof, First
Aquatint*
UVAM, 1975.43.53

214
Tree with Fence, n.d.
Drypoint
9⁵/₁₆ x 11³/₄ in.
(23.7 x 29.9 cm)
Signed l.r.: *Philip Platt*
UVAM, 1975.43.54

215
Giraffes, n.d.
Engraving
17³/₈ x 11⁵/₈ in.
(44.1 x 29.5 cm)
Signed l.r.: *Philip Platt*
Inscribed l.l.: *First Proof First Line
Engraving* and *For Mr
Catesby Jones*
UVAM, 1975.43.55

216
Bridge and Cityscape, n.d.
Aquatint
14¹/₄ x 10¹³/₁₆ in.
(36.2 x 27.5 cm)
Signed l.r.: *Philip Platt*
Inscribed l.l.: *For Mr Catesby
Jones*
UVAM, 1975.43.56

FRANÇOIS POMPON
1855–1933, French

217
Young Partridge, 1923
Bronze
9³/₄ x 8³/₄ x 3¹³/₁₆ in.
(24.8 x 22.2 x 9.7 cm)
Signed l.l.: *Pompon*
VMFA, 47.10.89

VALENTINE HENRIETTE PRAX
1899–1981, French

218
Title unknown, n.d.
Drypoint
12³/₈ x 16¹/₂ in.
(31.5 x 41.9 cm)
Signed l.r.: *V. Prax*
Inscribed l.l.: *26/50*
UVAM, 1975.43.71

HANS REICHEL
1892–1958, French, born
in Germany
Active in Germany and France

219
Garden, 1940
Gouache on paper board
9⁵/₈ x 7³/₈ in.
(24.4 x 18.7 cm)
Signed l.r.: *R 1940*
Inscribed l.r.: *Jardin*
VMFA, 47.10.84

GEORGES ROUAULT
1871–1958, French

220–223 from *City Outskirts* (La petite banlieue), Éditions des quatre chemins, Paris, 1929.

220
The Suburb of Long Suffering (Dead End), 1929
Lithograph
17⁵/₈ x 12⁵/₁₆ in.
(44.7 x 31.2 cm)
Signed l.r.: *G Rouault;* signed and dated l.l.: *GR 1929*
Inscribed l.l.: *67/100*
UVAM, 1975.43.57

221
From the Depths, 1929
Lithograph
17¹¹/₁₆ x 12³/₈ in.
(45 x 31.4 cm)
Signed l.r.: *G Rouault;* signed and dated l.r.: *GR 1929*
Inscribed l.l.: *62/100*
UVAM, 1975.43.58

222
The Suburb of Long Suffering (The Poor Family), 1929
Lithograph
17¹⁵/₁₆ x 12⁹/₁₆ in.
(45.5 x 31.9 cm)
Signed l.r.: *G Rouault*
Inscribed l.l.: *67/100*
UVAM, 1975.43.59

223
The Suburb of Long Suffering (Moving House), 1929
Lithograph
17¹⁵/₁₆ x 12³/₈ in.
(45.5 x 31.5 cm)
Signed l.r.: *G Rouault;* signed and dated l.c.: *GR 1929*
Inscribed l.l.: *24/100*
UVAM, 1975.43.60

224–226 from *Père Ubu's Reincarnations* (Les réincarnations du Père Ubu), Ambroise Vollard, Paris, 1932:

224
Girl with a Wide-brimmed Hat, 1928
Etching
17⁵/₁₆ x 12¹¹/₁₆ in.
(43.9 x 32.3 cm)
Signed and dated l.r.: *GR 1928*
Stamped l.r.: *VIENT DE PARAITRE*
UVAM, 1975.43.61

225
Prospectus for Père Ubu's Reincarnations, 1932
Wood engravings
17¹/₈ x 26 in.
(43.5 x 66 cm)
UVAM, 1975.43.61.a–d

226
Mademoiselle Irma, 1928
Etching and aquatint
17¹/₈ x 12½ in.
(43.5 x 31.7 cm)
Signed l.r.: *G Rouault*
Inscribed l.l.: *78/225*
UVAM, 1975.43.70

227–243 from *The Shooting Star Circus* (Cirque de l'étoile filante), Ambroise Vollard, Paris, 1938.

PROVENANCE
TCJ purchase from Pierre Matisse Gallery, New York, 1939

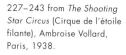

227
Parade, 1934
Plate I
Etching and aquatint
17¼ x 13³/₁₆ in.
(43.8 x 33.5 cm)
Signed and dated in plate l.l.: *1934 GR*
Inscribed l.r.: *I*
Gift of T. Catesby Jones
VMFA, 41.15.2.1

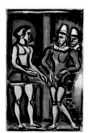

228
Black Pierrot, 1935
Plate II
Etching and aquatint
17½ x 13¼ in.
(44.4 x 33.6 cm)
Signed and dated in plate l.r.: *GR 1935*
Inscribed l.r.: *II*
Gift of T. Catesby Jones
VMFA, 41.15.2.2

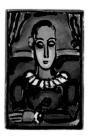

229
Bitter Lemon, 1935
Plate III
Etching and aquatint
17¹/₈ x 13¼ in.
(43.5 x 33.7 cm)
Inscribed l.r.: *III*
Gift of T. Catesby Jones
VMFA, 41.15.2.3

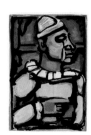

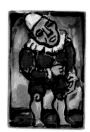

230¹
The Little Dwarf, 1934
Plate IV
Etching and aquatint
17¼ x 13¼ in.
(43.8 x 33.6 cm)
Signed and dated in plate l.l.: *1934 GR*
Inscribed l.r.: *IV*
Gift of T. Catesby Jones
41.15.2.4

PUBLISHED
Chapon, François, and Isabelle Rouault. *Oeuvre gravé: Rouault.* Translated by Gila Walker. Monte Carlo: Éditions André Sauret, 1978. P. 167.
Chapon, François. *Le livre des livres de Rouault.* Monte Carlo: Éditions André Sauret; Paris: Éditions Michèle Trinckvel, 1992. Cat. 243.

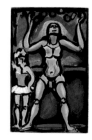

231
Juggler, 1934
Plate V
Etching and aquatint
17½ x 13¼ in.
(44.4 x 33.6 cm)
Signed and dated in plate l.r.: *G. Rouault, 1934*
Inscribed: *V*
Gift of T. Catesby Jones
VMFA, 41.15.2.5

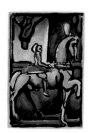

232
The Little Rider, 1938
Plate VI
Etching and aquatint
17½ x 13¼ in.
(44.4 x 33.6 cm)
Signed and dated in plate l.r.: *GR 1938*
Inscribed l.r.: *VI*
Gift of T. Catesby Jones
VMFA, 41.15.2.6

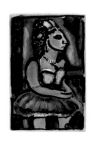

233
Madame Louison, 1935
Plate VII
Etching and aquatint
17⁵/₈ x 13¼ in.
(44.8 x 33.6 cm)
Signed and dated in plate l.c.: *GR 1935*
Inscribed l.r.: *VII*
Gift of T. Catesby Jones
VMFA, 41.15.2.7

234†
Weary Bones, 1934
Plate VIII
Etching and aquatint
17³⁄₈ x 13¼ in.
(44.1 x 33.6 cm)
Signed and dated in plate l.l.:
1934 GR
Inscribed l.r.: *VIII*
Gift of T. Catesby Jones
VMFA, 41.15.2.8

PUBLISHED
Chapon and Rouault. Cat. 247.
Chapon. P. 145.

235†
Madame Carmencita, 1935
Plate IX
Etching and aquatint
17¾ x 13¼ in.
(45.1 x 33.6 cm)
Signed and dated in plate l.r.:
GR 1935
Inscribed l.r.: *IX*
Gift of T. Catesby Jones
VMFA, 41.15.2.9

PUBLISHED
Chapon and Rouault. Cat. 248.
Chapon. P. 151.

236
Circus Brat, 1935
Plate X
Etching and aquatint
17⅝ x 13¼ in.
(44.8 x 33.6 cm)
Signed and dated in plate l.r.:
GR 1935
Inscribed l.r.: *X*
Gift of T. Catesby Jones
VMFA, 41.15.2.10

237
Master Arthur, 1934
Plate XI
Etching and aquatint
17⅛ x 13⁵⁄₁₆ in.
(43.5 x 33.8 cm)
Signed and dated in plate l.c.:
GR 1934
Inscribed l.r.: *XI*
Gift of T. Catesby Jones
VMFA, 41.15.2.11

238
Bittersweet, 1934
Plate XII
Etching and aquatint
17⅛ x 13⁵⁄₁₆ in.
(43.5 x 33.8 cm)
Signed and dated in plate l.l.:
GR 1934
Inscribed l.r.: *XII*
Gift of T. Catesby Jones
VMFA, 41.15.2.12

239
The Difficult One, 1935
Plate XIII
Etching and aquatint
17⅝ x 13¼ in.
(44.8 x 33.6 cm)
Signed and dated in plate l.l.:
GR 1935
Inscribed l.r.: *XIII*
Gift of T. Catesby Jones
VMFA, 41.15.2.13

240
Pierrot, 1935
Plate XIV
Etching and aquatint
17¾ x 13¼ in.
(45.1 x 33.6 cm)
Signed and dated in plate l.l.:
GR 1935
Gift of T. Catesby Jones
VMFA, 41.15.2.14

241
The Ballerinas, 1934
Plate XV
Etching and aquatint
17½ x 13¼ in.
(44.4 x 33.6 cm)
Signed and dated in plate l.c.:
GR 1934
Inscribed l.r.: *XV*
Gift of T. Catesby Jones
VMFA, 41.15.2.15

242
Auguste, 1935
Plate XVI
Etching and aquatint
17⅝ x 13¼ in.
(44.8 x 33.6 cm)
Signed and dated in plate l.l.:
GR 1935
Gift of T. Catesby Jones
VMFA, 41.15.2.16

243
Sleep, My Love, 1935
Plate XVII
Etching and aquatint
17⅝ x 13¼ in.
(44.8 x 33.6 cm)
Signed and dated in plate l.l.:
GR 1935
Inscribed l.r.: *XVII*
Gift of T. Catesby Jones
VMFA, 41.15.2.17

244–260 from *Passion,* text
by André Suarès; Ambroise
Vollard, Paris, 1939:

PROVENANCE
TCJ purchase from Pierre Matisse
 Gallery, New York, 1939

244†
**Frontispiece (Christ at the
Gates of the City),** 1935
Frontispiece
Color etching and aquatint
17⅜ x 13⅛ in.
(44.13 x 33.33 cm)
Signed and dated in plate l.l.:
GR 1935
Inscribed l.r.: *I*
Gift of T. Catesby Jones
VMFA, 41.15.3.1

PUBLISHED
Chapon and Rouault. Cat. 257b.
Chapon. P. 163.

245
Christ in the Suburb, 1935
Plate I
Color etching and aquatint
17⅜ x 13⅛ in.
(44.1 x 33.3 cm)
Signed and dated in plate l.r.:
GR 1935
Inscribed l.r.: *II*
Gift of T. Catesby Jones
VMFA, 41.15.3.2

246
The Tramp, 1935
Plate II
Color etching and aquatint
17⅜ x 13³⁄₁₆ in.
(44.1 x 33.5 cm)
Signed and dated in plate l.l.:
GR 1935
Inscribed l.r.: *III*
Gift of T. Catesby Jones
VMFA, 41.15.3.3

247
The Peasants, 1936
Plate III
Color etching and aquatint
17⅝ x 13³⁄₁₆ in.
(44.8 x 33.5 cm)
Signed and dated in plate l.r.:
GR 1936
Inscribed l.r.: *IV*
Gift of T. Catesby Jones
VMFA, 41.15.3.4

248†
Christ and the Holy Woman,
 1936
Plate IV
Color etching and aquatint
17½ x 13¼ in.
(44.4 x 33.6 cm)
Signed and dated in plate l.l.:
GR 1936
Gift of T. Catesby Jones
VMFA, 41.15.3.5

PUBLISHED
Chapon and Rouault. Cat. 261b.
Chapon. P. 167.

249
Christ and the Poor, 1935
Plate V
Color etching and aquatint
17 ¼ x 13 ⅛ in.
(43.8 x 33.3 cm)
Signed and dated in plate l.l.:
GR 1935
Inscribed l.r.: *VI*
Gift of T. Catesby Jones
VMFA, 41.15.3.6

250
Ecce Homo, 1936
Plate VI
Color etching and aquatint
17 ⅝ x 13 ⅛ in.
(44.8 x 33.3 cm)
Signed and dated in plate l.r.:
GR 1936
Inscribed l.r.: *VII*
Gift of T. Catesby Jones
VMFA, 41.15.3.7

251
The Old Man Plods On, 1935
Plate VII
Color etching and aquatint
17 ½ x 13 ⅛ in.
(44.4 x 33.3 cm)
Signed and dated in plate l.l.:
GR 1936
Gift of T. Catesby Jones
VMFA, 41.15.3.8

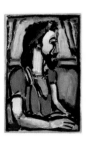

252†
Ecce Dolor, 1936
Plate VIII
Color etching and aquatint
17 ½ x 13 ⅛ in.
(44.4 x 33.3 cm)
Signed and dated in plate l.l.:
GR 1936
Inscribed l.r.: *IX*
Gift of T. Catesby Jones
VMFA, 41.15.3.9

PUBLISHED
Chapon and Rouault. Cat. 265.
Chapon. P. 176.

253
Christ (in Profile), 1936
Plate IX
Color etching and aquatint
17 ½ x 13 ³⁄₁₆ in.
(44.4 x 33.5 cm)
Signed and dated in plate l.l.:
GR 1936
Inscribed l.r.: *X*
Gift of T. Catesby Jones
VMFA, 41.15.3.10

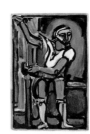

254
The Fisherman, 1936
Plate X
Color etching and aquatint
17 ½ x 13 ⅛ in.
(44.4 x 33.3 cm)
Signed and dated in plate l.r.:
GR 1936
Inscribed l.r.: *XI*
Gift of T. Catesby Jones
VMFA, 41.15.3.11

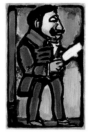

255
"A Ruffian . . . a jackal blessed by all the learned societies," 1935
Plate XI
Color etching and aquatint
17 ⅜ x 13 ³⁄₁₆ in.
(44.1 x 33.5 cm)
Signed and dated in plate l.c.:
GR 1935
Inscribed l.r.: *XII*
Gift of T. Catesby Jones
VMFA, 41.15.3.12

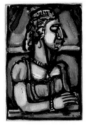

256
Woman of Means, 1936
Plate XII
Color etching and aquatint
17 ⅜ x 13 ⅛ in.
(44.1 x 33.3 cm)
Signed and dated in plate l.r.:
GR 1936
Inscribed l.r.: *XIII*
Gift of T. Catesby Jones
VMFA, 41.15.3.13

257
The Meeting, 1936
Plate XIII
Color etching and aquatint
17 ⅝ x 13 ⅛ in.
(44.8 x 33.3 cm)
Signed and dated in plate l.r.:
GR 1936
Inscribed l.r.: *XIV*
Gift of T. Catesby Jones
VMFA, 41.15.3.14

258
Christ and Mammon, 1936
Plate XIV
Color etching and aquatint
17 ½ x 13 ⅛ in.
(44.4 x 33.3 cm)
Signed and dated in plate l.r.:
GR 1936
Inscribed l.r.: *XV*
Gift of T. Catesby Jones
VMFA, 41.15.3.15

259
Christ and Disciples, 1936
Plate XV
Color etching and aquatint
17 ½ x 13 ⅛ in.
(44.4 x 33.3 cm)
Signed and dated in plate l.r.:
GR 1936
Inscribed l.r.: *XVI*
Gift of T. Catesby Jones
VMFA, 41.15.3.16

260
The Executioner's Assistant (Carrying a Piece of the Cross), 1936
Plate XVI
Color etching and aquatint
17 ⁷⁄₁₆ x 13 ⅛ in.
(44.3 x 33.3 cm)
Signed and dated in plate l.r.:
GR 1936
Inscribed l.r.: *XVII*
Gift of T. Catesby Jones
VMFA, 41.15.3.17

WILLIAM SANGER
Born 1888, American

261
Fishing Village at Vigo, Spain, 1917
Oil on canvas
17 ¾ x 28 ½ in.
(45.1 x 72.4 cm)
Signed and dated l.r.:
Wm Sanger 1917
VMFA, 47.26.2

262
Snow Scene, 1919–20
Oil on panel
22 ⅜ x 19 ⅜ in.
(56.8 x 49.2 cm)
Signed l.r.: *William Sanger*
VMFA, 47.26.1

PAUL SIGNAC
1863–1935, French

263
Croix-de-Vie, 1903
Watercolor and pencil on paper
10 ¾ x 17 in.
(27.3 x 43.2 cm)
Signed l.l.: *Paul Signac,*
Croix-de-Vie
VMFA, 47.10.85

FELIX E. TOBEEN
1880–1938, French

264
Resting (Basque Landscape),
ca. 1924
Oil on canvas
21¾ x 15 in.
(55.25 x 38.1 cm)
Signed l.r.: *Tobeen*
VMFA, 47.10.86

KRISTIANS TONNY
1907–1977, Dutch
Active in France, United States,
and the Netherlands

265
Title unknown, 1926
Lithograph
12¹³⁄₁₆ x 19¾ in.
(32.6 x 50.2 cm)
Signed and dated l.r.:
K TONNY 26
UVAM, 1975.43.62

HENRI DE TOULOUSE-LAUTREC
1864–1901, French

266
The Chap Book, 1896
Color lithograph
16⁵⁄₁₆ x 23⁷⁄₁₆ in.
(41.5 x 59.5 cm)
UVAM, 1975.43.93

JACQUES VILLON
1875–1963, French
Born Gaston Duchamp

267†
The Laden Table, 1913
Etching and drypoint
15½ x 21¹⁵⁄₁₆ in.
(39.4 x 55.7 cm)
Signed l.r.: *Jacques Villon*
UVAM, 1975.43.96

PUBLISHED
Auberty, Jacqueline, and
 Charles Perussaux. *Jacques
 Villon: catalogue de son
 oeuvre gravé.* Paris: Paul
 Prouté, 1950. Cat. 196.
De Ginestet, Colette, and
 Catherine Pouillon. *Jacques*

*Villon: les estampes et les
illustrations: catalogue
raisonné.* Paris: Arts et
métiers graphiques, 1979.
Cat. 285.

268†
Man Reading, 1929
Etching
15⁵⁄₈ x 11¹¹⁄₁₆ in.
(39.7 x 29.7 cm)
Signed l.r.: *Jacques Villon*
Inscribed l.l.: *19*
UVAM, 1975.43.66

PUBLISHED
Auberty and Perussaux.
 Cat. 219.
De Ginestet and Pouillon.
 Cat. 325.

269
Globes, 1930
Etching
11⁵⁄₁₆ x 15¾ in.
(28.8 x 40 cm)
Signed l.r.: *Jacques Villon*
Inscribed l.l.: *12/50*
UVAM, 1975.43.69

270†
Still Life with a Samovar, 1931
Etching and drypoint
13¾ x 10¹¹⁄₁₆ in.
(35 x 27.2 cm)
Signed l.r.: *Jacques Villon*
Inscribed l.l.: *épreuve d'artiste*
UVAM, 1975.43.67

PUBLISHED
Auberty and Perussaux.
 Cat. 232.
De Ginestet and Pouillon.
 Cat. 347.

271
Learned Man (J. P. Dubray),
 1933
Etching
16⅛ x 12¹³⁄₁₆ in.
(41 x 32.6 cm)
Signed l.r.: *Jacques Villon*
Inscribed l.l.: *9/50*
UVAM, 1975.43.68

MAURICE DE VLAMINCK
1876–1958, French

272†
The Storm, ca. 1912
Oil on canvas
23½ x 28¾ in.
(59.7 x 73 cm)
Signed l.l.: *Vlaminck*
Gift of T. Catesby Jones
VMFA, 46.3.1

PROVENANCE
TCJ Purchase from Fearon
 Gallery, New York, 1924

273†
Head of a Woman, 1922
Color woodcut
22⁵⁄₁₆ x 18¹⁄₁₆ in.
(56.6 x 45.9 cm)
Signed l.r.: *Vlaminck*
Inscribed l.l.: *No. 10*
Published by Galerie Simon,
 Paris, 1922
UVAM, 1975.43.92

PUBLISHED
Walterskirchen, Katalin von.
 *Maurice de Vlaminck:
 catalogue raisonné de
 l'oeuvre gravé.* Paris:
 Flammarion, 1974. Cat. 23.

274
Church in Beauche, 1926
Drypoint
9 x 11⅛ in.
(22.8 x 28.2 cm)
Signed l.r.: *Vlaminck*
Inscribed l.l.: *19/100*
From deluxe edition of *L'Art
 d'aujourd'hui,* 3, Spring 1926
UVAM, 1975.43.41

275
**The Village: Le Moutiers-les-
Perches,** ca. 1930
Etching and drypoint
17¹³⁄₁₆ x 19¹¹⁄₁₆ in.
(45.2 x 50 cm)
Signed l.r.: *Vlaminck*
Inscribed l.l.: *47/50*
UVAM, 1975.43.106

276
Artist unknown
Willows, n.d.
Etching
6 x 8¾ in.
(15.2 x 22.2 cm)
UVAM, 1975.43.72.c

277
Artist unknown, possibly Renez
Landscape with Bridge, n.d.
Etching
12⁵/₁₆ x 9 in.
(31.2 x 22.9 cm)
Signed l.l.: *Renez*
UVAM, 1975.43.78.a

DECORATIVE / NON-WESTERN OBJECTS

278
Servant Figure, Middle Kingdom,
 ca. 2061–1784 BCE
Wood
8³/₄ x 1³/₄ x 1¹⁵/₁₆ in.
(22.2 x 4.4 x 4.9 cm)
VMFA, 47.11.6

279
**Head of Imsety
(Lid of a Canopic Jar),**
 possibly New Kingdom
 (1570–1070 BCE)
Limestone
4⁵/₈ x 4³/₈ x 4¹/₂ in.
(11.7 x 11.1 x 11.4 cm)
VMFA, 47.10.90

280
Sculptor's Trial Piece,
 Third Intermediate Period,
 ca.1070–946 BCE
Limestone
4³/₄ x 5⁵/₈ x ⁵/₈ in.
(12.1 x 14.3 x 1.6 cm)
VMFA, 47.11.7

281
**Fragment of Decorated
Surface of Inner Coffin,**
 Third Intermediate Period,
 ca. 1070–656 BCE
Painting on plaster
5³/₄ x 2⁷/₈ x ³/₈ in.
(14.6 x 7.3 x 0.9 cm)
VMFA, 47.11.8

282
Archaic Goddess,
 5th Century BCE
Terra-cotta
6¹/₈ x 3⁷/₁₆ x 3¹¹/₁₆ in.
(15.6 x 8.7 x 9.5 cm)
VMFA, 47.10.91

283
**Archaic Goddess, with Carved
Base,** 5th Century BCE
Terra-cotta and wood
9¹¹/₁₆ x 3¹/₁₆ in.
(24.6 x 7.8 cm)
VMFA, 47.10.92A

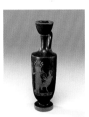

284
Figurine of a Young Girl,
 Hellenistic period
Terra-cotta
5⁷/₈ x 1⁷/₈ x 1³/₄ in.
(14.9 x 4.8 x 4.4 cm)
VMFA, 47.10.93

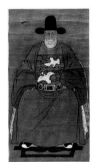

285
Lekythos, n.d.
Red-figured ware
8⁵/₈ x 2¹/₂ x 2⁷/₁₆ in.
(21.9 x 6.3 x 6.2 cm)
VMFA, 47.11.5

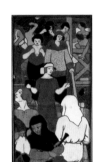

286
A Mandarin, 18th century
Tempera on cloth glued to
 a larger cloth
52¹/₂ x 29³/₄ in.
(133.3 x 75.6 cm)
VMFA, 47.17.1

287
A Lady, 18th century
Tempera on cloth glued to
 a larger cloth
57¹/₂ x 36 in.
(146 x 91.4 cm)
VMFA, 47.17.2

288
KAWAI KANJIRO
1890–1966, Japanese

Jar, first half of 20th century
Pottery
9¹/₄ x 7⁷/₁₆ x 6¹/₈ in.
(23.5 x 18.9 x 15.6 cm)
VMFA, 47.11.4

289
HAMADA SHOJI
1894–?, Japanese

Bowl, first half of 20th century
Pottery
3⁷/₈ in. x 10⁹/₁₆ in. (dia.)
(9.8 x 26.8 cm)
VMFA, 47.11.1

290
Covered Bowl, n.d.
Japanese
Pottery
6¹/₄ x 8¹/₄ in. (dia. with lid)
(15.9 x 20.9 cm)
VMFA, 47.11.3a/b

291
CORA RED SKIN
American Indian

Card Case, n.d.
Leather, suede, and beads
¹/₄ x 4¹/₂ x 5⁷/₈ in. (open)
(0.6 x 11.4 x 14.9 cm)
Gift of Mrs. Louisa Brooke Jones
VMFA, 46.12.1

292
LÉON JOUHAUD
1874–1950, French

Leaving the Workshop, n.d.
Enamel with frame
7⁷/₈ x 4¹/₈ x ¹/₂ in.
(20 x 10.5 x 1.3 cm)
VMFA, 47.11.9

Includes temporary
exhibitions comprised in
total or in part from the
T. Catesby Jones Collections

All exhibitions organized by
VMFA except *Modern French Prints*
(1944) and *Early 20th-Century
French Graphics* (1989)

Modern French Prints
> Grolier Club, New York, New York, opened October 19, 1944

The T. Catesby Jones Collection
> Virginia Museum of Fine Arts, Richmond, Virginia, February 26–April 4, 1948

Monroe Hall Gallery, Mary Washington College, Fredericksburg, Virginia, December 6–21, 1948

University of Virginia Library, Charlottesville, Virginia, opened April 13, 1949

Lynchburg Art Center, Lynchburg, Virginia, February 27–March 12, 1956

Randolph-Macon College, Ashland, Virginia, April 25–May 9, 1957

Modern French Paintings
> Norfolk Museum of Arts and Sciences, Norfolk, Virginia, March 1–26, 1958, and
> Mary Baldwin College, Staunton, Virginia, April 7–21, 1958

Roanoke Fine Arts Center, Roanoke, Virginia, October 20–November 10, 1958, and
Virginia Polytechnic Institute, Blacksburg, Virginia, November 10–December 3, 1958

Randolph-Macon Woman's College, Lynchburg, Virginia, September 21–October 19, 1959

Paris '20s: The T. Catesby Jones Collection
> VMFA Art Mobile, February 5–June 20, 1965

Jean Lurçat, An Exhibition of Paintings, Drawings and Textiles from the T. Catesby Jones Collection,
> Virginia Museum of Fine Arts, November 16–December 27, 1970

Selections from the T. Catesby Jones Collection
> Virginia Museum of Fine Arts, November 15–December 29, 1974

Early 20th-Century French Graphics: The T. Catesby Jones Collection
> Bayly Art Museum (now University of Virginia Art Museum), January 24–March 5, 1989

T. Catesby Jones and His Collection

Brock, Robert K. "Thomas Catesby Jones." *Record of the Hampden-Sydney Alumni Association* 10, no. 3 (April 1936): 5.

"Modern French Prints." *Gazette of the Grolier Club* 2, no. 4 (June 1945): 110–15.

"Modern Paintings, Drawings, and Sculptures, Assembled by the Late T. Catesby Jones and Given to the Museum." *Art Digest* 21, 18 (July 1, 1947): 11.

"Jones Collection of Modern Art Given to Virginia." *Art Journal* 7, no. 1 (Autumn 1947): 57.

Colt, Thomas C., Jr. "Jones: Advance-Guard Adventures." *Art News* 47, 1 (March 1948): 19, 55–60.

Virginia Museum of Fine Arts. *The T. Catesby Jones Collection.* Richmond: Virginia Museum of Fine Arts, 1948.

———. *Jean Lurçat: An Exhibition of Paintings, Drawings, and Textiles from the T. Catesby Jones Collection of the Virginia Museum.* Richmond: Virginia Museum of Fine Arts, 1970.

———. *Contemporary French Tapestries.* Richmond: Virginia Museum of Fine Arts, 1970.

University of Virginia Art Museum. *Early 20th–Century French Graphics: The T. Catesby Jones Collection.* Charlottesville: Bayly Art Museum, University of Virginia, 1989.

T. Catesby Jones's Writings

On Modern Art

Autobiographical letter. In *Law class of 1902, University of Virginia: Their report of thirty years made to their classmates at the thirtieth reunion, June 12 to 14, 1932, at the University of Virginia.* [Charlottesville]; New York: Court Press, [1932], 58–59.

"A Letter to a Friend on Modern Art" (March 14, 1932). In VMFA, *T. Catesby Jones Collection,* 7–13; also reprinted as: "Donor of Modern Art Analyzes Painting of Past 50 Years." *Richmond Times-Dispatch,* February 22, 1948.

Modern French Prints; An Address . . . Delivered on October 19, 1944 at The Grolier Club of New York. New York: Court Press, [1945]. Excerpted as "How the Collection Began" and "Fundamentals" in VMFA, *T. Catesby Jones Collection,* 14–15 and 16–17.

"S. W. Hayter." *Kenyon Review* 7, no. 3 (Summer 1945): 437–39.

"André Masson: A Comment." *Kenyon Review* 8, no. 2 (Spring 1946): 224–37. Excerpted in VMFA, *T. Catesby Jones Collection,* 31–32.

"Jean Lurçat and the Renaissance of Tapestry." Virginia Museum of Fine Arts, curatorial files. Typescript; published in shortened form in *Magazine of Art* 41, no. 1 (January 1948): 2–5.

Other

Documents in Commercial Transactions: Carrier's Liability—Harter Act—Hague Rules; an Address. New York: [The Insurance Society of New York], 1925.

"The Commencement Address by T. Catesby Jones, '99, New York City." *Record of the Hampden-Sydney Alumni Association* 14, no. 4 (July 1940): 7–10.

"The Iron-Clad Virginia." *Virginia Magazine of History and Biography* 49, no. 4 (October 1941): 297–303.

"The Merrimack and Her Big Guns." *Virginia Magazine of History and Biography* 50, no. 1 (January 1942): 13–17.

"Some Aspects of Allegiance." *Virginia Law Review* 32, no. 6 (November 1946): 1077–98.

General Bibliography of Recent Literature on French Art, 1900–45

Chapon, François. *Le Peintre et le livre: l'âge d'or du livre illustré en France, 1870–1970.* Paris: Flammarion, 1987.

Cowling, Elizabeth, and Jennifer Mundy. *On Classic Ground: Picasso, Léger, de Chirico, and the New Classicism, 1910–1930.* London: Tate Gallery, 1990.

L'École de Paris, 1904–1929, la part de l'autre. Paris: Paris-Musées, 2000.

Gee, Malcolm. *Dealers, Critics, and Collectors of Modern Painting: Aspects of the Parisian Art Market, 1910–1930.* New York: Garland, 1981.

Golan, Romy. *Modernity and Nostalgia: Art and Politics between the Wars.* New Haven and London: Yale University Press, 1985.

Green, Christopher. *Art in France, 1900–1940.* New Haven and London: Yale University Press, 2000.

———. *Cubism and Its Enemies: Modern Movements and Reaction in French Art, 1916–1928.* New Haven and London: Yale University Press, 1987.

Jeanne Bucher: une galerie d'avant-garde, 1925–1946. Edited by Christian Derouet and Nadine Lehni. Geneva: Skira; Strasbourg: Les musées de la ville de Strasbourg, 1994.

Paris 1937–Paris 1957: créations en France. Paris: Centre Georges Pompidou, 1981.

Sawin, Martica. *Surrealism in Exile and the Beginning of the New York School.* Cambridge, Ma.: MIT Press, 1995.

Silver, Kenneth E. *Esprit de corps: The Art of the Parisian Avant-Garde and the First World War, 1915–1925.* Princeton: Princeton University Press, 1989.

———. *Making Paradise: Art, Modernity, and the Myth of the French Riviera.* Cambridge, Ma.: MIT Press, 2001.

Strachan, W. J. *The Artist and the Book in France.* New York: G. Wittenborn, 1969.

Les surréalistes en exil et les débuts de l'école de New York. [Madrid]: Aldeasa, 2000.

Wallen, Burr, and Donna Stein. *The Cubist Print.* Berkeley: University Art Museum, University of California, Santa Barbara, 1981.

Wilson, Sarah, Éric de Chassey, et al. *Paris: Capital of the Arts, 1900–1968.* London: Royal Academy of Arts, 2002.

All images are © 2008 Artists Rights Society (ARS), New York / ADAGP, Paris, with the following exceptions:

Campigli images © 2008 Artists Rights Society (ARS), New York / SIAE, Rome
Klee images © 2008 Artists Rights Society (ARS), New York / VG Bild-Kunst, Bonn
Matisse images © 2008 Succession H. Matisse / Artists Rights Society (ARS), New York
Picasso images © 2008 Estate of Pablo Picasso / Artists Rights Society (ARS), New York
Photographs of Jones pp. 1 & 18, Virginia Museum of Fine Arts, Photo Archives
Fig. 1 Private collection, courtesy Galerie Beyler, Basel
Fig. 2 Worcester Art Museum, Worcester, Massachusetts, Gift of Mrs. R. L. Riley (Mary C. Riley)
Fig. 3 Private collection
Figs. 4 & 5 Digital image © The Museum of Modern Art / Licensed by Scala / Art Resource, NY. Photo by Soichi Sunami
Fig. 6 Digital image © The Museum of Modern Art / Licensed by Scala / Art Resource, NY. Photo by Beaumont Newhall
Fig. 7 Photo from *Cahier d'art,* 1929, Special Collections Department, University of Virginia Library
Fig. 8 Gift of T. Catesby Jones, Special Collections Department, University of Virginia Library, ND553 .L8 C5 1929
Fig. 9 Photo from *Magazine of Art,* 1948, Fine Arts Library, University of Virginia
Fig. 10 Virginia Museum of Fine Arts, Photo Archives
Figs. 12–16 Virginia Museum of Fine Arts, Photo Archives
Figs. 17–19 T. Catesby Jones Collection, Special Collections, University of Virginia Library, NC 251 .E69 1926, Gift of T. Catesby Jones
Fig. 20 Digital image © The Museum of Modern Art / Licensed by Scala / Art Resource, NY
Figs. 22–23 T. Catesby Jones Collection, University of Virginia Library, ND 553 .P5 S86 1937, Gift of T. Catesby Jones

PHOTOGRAPHY
CREDITS

All digital photography by Katherine Wetzel and Travis Fullerton, of VMFA, and Andrew Hersey, of UVAM, except for those figures noted above.

INDEX

Illustrations indicated by
page numbers in bold